Creative Arts in the Lives of Young Children

Play, imagination and learning

Creative Arts in the Lives of Young Children

Play, imagination and learning

Edited by **Robyn Ewing**

ACER Press

First published 2013
by ACER Press, an imprint of
Australian Council *for* Educational Research Ltd
19 Prospect Hill Road, Camberwell
Victoria, 3124, Australia

www.acerpress.com.au
sales@acer.edu.au

Cover design, text design and typesetting by ACER Project Publishing
Cover images © Shutterstock/SeDmi and Shutterstock/fotoecho
Indexed by Russell Brooks
Printed in Australia by BPA Print Group

Image credits: p. 8 © Sarah Buultjens 2012; pp. 20, 23, 66 © David
Smith 2012; pp. 50, 60 © Lea Mai 2012; pp. 91, 93, 94 © Amanda De
Lore 2012; pp. 114, 121 © Kay Yasugi 2012.

Every effort has been made to acknowledge and contact copyright
owners. However, should an infringement have occurred, ACER
tenders its apology and invites copyright owners to contact ACER.

National Library of Australia Cataloguing-in-Publication data:

Title:	Creative arts in the lives of young children: play, imagination and learning / Robyn Ewing, editor.
ISBN:	9781742860237 (pbk.)
Notes:	Includes bibliographical references and index.
Subjects:	Arts and children–Australia.
	Arts–Study and teaching–Australia.
	Creation (Literary, artistic, etc.)
Other Authors/Contributors:	
	Ewing, Robyn (Robyn Ann), 1955-
Dewey Number:	700.830994

FOREWORD

It is apparently efficient to divide everything into small compartments and fill each compartment with things that are the same, or at least close to the same. Thinking in this way leads to a series of decisions not unlike a filing cabinet.

The Sydney Theatre Company has been working closely with Robyn Ewing for the last four years. It is not a necessarily immediately perceivable connection between a Professor of Teacher Education and the Arts at the Faculty of Education and Social Work at the University of Sydney and an Actress and Writer who are the co-Artistic Directors of Sydney Theatre Company. In the filing cabinet of life, this unlikely combination would not be possible, but it has led, from our perspective, to a very fruitful collaboration.

Three of the great things about the Arts is that they are porous, oddly shaped and resist classification. These three wonderful attributes can easily be applied to any child we know. It is no accident that the artistic objects we put on stage are called plays, because they only ever work if there is a huge element of play in them. Role-play, re-enactment, lightness of touch, suspension of disbelief, imagination; that box is actually a space ship. There is a great deal of research which would suggest quite clearly that play, particularly dramatic play, is a vital part of education. A vital outcome of education is of course literacy and numeracy, but if the desired outcome is used to determine the approved process exclusively, the natural vibrancy of the children subject to it is in great jeopardy. An element of the Arts, an element of play, an element of the porous, the oddly shaped and the unclassifiable are vital to the energy of any classroom, and of course a classroom is not just the little boxy room that you go to when you're at school. In fact, unsurprisingly, childhood does not compartmentalise learning. Children are learning all the time, regardless of whether it's a school day or a weekend, it's Maths or English, it's a teacher or a parent. So this book has been designed for the first teachers they encounter – their parents – as well as early childhood educators and care givers. It is grounded in rigorous research, but at the same time it provides a range of concrete and fun activities, adaptable for every child. So there is a way, with careful application, dedication and a dollop of imagination that you can get the efficiency of the filing cabinet without sticking your children in a box.

One of our strongest motivations for coming back to Australia to live was because we felt it was such a great place to grow up. Our memories were not of tests and quotas but of games and play. Australia is currently at a cross roads in

education and we must ensure that the Arts are embedded in the early childhood curriculum for all children so that the porous, oddly shaped, unclassifiable aspects of their life are given voice and genuine consideration.

Andrew Upton and Cate Blanchett
Artistic Directors, Sydney Theatre Company

CONTENTS

ACKNOWLEDGEMENTS

First, I am particularly grateful to the Australian Council for Educational Research, and to Managing Editor and Publisher, Debbie Lee, for the invitation to develop this book.

Second, I am indebted to the highly accomplished authors who put such enthusiasm, creativity and imagination into the writing of their chapters: Heather Blinkhorne, Victoria Campbell, Amanda De Lore, Robyn Gibson, Sarah Ibrahim, Olivia Karaolis, Lea Mai, Janelle Warhurst and Gretel Watson. Thank you also to the students, teachers and parents who provided the photographs and artwork used in this book.

Third, I acknowledge my colleagues and students at the University of Sydney for their support and collegiality.

Fourth, I am highly appreciative of the support of David Smith and Suzanne Mellor, and my network of long-suffering, and loving, extended family and friends.

Fifth, I am especially blessed by the young children in my world, and grateful for their many contributions to the book: Timothy and Jordan; Alexander and Xavier; Alia, Evie and Ariel; and Thomas, Lucas and Finbar.

Finally, my deep appreciation to Andrew Upton and Cate Blanchett for their thoughtful Foreword and their support for the Arts in the lives of all children.

Robyn Ewing

ABOUT THE CONTRIBUTORS

The editor

Robyn Ewing is Professor of Teacher Education and the Arts and Associate Dean (Academic), Faculty of Education and Social Work at the University of Sydney, and a former primary teacher. One focus of her teaching, research and extensive publications has been the transformational role the Arts can, and should, play in children's learning. Her own expertise in the Arts has centred on the use of drama with literature to enhance students' English and literacy learning outcomes. She frequently works alongside other educators interested in reforming their curriculum practices. Current projects include a partnership with Sydney Theatre Company on School Drama, an initiative that aims to develop the drama expertise of primary teachers. She is also a chief investigator on the ARC Linkage project, TheatreSpace: Accessing the cultural conversation, examining what engages young people in theatre. Other research interests include the experiences of early career teachers and the role of mentoring in their retention in the profession; sustaining curriculum innovation; curriculum assessment and evaluation; inquiry and case-based learning; and arts-informed research methodologies. Robyn is National President of the Australian Literacy Educators Association and Vice-President of the Board of Sydney Story Factory.

The authors

Heather Blinkhorne completed her Master of Teaching at the University of Sydney in 2011, and is currently teaching at Curl Curl North Public School in Sydney. During her internship at the school Heather collaborated with class teacher Gretel Watson to create a literacy unit that would complement a storypath approach to HSIE/science. The wonderful results have left Heather passionate about engaging students through meaningful role-play, and about the importance of integrating literacy with everything. Heather hopes to build on this learning through the collaborative critical literacy and play-building projects currently running at the school.

Victoria Campbell is completing her PhD at the University of Sydney, where she is also a part-time lecturer/tutor in the K–6 Creative Arts Syllabus (Drama). She is currently working as an artist/facilitator for School Drama, a teacher professional learning program focusing on developing literacy through drama run by the

Sydney Theatre Company and the University of Sydney. Her research interests centre on the application of oral storytelling in educational contexts. Her recent study, The Selkie Project, provided a professional learning opportunity for primary teachers to practise, refine and enhance their narrative and oral storytelling skills, and highlighted how storying and oral storytelling link as art forms.

Amanda De Lore has a Bachelor of Education in Early Childhood and Primary Teaching, and is a qualified singing teacher. She lectures part-time in the Early Childhood Diploma of Education program at Wollongong University, and conducts music workshops for students and teachers at early childhood centres. Amanda has taught grades K-6 as a classroom teacher and worked as a support teacher for students with learning difficulties. She has also trained choir and dance groups for both the Schools Spectacular and regional events. In 2007, she utilised a federal government grant to write and stage a production celebrating cultural diversity incorporating the entire school population.

Robyn Gibson has been a primary school teacher, arts/craft specialist and tertiary educator in Australia and the United States. She is currently a Senior Lecturer in Visual and Creative Arts Education in pre-service teacher education programs in the Faculty of Education and Social Work at the University of Sydney. Robyn is an advocate for the imperative of creativity and imagination within the curriculum, and committed to the central role the Arts should play in lifelong learning. Her co-authored book *Transforming the curriculum through the arts* (with Robyn Ewing) was published in 2011. Her recent research has focused on the role of arts education in primary and secondary students' engagement, motivation and academic achievement.

Sarah Ibrahim has completed degrees in both business and commerce, and early childhood teaching. Motivated by her love of children and her desire to learn more about child development, in 2010 Sarah put her corporate career on hold and enrolled in the University of Sydney's postgraduate Bachelor of Teaching (Early Childhood), which she successfully completed in 2011. She then worked for a number of early childhood centres in teaching roles. Sarah's interests include sociocultural theories of child development, friendship in early childhood, and the role of observation and documentation in enhancing teaching practices and children's learning.

Olivia Karaolis is a teacher of students with special needs. She uses the creative arts to help children learn to communicate, play and be creative. Olivia is a graduate of the Ensemble Acting Studios, and holds a Master of Special Education. In 2007 she developed the UCPlay Project for United Cerebral Palsy in Los Angeles. The program brings creative arts classes to children with special needs in under-

resourced urban schools and preschools in Los Angeles, serving hundreds of children every week. Olivia lives with her husband and son in Santa Monica, California.

Lea Mai is completing her PhD on aesthetic experiences in early childhood in the Faculty of Education and Social Work at the University of Sydney. Her research interests include the cultural and participatory rights of children, and how young children engage with works of art. Lea lectures in Creative Arts in Early Childhood at the Faculty of Education and Social Work, University of Sydney, and has authored museum education programs for the university's art gallery.

Janelle Warhurst is Deputy Principal at Woollahra Primary School. She has more than 30 years experience teaching across K-6 in New South Wales schools. She loves engaging her students in meaningful and quality literary pursuits that foster thinking, creativity and learning. Her work in collaboration with other teachers, artists, the University of Sydney, the Australian Literary Educators Association, and the Artists in Schools Program (NSW Department of Education and Communities) has focused on teaching imaginatively, and has resulted in scholarly articles, published integrated units and workshops at conferences and staff development days. Her current project (2012) with the New South Wales Department of Education aims to assist teachers in developing strategies to improve literacy outcomes through process drama and play-building.

Gretel Watson is Assistant Principal at Curl Curl North Primary School. Gretel loves to connect learning in her classroom through storytelling, drama and art. She believes role-play opportunities are profoundly significant in students' cognitive and linguistic achievements, and that drama allows children to rehearse life experiences through play and to use new vocabulary in context. Storytelling has become one of Gretel's passions due to School Drama, a professional learning opportunity with the University of Sydney and the Sydney Theatre Company. Gretel worked with Victoria Campbell to develop her storytelling skills, which she continues to share with the children she teaches. Her passion and understanding for learning has deepened due to her links with professors and students from the University.

For all children whose sense of
wonder and imagination allow
us to see the world afresh.

Investing in quality early childhood education and the Arts

Robyn Ewing

In his latest picture book, *The artist who painted a blue horse*, Eric Carle (2011) encourages young children to have confidence in their creativity and celebrate their imaginations. One of the young Carle's art teachers when he was growing up in Germany recognised the free-flowing nature of his artwork and secretly shared with him the work of Franz Marc, an artist famous for his blue horses, who had been banned by the Nazi regime. Carle attributes his use of unconventional colours (e.g. his green lion and polka-dotted donkey) to this critical moment in his education. He suggests that children don't always need to stay within conventional lines and boundaries – and that there are no right or wrong colours.

Creative arts in the lives of young children draws together two essential, but all too often ignored, strands in education, both internationally and in Australia:
- the importance of high quality care and education in the early years of life in laying an optimal foundation for children's life chances; and
- the central role that imaginative arts experiences can, and should, play in the lives of all young children.

The critical importance of quality early childhood education

Alan Hayes introduced a comprehensive review of early childhood education in Australia (Elliott, 2006) with the words:

> *The importance of the early years to children's lives is now beyond question. A good beginning to life is well recognised as the foundation for future development, health and wellbeing, not only in the early years, but also throughout life.* (p. iii)

It is difficult to understand why, given the criticality of these early years, Australia's investment in them has historically been so minimal in comparison with that of most other OECD countries.

In a number of publications over the last five years, Professor Tony Vinson (e.g. 2004, 2007, 2009) has convincingly drawn out the relationship between inadequate education and a life of disadvantage, ill-health and poverty. He has warned us time and again about the huge human cost of inadequate investment in early childhood education, describing the provision of quality pedagogy in early childhood education as a moral imperative:

> *What an improvement it would be – morally, economically – to do something serious about challenging the inter-generational transmission of poverty and limited education that continue to help shape the destinies of significant numbers of our children.* (Vinson, 2006, p. 13)

Certainly, the introduction of the Commonwealth Government's framework document *Belonging, being and becoming: The early years learning framework for Australia* (DEEWR, 2009), now provides a foundation and framework for quality learning and teaching in all early childhood education and care settings. Yet as this book goes into publication, another Australian longitudinal study, *E4Kids*, commissioned by the Australian Government (2012) and being undertaken by the University of Melbourne and Queensland University of Technology, laments the ongoing issues: while early childhood education generally provides good emotional support, the level of instructional support is very varied across the country – in Elliott's metaphor, 'patchwork' in nature (Elliott, 2006).

The imperative of the Arts in learning

Alongside this concern is another: the paucity of funding invested by our education systems in rich arts experiences for young children. Dance, drama, literature, music, puppetry and visual arts are distinctive art forms in their own right. Notwithstanding

this distinctiveness, each art form embeds play, experimentation, exploration, provocation, expression and the artistic or aesthetic shaping of the body or another media. One of the defining features of humanity is that emotions as well as personal, sensory and intellectual experiences are inextricably entwined. From the beginning of human existence, Indigenous cultures have placed the Arts at the centre of knowing, being and becoming. As Jeff McMullen said when he introduced an Australian Aboriginal art exhibition at the Art Gallery of New South Wales in 2010:

> *The Aboriginal system of knowledge, art and human storytelling is not only the world's oldest earth science and environmentalism, it's a complex expression of the wonder of the journey of the human mind, as people try to fathom our relationship with the cosmos, our place in the bigger scheme of things.*

While not all arts experiences are imaginative, and it is clear that involvement in the Arts does not always correlate with creativity, it is widely accepted that creativity, imagination and the Arts are linked in important ways (see Thomson & Sefton-Green, 2011). In Jacob Bronowski's words (1978, p. 109), our world is a connected and holistic system, and imagining is about 'the opening of the system so that it shows new connections'. Ken Robinson asserts that:

> *As soon as we have the power to release our minds from the immediate here and now, in a sense we are free. We are free to revisit the past, free to reframe the present, and free to anticipate a whole range of possible futures. Imagination is the foundation of everything that is uniquely and distinctly human.* (2009, p. 58)

It is not surprising, then, that there is also unequivocal research evidence that there are strong links between high quality, arts-rich education and students' academic and affective achievement (e.g. Catterall, 2009; Fiske; 1999 President's Committee on the Arts and Humanities, 2011).

Children immersed in arts-rich learning environments are better equipped for the demands of lifelong change and the need to be flexible thinkers:

> *Most recently, cutting-edge studies in neuroscience have been further developing our understanding of how arts strategies support crucial brain development in learning.* (President's Committee on the Arts & Humanities, 2011, p. vi)

Further, engaging in arts processes and experiences can provide the potential to reshape the way learning is conceived and organised in educational contexts (Ewing, 2010a). Young children's thinking is inherently imaginative, and the boundaries between the 'real' world and their fantasies are very blurred. Susan Wright (2011, p. 3) reminds us that children seem to 'intuitively understand the

poetic nature of the arts', and adults must help them actively create their realities through helping them draw, paint, build, dance, dramatise and make music. The time, resources and – where appropriate – the scaffolding to engage in imaginative play and arts experiences is one of the most important gifts adults can provide for young children. Such activities are also usually enjoyable for all participants. And productive learning is more certain when we are having fun.

The centrality of quality early childhood education and arts-rich curricula have been well documented and referenced in the research, and also in policy literature and rhetoric, particularly over the last decade. Despite this, sufficient practical resources and funding have not historically been forthcoming in this country.

In addition, it is of great concern that it is often the children who are most in need who are deprived of such experiences and opportunities.

The underlying themes in this book

A number of underlying themes are important throughout the book. All are related to the potential for quality arts experiences in the early years to achieve transformational outcomes for children. These include:

- the enhancement and ongoing development of children's already rich imaginations
- the encouragement of children's innate creativity and problem-solving abilities
- the provision of opportunities to explore a broad and inclusive worldview and to reflect on the vast diversity of cultures and approaches to living
- the development of children's attitudes, skills and ways of being (habits of mind) to help them flourish in the ever-changing twenty-first century.

This book is grounded in current research and practice about the importance of the Arts in young children's lives. (Indeed, they are important in all our lives.) Written explicitly for early childhood teachers and caregivers as well as parents and other interested adults, it includes a range of engaging and practical creative arts activities and suggested experiences for children from birth to eight years of age. These activities and experiences closely align with both *Belonging, being, becoming: The early years learning framework for Australia* (DEEWR, 2009) and the *Shape of the Australian curriculum: The arts* (ACARA, 2011), and can be readily adapted for all age groups.

Most activities and experiences can be implemented or introduced with relative ease and without too much expense. While many children will enjoy working across the Arts, some may have preference for a particular media or type of experience at a very early age. Even when this is the case, children should be offered opportunities to explore a range of arts activities and experiences.

The following chapters are sequenced so that the book intentionally starts with the earliest years and the simplest of imaginative play. Subsequent chapters move to more adult scaffolded and formal experiences appropriate for the early years of school. All chapters, however, provide easy access to a range of experiences, materials and media that will enable young children to explore different ways of expressing who they are. But it is not necessary to read the book in sequence: the reader is invited to consult chapters of interest in any order.

Each chapter reflects the individuality, voice and expertise of its authors. While they are all accessible in style, with a keen awareness of the market, there has been no attempt to make chapters uniform.

In keeping with this, different states currently use different terminology to describe the first year of school. In New South Wales, Western Australia and the Australian Capital Territory the common term is 'kindergarten', while in Victoria, Tasmania and Queensland it is known as 'preparatory', in South Australia 'reception' and in the Northern Territory, 'transition'. In the Australian Curriculum it will be renamed as 'foundation'.

Outline of the book

This Introduction provides an overview, a rationale and a context for the book.

Chapter 1 demonstrates the centrality of holistic, imaginative play to a young child's intellectual and affective development. It offers suggestions for providing the spaces and places for child-initiated creative play.

Dramatic play is the focus of Chapter 2 – how child-initiated opportunities coupled with drama processes can contribute to children's development as confident, creative, engaged learners.

It is a truism that we live our lives by and through stories. Victoria Campbell particularly focuses on the primacy of narrative in the lives of young children in Chapter 3. She shows us how children use storying to sort out their knowledge and ideas about the world and explore its possibilities further. It is interesting to contemplate how our identity is inextricably linked with our stories.

Lea Mai bases Chapter 4 on her groundbreaking doctoral study of the importance of ensuring that aesthetic and cultural experiences are introduced to young children at an early age. The chapter also addresses the issues of how to integrate experiences of visiting professional arts organisations that welcome young children with art-making, so that they can develop their cultural awareness and aesthetic appreciation.

Literature is often overlooked in discussions of the Arts and education. Nevertheless, literature is the art form that the majority of Australians are most comfortable and familiar with. Playing with language and exploring literary

texts are closely examined in Chapter 5. As Margaret Meek (cited in Fox, 1993) asks:

> *What would we find if many more children than now do could have the experience*
> *of books read to them in infancy and discovered the joy and power of telling them?*
> (p. viii)

Heather Blinkhorne, Janelle Warhurst and Gretel Watson share units of work that underline the important role that literature can play in developing children's imaginations while they are learning to be literate.

Most children have a natural sense of rhythm, and delight in moving creatively to music. In Chapter 6 Amanda De Lore explores how music affects our feelings and sense of wellbeing. She provides many suggestions that will enable young children to experiment with sounds, singing and creative movement.

When visiting Reggio Emilio preschools in Italy, Nancy Hertzog (2001) noted that young children were encouraged to express their learning and communicate about the world as artists. Art is an important means of self-expression for young children; it encourages spontaneity, imagination, play and experimentation. In Chapter 7 Robyn Gibson provides a sound theoretical and philosophical foundation for arts education. She then demonstrates how playing with paint, clay and other media to make art is emotionally satisfying and will help young children to communicate things that are otherwise unsayable. All the time their artistry is developing.

Robyn Gibson and Victoria Campbell demonstrate how puppetry can enhance children's creativity and lateral thinking in Chapter 8. They help us understand how making and using puppets can develop children's resilience and resourcefulness.

Finally, in Chapter 9, Olivia Karaolis provides a moving account of her work in Los Angeles and underlines how especially important arts experiences are for children with special needs. She includes a rationale along with practical measures to enable these children to benefit from arts-rich experiences. The experiences and activities described are valuable for all children.

The Postscript draws all the preceding chapters together through the lens of a preservice early childhood teacher undertaking her first professional experience. Excerpts from Sarah Ibrahim's creative arts portfolio allow us to share her journey with a young child, Asher, as he explores his interest and enthusiasm for dinosaurs through a range of meaningful arts experiences. She demonstrates clearly why the Arts must play a central role in the lives of all young children. At the same time we can see how the scaffolding of these imaginative activities also renews her creative potential alongside that of the children she works with.

Imaginative play in the lives of young children

Robyn Ewing

I've come to understand that in a world where so much is unequal – creativity is the great equaliser. (Clark, 2009, p. 187)

Twelve-month-old Timothy and his dad are having fun rolling the ball across the sunroom floor to each other. The ball accidentally rolls under the lounge and disappears from view. Timothy's dad turns his hands up, rolls his eyes to the ceiling and frowns as he says: 'Where's the ball?' From then on, Timothy deliberately rolls the ball under any nearby furniture, upturns his hands and mirrors his dad's expression – albeit with a slight twinkle in his eye. He laughs when the ball is retrieved and repeats the sequence many times. He has adapted the first game to create a new game that involves helping the ball to disappear temporarily – one that he never seems to tire of.

Three months later, Timothy welcomes you into his improvised 'kitchen' and invites you to sample his tray of blue playdough muffins. He looks expectantly for your affirmation of his culinary skills, both before and after he has placed his muffins in an imaginary oven. He smiles appreciatively and nods in agreement as you exclaim how delicious they taste.

By nineteen months of age Timothy is taking his stuffed Tigger everywhere. He carefully dresses Tigger in a nappy, and changes it regularly. When his mother comments that Tigger's nappy has slipped and needs 'fixing', he finds his toolkit and selects his hammer to carry out the task. Another favourite, a doll named Baby sits beside him as he eats his cereal, largely unassisted. He pauses to offer Baby a spoonful of cereal and then makes encouraging eating noises (mimicking those his parents often make when they are encouraging him to eat). He grins, obviously pleased with Baby's efforts. And so begins a regular playful dinnertime game. Both Tigger and Baby are wrapped for bedtime, and when travelling must sit in the car seat with their seat belts fastened.

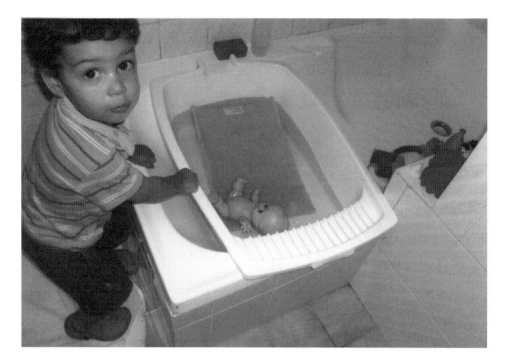

Figure 1.1 Timothy baths Baby

Play as the right of every child

The United Nations High Commission for Human Rights deems play so important that it is enshrined in the Convention on the Rights of the Child (OHCHR, 1989) as a right of every child. Nelson Mandela is credited with the assertion that 'there can be no keener revelation of a society's soul than the way in which it treats its children'.

Being with young children as they excitedly and spontaneously explore their world and give themselves so earnestly to this exploration is inspiring. The world of young children should be crowded with such episodes of imaginative play, or 'let's pretend', and it should be of their own making:

I'll be the fireman and you can drive the truck.

This is my café. I'll take your order in a minute.

You can be my little girl. And you're not feeling well so I'll call the doctor.

Most young children, given the chance, are endlessly curious, creative, energetic and uninhibited. They learn so much about the world through all kinds of play. As Donald Blumenfeld-Jones (2010) asserts, children are born creative. He affirms that, through acts of creativity such as imaginative play, children learn important human capacities that can be developed to benefit both the individual and society. Certainly there is a growing recognition of the need to foster this innate creativity in children, and it is becoming an increasing focus of early childhood education policy and curriculum documents, both in Australia and globally.

This chapter first briefly considers how to define play more generally, before exploring the benefits of imaginative play and the adult's role in play contexts. The importance of enabling children to drive their own imaginative play contexts and the role of the adult in facilitating such opportunities is considered. While adults may well be facilitators in providing the time and resources, and sometimes the scaffolding, it is helpful, especially initially, to think of them as 'joiners' in play contexts. Some different types of play are also examined as a precursor to the focus on different kinds of imaginative play in the Arts that unfold in subsequent chapters.

Play as universal

Children have engaged in playful activities through the ages across all cultures. Yet we know that not all children equally enjoy the right to play. There are still children who are forced to labour, even to fight, from an early age. An estimated 300 000 children under 14 are engaged in producing cocoa beans for chocolate on the Ivory Coast, for example (see <www.ethical.org.au>). Other children have their childhoods destroyed by war or violence. A recent survey undertaken by ChildFund Australia (Spence, 2011) notes that many children in developing countries have high levels of responsibility, and any free time from school is spent helping with household or farm chores or caring for younger siblings. While this sharing of family responsibilities is not in itself a negative thing, when there is no time at all for play there is cause for concern. Spence (2011) comments that there is a critical balance between work and play that must be struck if children are to develop their full potential as human beings.

Defining 'play'

The word 'play' has at least 17 meanings, according to the *Concise Oxford Dictionary*. Of relevance for this discussion are the following descriptions:

> *Move about in lively or unrestrained or capricious manner; frisk, flutter, pass gently; amuse oneself; pass time pleasantly; pretend for fun; spontaneous activity.*

These descriptions are not limited to children: most people engage in playful experiences, such as make-believe, fantasy, daydreaming and humour, at least some of the time. Despite the assertion that play is the 'essence' of learning for young children, there are few definitions that specifically relate to play in the early years.

PlayEngland's website <www.playengland.org.uk> defines play as 'what children and young people do when they follow their own ideas and interests, in their own way, and for their own reasons'. Its *Charter for children's play* identifies play as

> *integral to children's enjoyment of their lives, their health and their development. Children and young people – disabled and non-disabled – whatever their age, culture, ethnicity or social and economic background, need and want to play, indoors and out, in whatever way they can. Through playing, children are creating their own culture, developing their abilities, exploring their creativity and learning about themselves, other people and the world around them.*
>
> *Children need and want to stretch and challenge themselves when they play. Play provision and play space that is stimulating and exciting allows children to encounter and learn about risk. This helps them to build confidence, learn skills and develop resilience at their own pace.*

Csikszentmihalyi (1981) described play as 'a subset of life … an arrangement in which one can practise behavior without dreading its consequences' (p. 14). Scales et al. (1991) called play 'that absorbing activity in which healthy young children participate with enthusiasm and abandon' (p. 15). For Garvey (1979, p. 5) play is an activity that is:

- positively valued by the player
- self-motivated
- freely chosen
- engaging
- related in some way to other everyday activities that are not regarded as play.

As early as 1932, Mildred Parten categorised different kinds of play behaviour based on her research with two- to five-year-olds:

- **Onlooker:** Playing passively by watching or conversing with other children engaged in play activities.
- **Solitary/independent:** Playing on your own.
- **Parallel:** Playing independently, even in the middle of a group, and remaining engrossed in your own activity. Children playing parallel to each other sometimes use each other's toys, but always maintain their separateness.
- **Associative:** Sharing materials and talking to each other during play, but not collaborating together about the play itself.

- **Cooperative:** When children collaborate to organise themselves into roles with specific topics or themes in mind (e.g. assigning the roles of doctor, nurse, and patient to play 'hospitals').

While this is not a linear progression, Parten commented that she observed children participating in the more social types of play more frequently as they grew older (1932, p. 259). Children who have older siblings may well become involved in cooperative play at an earlier age than those who are only children.

Imaginative play: A serious pastime

Imaginative play helps young children demonstrate and practise what they already know, while they are also in the process of learning more about the world. Observing children engrossed in such activities also shows us *how* they are thinking about and learning language. Vygotsky (1966/1933) suggests that a child who is beginning to assign symbolic meaning (as Timothy does above with the playdough) and is ready to take on a role (as Timothy does in seeing to the needs of Tigger) is demonstrating the markers of the early stages of abstract thought.

In her work on young children's stories, Carol Fox (1993) wished that we could find another term for imaginative play because, in her view, the word 'play' tries to encapsulate such a conundrum. On one hand it is serious and intense and requires much effort on the part of the child engaged in the activities. At the same time, such activities are ephemeral and therefore can be viewed by observers as relatively inconsequential. She suggests that we should talk about imaginative play as 'serious play' or 'play for real' (p. 190). She exhorts us to value imaginative play, rather than be dismissive of it, wherever and whenever it happens: in the home, playgroup, childcare centre and early childhood curriculum.

In a similar vein, the historic Plowden Report (Central Advisory Coucil for Education, 1967) in the UK noted that serious, imaginative play should be the central feature of all nursery and infant schools. Further, it stated that making any distinction between children 'playing' and 'working' in their early years at school was to engage in a false and unhelpful dichotomy. In Australia, the Early Years Learning Framework (EYLF) for early childhood educators, parents and policymakers emphasises play-based learning, and the importance of creative play in enabling children to become confident and active learners:

> *Play provides opportunities for children to learn as they discover, create, improvise and imagine. When children play with other children they create social groups, test out ideas, challenge each other's thinking and build new understandings.*
> (DEEWR, 2009, p. 5)

Imaginative and creative play is thus critically important in enabling children to explore multiple ways of knowing and being.

An additional benefit of play that contrasts with more passive entertainment, such as watching television, is its contribution to the development of active, healthy bodies. In fact, in many developed countries where there are grave concerns about increasing child obesity and physical fitness, it has also been suggested that encouraging unstructured play will actually increase children's physical activity levels.

Obstacles to imaginative play

Yet it is no surprise that the increasingly rapid pace of many twenty-first century lives has contributed to less time and space being available for such spontaneous free play. Young children are often caught up in the complexities of adults' busy lives. In addition, demands for formal learning programs and more structured activities in some early childhood contexts – to ensure academic 'readiness' for school – seem to be forever stretching downwards, putting pressure on even the youngest children and their parents and caregivers, so that imaginative playtime is squeezed out.

Consider, for example, the plethora of so-called 'enrichment' programs, computer programs and books that are available today – such as Teach your Baby to Read (see <www.brillbaby.com>). This is in spite of the fact that there is now strong research evidence that children who learn to read at an early age have no academic advantage over children who take a little longer to learn to read independently (see Suggate, 2009).

Hirsh-Pasek and Golinkoff (2003) document the trend in the USA away from imaginative child-directed play. They describe this move as a crisis for children in terms of their cognitive, social, spiritual, emotional and physical development. In many early childhood classrooms it seems that so-called play activity centres are aimed at teaching specific content in a particular area (e.g. number bingo, flashcards of common vocabulary or recounting a story exactly as told by the teacher) and are heavily dominated by the teacher, rather than the children, with little allowance for messy experimentation or exploration (Graue, 2011, p. 15). Early childhood educator Lilian Katz (cited in Miller & Almon, 2009) claims that

> *especially in the case of boys, subjection to early formal instruction increases their tendency to distance themselves from the goals of schools, and to drop out of it, either mentally or physically.* (p. 1)

Researchers express concern that children are becoming *over-protected*. Lindon (2001), for example, argues that risk is part of imaginative play and that children

must have both the right to play and the right to take risks as part of play. She suggests that adults are forgetting that children need to experience risk if they are going to learn how to assess and manage risk in the many life situations they will confront.

Perhaps above all, imaginative play is much more than a simple joy experienced in childhood. Rather, it should be an important part of all learning situations: everyone, not only the young child, needs 'what if?' opportunities to play, create, imagine and dream. This book focuses particularly on imaginative play and how this can be realised through the Arts – because both should be a critical part of children's lives.

Researching the benefits of play: A caveat

While many educators and psychologists theorise about the benefits of play, it is difficult to prove these benefits in a causative sense. In any case, research about play has not been regarded as a high priority by large funding bodies. More research needs to be undertaken in this area.

In addition there are many ethical, conceptual and methodological issues related to this kind of research (Barnett, 1990; Children's Play Council, National Playing Fields Association and Playlink, 2000; Pellegrini & Smith, 1998). These include the problems relating to defining play (and, therefore, non-play) discussed briefly above. It is also not feasible, ethical or desirable to design comparative studies where children who are engaged in play can be compared with those who are deprived of play, without controlling for the effects of many other variables in a growing child's life.

One of the few longitudinal studies providing evidence about the benefits of preschool education that includes play is the HighScope study of 123 disadvantaged African Americans (HighScope Educational Research Foundation, 2005). The children in this study were divided into two groups at ages three and four, with one group receiving what was described as a high-quality active preschool program that included adult-directed play. The other group was not involved with a preschool program. Thirty years later 95% were interviewed and data from schools, social services and criminal records were analysed. Those who had attended the preschool program had achieved higher literacy scores at ages 14 and 19 and 71% had graduated from school, compared with 54% of the non preschool attenders. When interviewed again at 40, those who had the preschool program had higher earnings and were more likely to be working.

Once again it is important to note that such research may not be allowed today, on ethical grounds. In addition, the study examined the associative or co-relational rather than causative benefits of preschool and later adult achievement. It did not look at play per se. But it does indicate that early positive play experiences are important developmentally.

The role of the adult in child-directed, imaginative play

Any context for young children's activities, including play, must be created in such a way as to ensure that there are many opportunities for different kinds of play, including informal and unstructured, as well as more formal activities. As facilitators of children's imaginative play, parents, early childhood workers, preschool and classroom teachers need to realise their importance in creating the spaces and places for such play – including the opportunity for the child to make a mess. They must also recognise that often, especially initially, they need to take a support rather than a lead role in these play situations.

In any game or structured activity, the more experienced person generally takes the lead in explaining or demonstrating the process in the first instance. Gradually, however, the player/learner takes more and more of the lead and, in time, not only assumes full control of the game, but invents other rules and ways of playing it. As with the much-documented way the child learns to play the game 'peek-a-boo' (Bruner & Sherwood, 1976), for example, it is often an adult or older child who takes responsibility at the beginning for introducing and modelling the procedures/ rituals of hiding their face and then reappearing. And so with imaginative play, the child will stretch and extend traditional games and activities to create new ones.

Young children need many such opportunities to control the play situation, play out the story and pace the activities themselves. The enabling of such opportunities for all young children is currently termed 'developmentally appropriate practice' (Fleer, 2009) in many policies, articles and handbooks on early childhood education. This is because it encapsulates a set of dispositions and practices that nurture children's curiosity, creativity and imagination. When engrossed in such practices, young children are capable of long periods of intense concentration that far exceed what is generally expected of them. Adults should also observe children during imaginative play whenever possible and practical. Such observation is not necessarily only for formal diagnostic or assessment purposes. Rather, the main aim should be to find more ways to encourage further creative interactions, and the ongoing development of children's imaginations. Questions asked by adults need to be tentative and open-ended.

Different kinds of play

Jean Piaget (1962) described three different kinds of play (*practice* or exploratory, *symbolic* and *rule-bound games*), based initially on his wife's observations in the 1920s of their three daughters' play activities. Subsequent researchers in the Piagetian tradition added *constructive* play with materials as a fourth category, based on children's use of building blocks, collage materials and playdough to make things. Much later, however, Bob Hughes (1996) created a list of 16 kinds of play, primarily

to represent the richness of play and for the use of adults who were working with young children and needed a way to delineate their types of play. Some appear to be discrete, others overlap with other types.

Hughes' types of play are summarised below, with some examples.

- **Symbolic play**: Allows control, gradual exploration and increased understanding without the risk of being out of your depth. Timmy's playdough was moulded into muffins that were then 'baked' in the 'oven' and offered for pretend consumption.
- **Rough and tumble play**: Involves close encounter physical play. This may include touching or tickling or wrestling. Often a child measures how strong he or she is in comparison to the other child or children or the adult involved.
- **Sociodramatic play**: Enacts real and potential experiences of an intense personal, social, domestic or interpersonal nature. In coming to terms with the death of a pet or loved one, for example, children may re-enact the experience.
- **Social play**: Enables the rules and criteria for social engagement and interaction to be revealed, explored and amended. Children agreeing on the rules and various roles for playing shops or hospitals or schools are engaging in social play.
- **Creative play**: Allows for a new response, the transformation of information and awareness of new connections, and may incorporate an element of surprise. Examples range from creating a new use for an everyday object, to taking the rules of traditional games and making up new ones.
- **Communication play**: Play with words, nuances, facial or gestural expression to communicate ideas. Miming an action for someone else to guess, telling a joke or riddle or sharing a poem are all examples of this kind of play.
- **Dramatic play**: Events are dramatised by children even though they may not have been direct participants – they may dramatise an event they observed at school or at a play.
- **Deep play**: Allows the child to encounter risky or even potentially life-threatening experiences, to develop survival skills and conquer fear. Climbing a tree, balancing on the fence or jumping off a climbing frame believing you can fly may all involve risks for the young child.
- **Exploratory play**: Accesses factual information through manipulative behaviours such as handling, throwing, banging or mouthing objects. A baby will often explore a book by first putting it in his or her mouth. Exploring a new physical space could also be interpreted as exploratory play.
- **Fantasy play**: Rearranges the world in the child's way to create a fantasy situation – for example, being incredibly strong like Pippi Longstocking or Popeye or Superman and able to perform amazing feats. Or inventing an imaginary person or animal.
- **Imaginative play**: Involves pretending that the conventional rules do not apply. Children may pretend, for example, that animals can talk or that they have an invisible friend, or they may assume the qualities of the wind or rain.

- **Locomotor play**: Moves the body in any or every direction. *What's the time Mr Wolf?* for example, involves a good deal of chasing and running away.
- **Mastery play**: Seeks control of the physical and the natural environment. This kind of play involves the child in physically interacting with nature and natural environments – making a sandcastle with a moat and bridge, for example (and allowing water to do serious damage).
- **Object play**: Uses infinite and interesting sequences of hand–eye manipulations and movements with objects to explore their uses or use them in a novel way. Wands emerge from sticks, for example, lego bricks are shaped into bridges.
- **Role play**: Mimics everyday activities, for example, pretending to use a mobile phone, brush teeth, or run a race.
- **Recapitulative play**: Allows the child to explore ancestry, history, rituals, stories and rhymes, for example through masks.

Some of these suggested types of play flow into other types of play and back. 'Symbolic' play, for example, is often linked with some kind of 'dramatic', 'fantasy', 'imaginative', 'pretend' or 'role' play, as exemplified below:

Symbolic play

Five-year-old Alexander regularly created a fire station scenario from his loungeroom. The lounge became the fire station itself, while the fire truck was represented by the toy-car simulator that had a button with a siren. With his grandpa as assistant he would get dressed, including donning helmet, as soon as the alarm sounded (the kitchen timer) and start up the fire engine. As the fire chief, he would dictate who would drive to the fire and they would then use a toy light sabre and toy musical stick as the hoses to extinguish the fire.

Very often complications would arise: the assistant was sometimes asleep and had to be woken by the fire chief; it would be hard to locate a water source; or someone trapped by the fire would need to be rescued.

Much of this scenario was inspired by a DVD Alexander had been given about the roles of firemen. It had also been developed through stories his father, a voluntary rural fireman, had told him, and his ride in a fire truck on his birthday (as told by Alexander's grandpa, December 2011).

As mentioned earlier, the renowned constructivist psychologist Lev Vygotsky (1966/1933, 1978) viewed what he termed 'pretend' play as allowing a child to take the next developmental leap or become 'a head taller than himself'. He provided the example of a child pretending that a broomstick is a horse. The ability to do this means that the child can separate the object from the symbol. This is seen as marking the beginning of thinking abstractly. Building on Vygotsky's work, others

(e.g. Bergen, 1998) noted strong relationships between a child beginning to engage in 'pretend' play and the beginning of their receptive and expressive language development. Engaging in pretend play requires a child to be able to transform objects and actions symbolically, and depends on interactive social dialogue and negotiation between those involved in the play. The child must take on a role and be able to improvise and portray appropriate emotions for that role. As Garvey (1991) has shown, play should be seen as a continuous moving backwards and forwards through various realities – it is an attitude or orientation to the world.

Interestingly, these definitions and principles of play suggest behaviours that are embedded in many recent quality teaching and learning frameworks employed in school contexts in Australia. See, for example, the Project for Enhancing Effective Learning (PEEL, 2009); Productive Pedagogies (Education Queensland, 2000); and the NSW model of pedagogy (NSW Department of Education and Training, 2003).

Gonzales-Mena (2008) proposes five qualities aligned with play:

- intrinsic motivation
- active engagement
- attention to the process rather than the outcome
- non-literal behaviour
- freedom from externally imposed rules.

As parents, caregivers and teachers we should cherish opportunities for our children to play imaginatively, and make time for these. It is worth noting that such times are important for young children both before and after they start formal school. Julie Dunn (2003) notes that, while many early childhood centres and preschools allocate plenty of time for child-led imaginative play, scheduling such time often disappears from the early childhood classroom in schools as more formal academic activities are regarded as more important and tend to dominate the timetable.

For further thought …

Even very young children in the first few years of life are aware of an adult or caregiver's approval and pleasant surprise at their creative achievements through play. They will overhear their activities recounted to others who were absent during the experience. Listening to such talk assists children in their own reflecting on their play, even before they can clearly articulate this. Making time for children to think about and, where appropriate, to talk about their imaginative experiences, thoughts and feelings – or to represent them in another media – is also an important part of the whole process of learning and understanding through play. This may be done informally, perhaps while children are engaged in other play activities.

Conclusion

Child-directed imaginative play allows children to learn how to work in groups, to share, to negotiate, to resolve conflicts, and to learn self-advocacy skills. When we allow children to drive the play situation they can develop decision-making skills, move the activity at their own pace, discover their own areas of interest, and ultimately engage fully in the action. In many of these play situations, children will either invite nearby adults to join in, or assume that they are involved. When adults try to over-manage the activity, however, and expect children to conform to adult rules or expectations during the play context, children often lose interest as well as some of the joy in the pretend game. Alternatively, they may reclaim their territory through reshaping the rules or telling the adult he or she is wrong. The benefits of such play may also be lost, particularly in nurturing the children's creativity, capacity for leadership, and opportunity to develop group skills.

Rita King and Joshua Fout, the co-directors of the web portal, Imagination: Creating the Future of Education and Work, claim that we are currently living in the 'imagination age'. Given the failure of many of our economies and traditional ways of thinking, they suggest it is imperative that we all find time to imagine, and then create, new global ways of looking at the world. We must ensure that young children therefore are never denied imaginative play opportunities. The activities described in this book emphasise imaginative play through quality arts experiences. They provide starting points in establishing the spaces, the contexts and the conditions that will encourage children to readily engage in imaginative play and explore a range of arts experiences whenever they can. These suggestions will need to be adapted, changed and extended to meet the particular needs, interests, abilities and cultural backgrounds of individual children. Most importantly, these open-ended possibilities should encourage the children (with or without the involvement of a supporting adult) to have fun. Schiller (1967) commented in 1795 that

> *it is precisely play, and play alone, which of all man's states and conditions is the one which makes him whole and unfolds both sides of his nature at once.* (p. 105)

This book is a realisation of that view, and a prompt for making it a reality.

Observing children engaged in imaginative play or joining with them in child-directed pretend play gives us a unique opportunity to see the world from a child's vantage point at a moment in time. The child navigates and directs a world he or she has created 'just so' to fit his or her own needs. Children who think and feel deeply will continue to build on their innate imaginative and creative capacities. Imaginative play opportunities provide an important context for this to happen. Timothy and Alexander show us how early such imaginative play begins.

The next chapter explores dramatic play, and how it can build on these early experiences to enable children to become increasingly creative and reflective.

The role of dramatic play in developing confident, creative learners

Robyn Ewing

The dress up box at their grandparents' house provides the trigger for six-year-old Alia and four-year-old Evie's dramatic play each time they visit. Draping themselves in scarves, oversized jackets and high-heeled shoes almost instantaneously transforms them into other people, and transports them to new places.

There might be a waiter to take your order and a chef to whip it up, until some kind of problem arises in the restaurant. The chef may object to the waiter's bossy tone. The waiter may drop the tray. There may be a visit to the restaurant by Goldilocks, or she may call in to the house of the five bears (there are five teddies in this house). Or an ambulance may arrive after a phone call from a worried mother to transport her desperately sick child to get help from a doctor at the hospital.

During the dramatic play all sorts of everyday items take on new identities to serve as props for these adventures. Coasters become dishes, the shell collection is given financial status. There are supporting roles assigned to both grandparents in each scenario, and they are usually given clear parameters within which to operate. They might, however, sometimes ask open-ended questions to suggest variations on the storylines, or introduce new vocabulary to the dialogue.

When music is added, the children devise a range of dances to reflect the different moods evoked. Much rehearsal, supervised by the elder sister, leads to the generation of handwritten programs, advertising signs promoting the imminent performance, and tickets. Dramatic tension is created when the second actor threatens not to perform and has to be cajoled back into the fold. Finally, tickets are dispensed for the adults, and they take their seats in readiness for the impromptu performance.

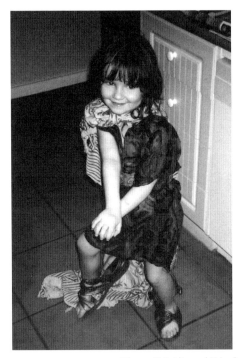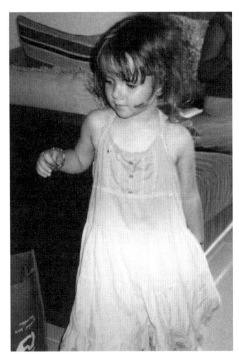

Figure 2.1 Alia and Evie dress up to give a performance

In this chapter the way young children use their creativity and imaginations to tell stories by engaging in imaginative dramatic play is considered in more detail. Dramatic play usually develops naturally and seamlessly from other forms of play as children build on their own lives, opportunities and experiences to imagine and create new worlds and possibilities. The examples above convey the notion that dramatic play is not about *acting* someone else: it's about *being* someone else. While engaged in this kind of play, a child will correct you if you use his or her everyday name. Usually, some kind of problem or complication or dramatic tension will arise during the episode, and the children will explore how this might be resolved. Through dramatic play children can suspend their own world, step into the shoes of others and behave 'as if.'

Some research suggests that girls engage in dramatic play more frequently than boys, and that once children are aware of their sex they will play more often in same-sex groups. At this point it must be emphasised that, while there are biological differences between the brains of boys and girls, it is vitally important not to over-generalise about gender differences in dramatic play contexts. It is wrong, for example, to argue that all boys will prefer dramatic play centred around building with blocks or physical play, and that all girls will automatically play out

domestic scenes. In Australia, Davies (1989) found that gender-specific behaviours in play evolve over extended timeframes, and depend very much on the kinds of experiences and cultural backgrounds afforded boys and girls. At the same time, if parents and caregivers reinforce or create traditional masculine or feminine stereotypes in play provision, there is no doubt that this will contribute to and thus limit the shaping of children's dramatic play.

The benefits of dramatic play

In engaging in dramatic play, children are pretending in order to learn (O'Toole & Dunn, 2002) and to make sense of so much about their own worlds, identities and relationships. Such imaginative behaviour is envisioned in the 'belonging, being and becoming' principles of the Early Years Learning Framework (DEEWR, 2009). Children are developing their language skills and vocabulary while exploring different ways of interacting and behaving. Such play can enable them to process new or difficult experiences. Anthony Browne, who is formerly the British Children's Laureate, attributes his success as an award-winning illustrator and author to what he calls 'playing the shape game' (2011, p. 9) – constantly transforming or re-imagining one thing into another.

Both undirected children's make-believe experiences and the adult-facilitated process drama activities, discussed later in this chapter, link directly to the sharing of oral and written stories, picture books and films. In both kinds of situation, children's understanding of narrative is being developed and extended. Bruner (1990), who built on Vygotsky's constructivist theories to further elaborate the concept of scaffolding, suggested that the construction of imaginary narratives helps children think sequentially, while also enhancing their creative capacities.

Dramatic play as a cultural universal

Dramatic play is a universal in all cultures. In her book *Playground,* Nadia Wheatley (2010) relates how 'play camps' were an integral part of every Aboriginal home and that some of these play sites dated back hundreds of years, being rebuilt by children every time their parents returned to a particular campsite:

> *Whenever families stopped and set up camp, there was always a special area where kids built their own small windbreaks or shelters … In the play camps, boys and girls acted out events and even ceremonies that they observed in the grown-ups' camp.* (p. 60)

In Wheatley's book, several Aboriginal elders remember how they used forked sticks or gumnuts to make 'babies' and then carry them in toy coolamons.

Cuttlefish were used to make a miniature campsite. Play fighting with waddies for the girls and blunt sticks representing spears for the boys would be part of the fun.

Dramatic play in any culture can thus be seen as a merging of the child's real world with their imaginative capacities. Initially this chapter concentrates on child-initiated dramatic play and the way that parents, caregivers and teachers can support opportunities for such play. It then examines how teachers, parents and caregivers can use a range of strategies to extend children's understanding of drama and facilitate deeper learning and understanding. As Jerome Singer (2006) notes, the importance of scaffolding support

> *seems especially true for imaginative play since its delicate, internalized structure seems to feed on a combination of parental approval and support, guidance into plot content and, at least initially, modeling of parental playfulness and story-telling.* (p. 428)

Balancing opportunities for children to initiate and manage their own dramatic play alongside the gentle scaffolding of further drama experiences requires sensitivity to each child's developmental needs and cultural background.

Elements of dramatic play

In her now fifty-year-old studies of Israeli and American children, Smilansky (1968) theorised six elements of dramatic play:

- **Imitative role-play**, in which the child takes on a make-believe role using physical action and/or talk.
- **Make-believe using everyday objects, resources or toys** as substitutes for those needed while 'in role' (see Figure 2.2).
- **Verbal make-believe**, where descriptions or declarations, rather than the physical actions themselves, are dominant.
- **Persistence in the make-believe episode**, because it indicates that the child really is authentically engaged. Smilanksy suggested that such play must last for at least 10 minutes.
- **Interaction** involving at least two players (although one may be imaginary).
- **Verbal interaction** between two or more children related to the play episode.

The final two criteria involve social interaction, and have been further described by Smilanksy and Shefatya (1990) as 'sociodramatic play,' because at this stage children are combining physical, cognitive, verbal and social play in more sophisticated scenarios than is the case with the first four.

Figure 2.2 Alexander improvises using a found object

Initially parents, caregivers and early childhood teachers can have a pivotal role in establishing safe physical spaces, ensuring there is time for such activities and providing the resources to encourage children to engage in dramatic play.

Creating the spaces and places for child-initiated dramatic play

Adults can collect materials and items relating to particular areas or themes around which dramatic play might develop. The most regularly created space represents 'home', but generic items including, for example, large cardboard boxes and cylinders can just as easily become a garage, fire station, school, market or shopping centre, hospital, zoo, farm, post office, ferry, garden shed, train, restaurant or beach. Alternatively, specific items suitable for different themes can be collected and stored in boxes or crates, and children or an adult can select from these. Dinham (2010) suggests that books and CDs can be included in these collections.

Time is also a key factor in enabling dramatic play. Time to build, time to make or create, time to dress up or play with puppets all provide opportunities to talk, cooperate and establish trusting relationships and contexts.

Dressing up

Every home, early childhood centre, playschool, preschool and kindergarten/ reception classroom should, where at all possible, include a dress-up box, drawer or cupboard filled with old and cast-off clothes, shoes, hats, coats and scarves of adults and older siblings, and with coloured lengths of different textured material. Of course the more interesting or unusual these items are, the better. Other accessories like bags, jewellery and walking sticks can be added as they become available. If space permits, other props can be included in the collection. Children will enjoy using the dress-ups and accessories, both inside the house and in outside settings. Getting dressed up seems to help them almost magically transform themselves into characters from their own and other worlds. They will create a new story or retell a familiar one, or devise a performance to present to their peers and adults.

Playing with cardboard and junk materials

Making a city, house, farm or boat from junk materials is another kind of creative beginning that can take children in many different make-believe directions. This enables children to create models with cardboard boxes, empty, interestingly-shaped containers, toilet roll ends, coloured paper, tape, felt pens or crayons and glue. Once again, children will need plenty of time to create their city, and the opportunity to return to it and allow it to evolve over time can be particularly valuable. An adult or childcare worker may perhaps begin to play with the materials or suggest the possibility of creating something from the junk – or ask some 'what if?' questions. Children can discuss the kind of people who live in or near this place and what they do as they are working. They may develop this further to create a story about the kind of place they have constructed, and add details about the people who live there. Children from diverse backgrounds will of course create different kinds of contexts, depending on their abilities and experiences.

Improvising

Improvising depends on thinking spontaneously and accepting the 'offers' we make each other. If Alia and Evie's dialogue in the café they have created intimates that grandpa is a customer waiting to order his breakfast, and getting grumpier by the minute, grandpa must accept this 'offer' and place his order while indicating his impatience at such a long wait for service. If he blocks their *offer* and insists he is not grumpy or not a customer in the café, the dramatic play may come to a premature end, which would be disappointing for the children and perhaps discourage them from including grandpa or another adult next time.

Over more than two decades William Corsaro (1985, 2003) has studied children's communicative strategies during what he terms 'fantasy play'. The play he observed occurred regularly in areas set aside for Lego or other blocks, or around sand tables/pits. He hypothesised that through this play the children

involved built a shared history and developed friendships that enabled improvised cooperative fantasy play in which they manipulated toy animals, blocks, Lego bricks and people, and other objects. At four years old Alexander, for example, was regularly engaging in detailed dramatic play around his Thomas the Tank Engine railway village, or using his Thunderbird figurines.

Interestingly, three recurring themes were identified as predominating by Corsaro during these episodes:

- danger–rescue
- lost–found
- death–rebirth.

These themes are illustrative of the big philosophical issues young children are interested in and often ask questions about in sessions like news time or show and tell (Ewing, 1995). Corsaro and Johannesen (2007) comment that these themes can also be seen in fairytales and popular children's media as well as everyday news. They note:

> *These themes were somehow extracted from such sources and used as shared knowledge and were stretched and embellished in fascinating ways.* (p. 448)

Dramatic play is never trivial and should always be closely observed by parents and caregivers. Some theorists suggest that such improvised fantasy play may be unique to early childhood cultures, and may become less frequent as more formal rule-bound games begin to take over their recreation time.

Extending these findings, Sawyer (1997) closely observes children's 'social pretend play' in which children's imaginations are given free rein to create improvisational performances:

> *They manipulate dinosaur figurines to create a drama of panic after an earthquake. They play out a story in which a duck and a dinosaur are best friends. They build spaceships with elaborate systems of weaponry and controls, and go on adventures to exotic planets.* (p. xviii)

In concluding his discussion of the value of allowing children's imagination to blossom, Sawyer notes that conversations in these play episodes are more improvisational than the average adult conversation.

Puppets and masks

A collection of simple hand and finger puppets, some made with the help of the children from junk materials, should also be easily accessible at home and in the early childhood centre and classroom. For some children, giving human

characteristics to any inanimate object can be a useful way into imagining because they feel more confident when it is the puppet doing the talking to tell the story or express an emotion. An upturned table can improvise as a simple puppet theatre. For this reason puppets are often used in play therapy with children who have experienced extremely disturbing events in their lives. Chapters 8 and 9 address children's use of puppets in more detail.

Designing, making and wearing simple masks is another way of enabling children to distance themselves from imagined events or actions. Children will need to understand that a mask only carries one facial expression, and they must use their bodies and elaborate gestures to communicate more nuanced feelings.

Adult facilitated drama experiences

In exploring how the educator can extend children's self-directed dramatic play, a range of *process* or educational drama strategies (O'Neill, 1995) can be introduced to children at the appropriate time. The later stages of preschool or early in the first year of school may often be a good time to introduce such strategies, while still ensuring that children have free time for their own dramatic play. Process drama emphasises the actual experience of the drama rather than any resultant performance or other formal outcome. In this way children can be encouraged to further experiment with taking on different roles and perspectives through walking in others' shoes. They will continue to develop their capacity to empathise and ability to collaborate. At times, the interested adult (or older child) may wish to enter into the dramatic play as a co-player or more deliberately in role, to ask a question or suggest a focus or new direction.

All the strategies discussed below have been written about at length (see Ewing, 2010b; Ewing & Simons, 2004; Gibson & Ewing, 2011; Miller & Saxton, 2004; O'Toole & Dunn, 2002). Several examples of scaffolding possibilities using mime, storydrama, sculpting, depiction, tapping in, hotseating and teacher-in-role are elaborated below.

Introducing mime

Many two- and three-year-old children are already used to enacting activities and situations without words. Specifically focusing on mime helps them understand how powerful non-verbal communication can be in meaning-making. They can focus on the use of their faces, gestures and bodies to convey how they are feeling. It is useful to begin mime activities by focusing on using actions that young children are very familiar with, such as brushing their teeth, drinking water or getting dressed. They can mirror what the teacher is miming and then move into

pairs and work as mirrors for each other. Or they may begin by concentrating on showing particular emotions, just using their facial expressions or simple gestures. Children need to understand that they have to establish the detail of their action or emotion if they are to communicate it effectively. YouTube clips of the great mime artists (such as Marcel Marceau or Jacques Le Coque) can be used to illustrate this to children, and can motivate them to observe movements and actions more carefully.

Well-loved children's literature provides an excellent starting point for mime and other drama activities. The animals in *Farmer duck* (Waddell, 1991) only ever communicate by quacking, mooing, baaing and clucking. As the story progresses, however, the duck becomes increasingly exhausted as she undertakes all the work on the farm while the lazy old farmer grows fat from remaining in bed and constantly asking how the work is progressing. The other animals care about the duck and become very angry about the way she is being treated. They concoct a plan to address the situation. The children can mime the way the duck becomes progressively sleepy, weepy and finally totally exhausted as she undertakes all the farm chores. Similarly they can mime the indignation of the other animals, and their solution.

Miming the four very different characters introduced in *Voices in the park* (Browne, 1998) provides a good prompt for learning more about the way body language tells us so much about how we and others are feeling. Mrs Smythe is a snobbish woman with a lonely, rather shy son called Charles, and a dog named Victoria. They walk to the park where they meet the unemployed and rather depressed Mr Smith, his sunny and energetic daughter Smudge, and their dog. Children can mime how each character feels before and after their meeting at the park. They can even walk in role as each character. How do you walk when you are sad and lonely? Uptight? Happy and carefree?

Storydrama

Storydrama is a more structured dramatic activity that involves an adult or older child reading a picture book, traditional story, myth, poem or song, or telling a story orally, while providing an opportunity for children to embody the events through dramatising them. The enactment can happen either during the reading/retelling or afterwards. To enable children to gain more benefit through familiarity with the narrative, the story may be reread/retold several times. Children can undertake all the actions and multiple roles in unison as the story unfolds or, alternatively, can join forces in small groups to concentrate on one particular character's actions or to retell one section of the story. This is, after all, imaginative drama process, and is limited only by the child's imagination.

For example, children can all make mischief with Max in *Where the wild things are* (Sendak, 1967). As the story develops they can become the forest growing in his room, embody the sea over which he sails and finally, as wild things, create the wild rumpus. Alternatively they can divide into groups to enact the different parts of the story separately. Percussion instruments or simple body percussion can also be added. The silent arrival of Max's dinner under his bedroom door can also be enacted, and will help still the wild rumpus.

Lauren Child's *Who's afraid of the big bad book?* (2003) is another book that can be used effectively for storydrama. The children will first need to be reminded of, or introduced to, the stories of *The three bears* and *Cinderella*. They might like to do this in a storytelling circle where every child adds a sentence in turn to build the sequence of events. As *Who's afraid of the big bad book?* unfolds, the unfortunate Herb, who has mistreated his books in the past, wakes to find he has not only fallen asleep reading: he has also fallen into his storybook just as the three bears return to find Goldilocks in their cottage. Children take great delight in enacting the angry Goldilocks, who is extremely agitated that Herb seems to be stealing her story limelight. Or they may choose to be one of the three bears, none of whom appears perturbed at Herb's sudden arrival as they offer him the lukewarm and very hot bowls of porridge. Later the children might dance at the ball waiting for Prince Charming (who never arrives), or admonish Herb for embellishing all the ladies at the ball with green moustaches. Finally they can become Cinderella's fairy godmother as she grudgingly agrees to help Herb escape Cinderella's stepmother and Goldilocks (despite the fact that she usually doesn't work with boys). They can recreate Herb's journey up the words of the story and back to his own bed.

Sculpting

Children can be introduced to sculpting their favourite character from a chosen story in pairs. Initially the teacher may be a model for the sculpting activity. Once the children have understood that they are moulding the character as they have imagined him or her, they can be paired and decide who will be sculptor and who will be sculpted. It is useful for the child who is sculpting to think of their partner as 'thinking clay'. The partner who is being sculpted cannot argue with the sculptor but must try to represent the expression, stance and gesture that is being described or demonstrated by the sculptor. Then the roles can be swapped: the sculptor becomes the sculpted.

Drama from a picture

Taking one very distinctive image from a picture book and asking children to represent the image as if it was a photo in a frame can also be an excellent

starting point for helping children pay close attention to one significant moment in a story. The image of the frog prince and the frog princess at loggerheads with each other in the early part of *The frog prince continued* (Scieszka, 1991) is an excellent example. The teacher can then gently tap both children in the 'picture' on the shoulder to gain access to each character's thoughts or emotions at this particular point in time ('tapping in' or 'thought tracking'). Children can thus appreciate that many individuals will intepret the same character or situation in a myriad of ways and that there is no one right or wrong way of interpreting the image.

Depiction or still image

Once successful with sculpting, children can move to working in small groups of three of four to depict their favourite moment in an excursion or a story or their view of the most important part of the story as a 'frozen moment', 'tableaux' or 'still image'. Depiction is about capturing one moment in time so it can be examined carefully (just as when a still photo is taken). Alternatively the story can be told or read to the climax or dilemma, and children can be asked to represent what they think will happen in the next scene. Again, 'tapping in' can be used to find out how each character is feeling.

For example, children could be asked to depict:
- How might *The paperbag princess* (Munsch, 1989) rescue Prince Ronald from the dragon?
- What will the mouse do when he finally meets up with *The Gruffalo* (Donaldson, 1999)?

Teacher in role

As mentioned earlier, it is often desirable for adults to immerse themselves in the dramatic play as co-players (Dunn & Stinson, 2011). In child-initiated dramatic play, joining the drama as a co-player usually happens spontaneously or at the invitation of the children. Sometimes, however, the teacher can structure this more formally. Once the teacher has planned to do this, careful thought must be given to the best way to be involved so that the drama process extends the children's dramatic experience and is not over-directed by the teacher. One way is for the teacher to become one of the characters in the story and allow the children to ask questions (this strategy is called 'questioning in role' or *hotseating*). For example, the teacher may say 'When I put on this scarf I am going to be the penguin who knocks on the boy's door (*Lost and found*, Jeffers, 2005a). Think about the questions you'd like to ask him.' Or: 'I'm going to become Mrs Piggott (*Piggybook*, Browne, 1986) when I put on this apron. What do you want to ask her?'

Alternatively, the teacher may enter the drama as an additional character. She or he might be one of Charlie's friends at his monster birthday party (*This is ACTUALLY my party*, Child, 2008). Or she could become *Marshall Armstrong*'s teacher on his first day at his new school (Mackintosh, 2011). She may ask the children for advice about how she should behave. Ewing and Simons (2004) suggest that the teacher may find it best to take on a middle- rather than high-status role in the drama, and that will help them to resist the urge to over-'instruct' while in role. In re-enacting the wedding feast from *The werewolf knight* (Wagner & Roenfeldt, 1995), for example, it may be preferable for the teacher to take on the role of one of the king's noblemen, rather than the king himself, when advising the wedding guests that there will be no wedding.

Dunn and Stinson (2011, pp. 117–19) provide an extended example of a teacher in role inspired by a picture book, where children are introduced to new ideas and tensions and where alternative roles and symbolism are modelled from within the drama.

Mantle of the expert

Another strategy that the children can be introduced to as they become more confident is 'mantle of the expert' (or 'enactment of the expert'). Children are given a role with expertise to address the particular problem confronted in the drama. For example, after reading Oliver Jeffers' *How to catch a star* (2005b) a group of Year 1 children were asked to step into role as a group of scientists visited by the boy who wanted to catch the star. In small groups they designed innovative star-catching devices, and were able to present them in detail to their classmates.

A group of eight-year-olds in Year 2 in a western Sydney classroom were enrolled by the teacher as zoo inspectors after reading and discussing Anthony Browne's *Zoo* (1992). They were asked to review the state of the zoo described in the book with a view to improving the lives of the animals in captivity there. They worked in small groups for over 30 minutes, and then shared their recommendations with the rest of the class. They then continued the discussion as a whole class. Finally, they wrote their own recommendations about how to improve the zoo.

As described in the opening vignette in this chapter, children enjoy opportunities to present their dramatic ideas to each other in impromptu performances. There may also be times when a broader range of audience (which may include other groups in the centre/preschool/school, or parents and other family members) can view the children's dramatic work.

In addition, children need to experience theatre performances as well as art galleries and museums and have time to reflect on them. Lea Mai discusses this in more detail in Chapter 4.

Reflecting on and responding to drama performances

Children love to attend live theatre, dance or music performances. Finding ways for children to become aware of the world of theatre and build their knowledge and experiences of different performing art forms will gradually develop their understanding of the aesthetic:

> *Performance, the imagined and enacted world of human beings, is one of the primary ways children learn about life – about actions and consequences, about customs and beliefs, about others and themselves.*
>
> *Attending high quality performance provides students with the opportunity to learn through experience as audience and to respond and evaluate performance and communicate their responses through verbal and non-verbal means.* (Windmill Theatre, 2012, paras 2–3)

The recent Australian Research Council project, TheatreSpace: Accessing the Cultural Conversation (Anderson et al., 2011), demonstrated the critical importance of family and caregivers bringing young people to live theatre performance. The young people in the project who had been introduced to the culture of live theatre performance from an early age by a parent, other family member or friend, or teacher often remembered their sensory images and feelings during these experiences rather than the content itself. They tended to be very confident about the world of theatre, and they were highly articulate about the use of theatrical elements to create meaning.

Children's Voices was a longitudinal research project (2003–05) that explored and documented 140 South Australian children's perceptions of quality theatre and its impact on them, their teachers and their school communities (Schiller, 2005). The children were aged between five and 12, and all had the opportunity to attend two to three arts performances each year for three years. Not only did these opportunities improve the participant children's literacy as they progressively became more confident and articulate about responding to the performances; they also developed their intercultural awareness and empathy. Such attributes are important for lifelong learning.

Discussing expectations of a performance and then sharing observations and experiences afterwards should be part of the whole theatre-going event. Children may wish to draw or paint a response as well as discuss their understandings and perceptions of the performance.

Theatre performance for young children

Unfortunately there is not enough live theatre available in Australia for young children. Below are a few excellent examples of theatres, companies and festivals that place a high emphasis on providing high quality theatre for children.

Barking Gecko

Established in Western Australia more than twenty years ago, Barking Gecko aims to 'commission, produce and present extraordinary theatre for young people and their families' (see <www.barkinggecko.com.au>). The company also endeavours to make theatre more accessible to a broad range of young audiences across Australia and more widely.

Windmill Theatre

Windmill Theatre began in 2002 in South Australia with the explicit purpose of telling, creating and sharing stories of relevance for young people in innovative ways. In meeting this challenge the company aims to position 'theatre for children, young people and families in a dynamic national and international conversation that is defining the future of theatre practice' (see <www.windmill.org.au/about-us>). Their 2012 program included *White* for under-fives, as well as *Pinocchio*.

Out of the Box

This Festival is the brainchild of Queensland Performing Arts Centre, and originated in 1992. High quality arts experiences are offered every two years for children eight years of age and under. Recent highlights have included Shaun Tan's *The red tree*.

Actor on a Box

Actor on a Box has been designed by the Sydney Theatre Company to introduce the magic of theatre to audiences under eight. Each fun program combines storytelling and physical theatre. Recent stories featured have included *The loaded dog* (Henry Lawson), *The red and white spotted handkerchief* (Tony Mitten) and *The dreaming – Wake up Australia* (Leah Purcell).

For further thought ...

It is concerning that some research studies have suggested that children's dramatic play is declining both in quality and quantity (see Elkind, 2008a; Zigler & Bishop-Josef, 2009). Elkind (2008b) suggests that 'The decline of children's free, self-initiated play is the

result of a perfect storm of technological innovation, rapid social change, and economic globalization' (para 12).

It is important to reflect on how technology and globalisation might encourage and extend rather than diminish dramatic play opportunities for young children.

Conclusion

This chapter has demonstrated the importance of both child-initiated dramatic play and adult-led drama experiences in the lives of young children. While engaging in 'as if' experiences, children are nurturing their imaginations and building confidence in who they are and who they would like to become.

In the next chapter, the role of storying in developing a child's identity is explored.

Playing with storytelling

Victoria Campbell

The oral story is soft and malleable. It yields to the pleasures and needs of its audience. Its language is not the precise and unchanging form of the written story, created by a single author, but the evolving, flowing language of the community. (Livo & Rietz, 1986, p. 15)

She took a deep breath. Twenty-seven sets of eyes looked up at her. As she spoke the classroom darkened and turned into night. Her voice grew loud then soft, her body shifted and changed. The moon shone on the children's faces and the ocean lapped at their feet. They were entranced. It was the first time their teacher had told them a story without a book. When she finished they asked for more.

An oral story is one that is told, not read. Oral storytelling is unmediated by the written text (Daniel, 2007). It is a personal and immediate form of communication, dependent on a flowing exchange between the teller and listener. It is reliant on the *intra-* and *inter*-personal dimensions of communication. This is as true for children telling stories as it is for adults. It acknowledges that both students and teachers bring personal histories and experiences into the classroom, and values these experiences as foundations for authentic learning. This chapter focuses on oral storytelling as an engaging, imaginative and productive pursuit in the preschool, early childhood classroom and early childhood centre. It examines both the importance of encouraging young children to tell stories, and issues relating to early childhood educators who have, or would like to develop, skills as oral storytellers. As such it is dedicated to those teachers who are committed to passion, creativity and artistry in teaching, who, as described by Day (2004), 'acknowledge

that teaching is not only about intellectual and emotional engagement with others ... but also intellectual and emotional engagement with self' (p. 1).

One of the governing principles in the Early Years Learning Framework (DEEWR, 2009) encourages early childhood educators to ensure children have quality learning experiences that aid in the development of identity. It is often through relationships with others that we define who we are. Similarly, children need to know who they are in the world to develop and maintain meaningful relationships. Who you are as a person matters. What you experience, what you feel, how you think, matters. Research conducted by Engel (1997) into emergent storytelling in the first three years of a child's life supports this view. For Engel when children share personal stories, 'one of the things they do is to narrate an inner life, and an identity, and share that inner life and identity with others' (para. 46).

When children are given opportunities to orally tell stories, whether personal or fictional, they must draw on their own unique personalities to bring the story to life for those listening. And yet the literature indicates that authentic oral storytelling is often a limited experience in early childhood classrooms and centres; and if it is implemented it is struggling to survive, here and internationally, in the face of increasing pressure to reduce learning to standardised outcomes (Cooper, 2005).

Oral storytelling and literacy

While the major focus of this chapter explores the connections between oral storytelling, identity and relationships in the early childhood classroom, it would be remiss not to mention the many educators and researchers, both Australian and international, who have written about the important links between oral storytelling, language acquisition and literacy development in young children (Cooper et al., 2007; Ewing & Simons, 2004; Fox, 1993; Hill & Launder, 2010; Horn, 2005; Isbell et al., 2004; Mallan, 1993; McGrath Speaker, Taylor & Kamen, 2004; Rooks, 1998; Wells, 1986). Although much has been written about the link between oral language and emerging literacy in early childhood, there are very few recent studies, particularly in Australia, that provide rigorous evidence that oral storytelling by children in the early childhood classroom is a valuable strategy that will aid in academic and social learning.

There are, however, several pivotal studies in early childhood that have influenced research in this area. Wells (1986) investigated the connection between literacy development and oral storytelling, and identified the positive effect narrative activity can have on a child's emerging literacy skills. In his final analysis, Wells found that the sharing of stories, both at home and at school, gave a child a literary advantage. Another qualitative study, conducted by Fox (1993), found that early exposure to quality literature is a defining feature of children's ability to tell their own stories. In her study, Fox collected, recorded and analysed

numerous oral stories told by five preschool children. She focused on elements such as the children's choice of words, phrases, story structure, and personal styles of narration. Fox found that the children used multiple frames of reference to bring their stories to life, such as personal experiences, other oral stories, children's books, rhymes and verse, radio and television. She concluded that the children exhibited a form of imaginative play in their attempts to master a story: 'it can show us what children are like inside, how they make sense of their experience, how they make things meaningful' (p. 190). Both Fox and Wells argue that exposure to quality talking and listening experiences are essential for children's ability to *story*.

Storying, narrative understanding, identity and play

At the heart of children's early literacy experiences is their ability to *story*. In order to create stories, children need to be involved in the act of 'storying'. For Lowe (2002), the concept of *storying* goes beyond the mere telling of a story; it is a 'meaning-making' activity where stories work as a meta-narrative, 'something that threads between the many separate fragments of information and experience that we encounter' (p. 7). Livo and Rietz (1986) also use the term 'storying' as an act we engage in to 'story events', to help aid memory and to bring a 'higher level of comprehensibility to the things we do' (p. 5).

Young children draw on their knowledge of stories when creating their own oral narratives (Fox, 1993). In her study Fox maintains that 'storytelling is a play activity', that although the children get themselves into a 'syntactic muddle' by attempting to use 'grammatically complex sentences' to make their story sound like 'story language … they are telling their stories for fun because they want to', and enjoy 'their freedom from the constraints of more mundane language interactions' (p. 28). This 'story language' depends on narrative understanding, and as such is often viewed as a meaning-making activity with an inherent organising structure that aids children's ability to define themselves and to make sense of their own experiences and the world around them (Egan, 1997; Lowe, 2002; Paley, 1990).

Likewise, psychologists, such as Bruner (1990) and Engel (1995), acknowledge that young children create meaning and make sense of their world through narrative. For Bruner this 'narrative sense' (p. 68) or ability to construct coherent narratives is crucial for the formation of self. When children story, they are engaged in socially constructed activity dependent on the relational aspects of telling and listening to others. In this way their *identity* is socially constructed (Engel, 1995). Vivian Gussin Paley, an American early childhood educator, has extensively researched the correlation between storytelling, play and social construction of identity. Paley (1990) recognises that 'play and its necessary core of storytelling are

the primary realities in the preschool and kindergarten' (p. 6), and that engaging children's imaginations through storytelling is central to both academic and social learning. She asserts that 'it is play, of course, but it is also story in action, just as storytelling is play put into narrative form' (p. 4).

Paley's approach to oral storytelling places the child at the centre of the learning experience. It consists of two important strategies. First, a child dictates an oral story to the teacher. The teacher may use prompts, but the child remains the 'author' of the story. After the child has narrated the story it is 'dramatised' by the rest of the class; the child who narrated the story assists in 'directing' the performance. In this way Paley's method 'makes play, along with its alter ego of storytelling and acting the universal learning medium' (p. 10). More recently, several authors have enthusiastically investigated Paley's storytelling legacy (Cooper, 2005, 2009; Cooper et al., 2007; Nicolopoulou, 2008). Nicolopoulou, McDowell and Brockmeyer (2006) provide a succinct account of the child's participation in Paley's storytelling strategy in the following passage:

> Although this is a structured and teacher-facilitated activity, it is simultaneously child-centered. The children's storytelling is voluntary, self-initiated, and relatively spontaneous; each child is able to participate according to his or her own individual interests, pace, inclination, and developmental rhythms … In addition, the group story-acting integrates a significant play element into this narrative activity – not only in terms of the children's involvement in narrative enactment itself (which is a central feature of pretend play) but also in terms of other kinds of peer inter-actions that typically accompany children's social pretend play (including the selection of actors for role playing and the turn taking involved in alternating between participation as actors, actor-authors, and audience members. (p. 129)

Nicolopoulou has argued elsewhere (2005) that learning experiences of this kind develop 'social competence – including both socio-relational skills and social understanding – and the formation of self and identity' (p. 500).

Cooper et al. (2007) also investigated children participating in Paley's 'storytelling curriculum' over a year. Comparisons were made with children of similar age and setting who did not participate in such a program. While self-expressive storytelling experiences were central to the study, it primarily focused on literacy development in pre-kindergarten and kindergarten children. Both the control and test groups of children were assessed using pre-test and post-test measures based on American models of vocabulary assessment (Pearson Assessments' Expressive Vocabulary Test and the Peabody Picture Vocabulary Test). The research revealed that children participating in the storytelling curriculum, compared to those who did not take part, showed considerable improvement in vocabulary and other literacy skills. Through extensive research and analysis of the

central tenets and effectiveness of Paley's approach, researchers, such as Cooper (2005) and Nicolopoulou (2005), urge educators to consider the value of such storytelling programs in light of the disconcerting current educational climate where 'holistic, play-based curricula like storytelling are rapidly being replaced in early childhood classrooms by curricula aimed at specific sub-skills of reading and writing' (Cooper, 2005, p. 229). Cooper and Nicolopoulou include detailed accounts of how to approach and implement Paley's storytelling strategies with young children.

At the heart of these self-generated stories is the implicit valuing of self-expression and child identity. In these types of learning experiences children are personally connected; their imaginations are allowed to make meaningful connections through imaginative play and storytelling as they draw on all that they have experienced and learned in their very young lives. They are learning about themselves and about others, and are laying the foundations for literary success. When given opportunities to *story* children understand that their words, thoughts and feelings have value. They know they are being *heard*. Not only does this aid in the development of identity but also, through authentic talking and listening, it builds relationships with others and encourages joy in learning.

Encouraging children to story

Booth and Barton (2000) also agree that children have an inherent desire to *story*: 'they can find "self" inside the act of storying, as they try to order and communicate their thoughts, constructing both the story and their identity in the process' (p. 15). These authors urge parents and educators to assist young children's 'narrative development' (p. 20), to nurture a love of story and the ability to tell stories so they can share their lives with others in meaningful ways. Drawing on Engel's study (1995), Booth and Barton provide a concise list of suggestions for educators and caregivers who are interested in fostering children's storytelling ability:

- **Listen attentively**: the listener can help in the shaping of the story.
- **Respond substantively** as a true listener, rather than just a critic.
- **Collaborate** by asking questions that help shape and direct the child's story.
- **Provide a multiplicity of voices and genres**, choosing stories and poems because they are told in interesting ways, or because they have beautiful language.
- **Encourage a wide range of story form**s as children try to express and create themselves through their stories.
- **Permit stories about things that matter**, for the impulse to retell is powerful (p. 20).

Children telling traditional tales

Educators need to expose young children to a wide range of story forms to encourage children's storying ability. Jane Yolen (2000) calls the traditional tale, such as a folktale, fairytale, myth or legend, a 'lively fossil' (p. 21). Many tongues have shaped stories of this type throughout the centuries; they are ancient, yet they are as alive today as they were thousands of years ago. They have stood the test of time, and provide a narrative framework that has the power to galvanise listeners. Not only are these tales an excellent place to start with young children, they also provide imaginative gateways into other cultures. For Shimojima (2006), when children are exposed to folktales from other cultures

> *they learn that all people share the same hopes, fears, and dreams; that love and betrayal are universal; and that tricksters, heroes and heroines, silly folk, wise elders and evil villains exist everywhere.* (p. 2)

Introducing traditional tales into the lives of young children expands their thinking about different cultures and helps open their minds to a broad and inclusive view of the world. Exposure to such stories will provide imaginative ideas for children to draw on. However, retelling a traditional tale, from beginning to end, requires greater skill than telling an improvised, self-expressive story. Engel (1995) comments on children's storytelling development in the following way:

> *By the time children are 3 years old ... many of their stories will have a beginning, middle and an end ... by the time they are 5 they will have distinctive personal styles of storytelling. They will also know the story custom of their particular community ... by the age of 8, most children can tell several different types of stories upon request and can accurately relate complex events.* (pp. 16–17).

One of the most powerful means to assist children in this learning is for the teacher or caregiver to orally tell stories. In this way, the adult models how to successfully tell a tale, while also giving children exposure to a greater source of narratives which will help with their ongoing storying (Whitehead, 2004). When teachers engage in imaginative learning experiences, such as oral storytelling with children, they provide environments that build language, literacy and deeper understandings about the world.

The teacher as storyteller

Egan (1986, 1997) suggests that once we recognise the important role story structure plays in human understanding, 'then we are led to reconceive the

39

curriculum as a set of great stories we have to tell children and recognise … school teachers as the storytellers of our culture' (1997, p. 64). Daniel (2007) argues that

> *unless teachers feel that they themselves are equipped to be classroom storytellers, then the activity of classroom storytelling delivered by an adult will remain the preserve of the professional teller of tales instead of its being regarded as a general teaching method, rich in potential for assisting children to become effective learners.* (p. 735).

Daniel, like Egan, maintains that the principal storyteller in the classroom should be the teacher. Teachers should have the ability to construct coherent narratives in order to *tell* stories as part of their pedagogy, and they need to develop their skills as storytellers in order to do so. This may be easier said than done. It would be easy to assume from the literature that it is not common practice for teachers to tell oral narratives in the classroom, unmediated by a written text. To my knowledge, there are no studies that survey the number of teachers, early childhood or other, practicing oral storytelling as part of their pedagogy, nor are there studies that investigate the resistance or reluctance for teachers to develop these skills, if indeed this is the case.

Furthermore, there is little research investigating teachers who are practicing the art of storytelling in early childhood classrooms and centres, although there are many authors who offer useful guidelines for developing teachers' artistry in this area (Collins & Cooper, 2005; Livo & Rietz, 1986; Norfolk, Stenson & Williams, 2006). There are, however, several studies that have specifically investigated the role of teachers as storytellers in various educational contexts. Certain aspects of these studies relate, if not directly, to early childhood pedagogy (Campbell, 2008; Daniel, 2007; Kuyvenhoven, 2009; Mallan, 1993; Mello, 2001a, 2001b; Poston-Anderson & Redfern, 1996; Rosen, 1988; Sim, 2004). A recent investigation into the pedagogical implications of four preservice primary teachers developing oral storytelling skills found that overall, developing these skills had positive implications for emerging teacher identity and pedagogy (Campbell, 2008). The research revealed that notions of *personal* and *self* were central to the participants' learning to become confident storytellers. Personal identity, artistry and enhanced learning about narrative were other key themes that arose during the study. Although the constraints of Campbell's study did not permit exploration of classroom dynamics during storytelling sessions, the participant teachers recognised that oral storytelling had the potential for positive transformation of teacher–student relationships.

Other authors also assert that positive relationships are forged between teachers and students during oral storytelling, and that this in turn leads to inclusive, dynamic classrooms. Zipes (1995) argues for more storytelling in schools because it engenders a strong sense of community in the classroom. Similarly,

Poston-Anderson & Redfern (1996) in their inquiry into the value of teachers as oral storytellers in the classroom, and other contexts, support this view. They maintain that 'storytelling is a means of relating, entertaining, educating and sharing ... it builds relationship within the group' (p. 246). Another qualitative study, conducted by Sim (2004), investigated three teachers' use of storytelling as a pedagogical practice to enhance classroom community. Sim observed that these teachers viewed the use of 'personal disclosure' stories as an integral part of their teaching philosophy:

> *Overall, using self-disclosure as an explicit teaching strategy seems to hold a similar purpose for the three teachers involved: to develop a learning environment that is characterised by tolerance so that there is an openness that encourages sharing and expressing ones hopes and fears. They view their use of the personal as ... building a classroom community where students learn, confident in the knowledge that their ideas are accepted, that they can talk openly and that learning can be fun.* (p. 362)

These authors offer statements and reflections rather than a deep analysis of the dynamics operating in the storyteller–story-listener space. However, a recent ethnographic study by Kuyvenhoven (2009) explores these qualities in a more substantial manner. Kuyvenhoven sought to investigate the concept of 'presence' in the classroom with a teacher whose pedagogy is informed by a strong oral storytelling practice. She observed that during the storytelling sessions the community of learners, including the teacher, developed deep understandings about each other. Although Kuyvenhoven's study focused on a Year 4/5 primary classroom, there are several elements that apply to the early childhood classroom, particularly in regard to the notion of *playing* with story. In one example, during the telling of *Rumpelstiltskin* the teacher-storyteller invited vocal and physical responses from the students. Kuyvenhoven observed that the students 'opened the story to each others voices and presence ... they played with Linda [the teacher], with each other, and with the story' (p. 96). In this way narrative functions as a type of 'holding environment' (Winnicott, 1980) within which participants feel free to engage in improvisational activity and *play*. This is an important aspect to consider in early childhood, where children are exploring their worlds and forging identities in relationship with other people.

The reciprocal relationship between storyteller and listener is bound by the secure structure of the narrative itself. For Kuyvenhoven, this place is where children begin 'the work of imagining their way into a storyworld, an intense activity of deep imaginative engagement' (p. 53). ('Imaginating' was a word coined by one of the children in Kuyvenhoven's study to describe the experience of listening to a structured story such as a fairytale or folktale.) Figure 3.1 illustrates this dynamic operating in an oral storytelling encounter.

Figure 3.1 The relationship between teller and listener is held within the structure of the narrative (story)

Furthermore, when adults share stories with children in this manner they share a part of themselves. This was true for 'Bianca', a participant in Campbell's (2008) study focusing on pedagogical implications of preservice primary teachers developing oral storytelling skills. Bianca was keen to reconnect with her cultural identity and to explore ways to introduce it into her teaching. She chose to tell a true story set in rural China, about her great grandmother's children who where kidnapped by bandits and returned through her grandmother's noble deed. Through practise with the various elements of storytelling Bianca's tale took on the proportions of a deeply moving fairytale. It had all the key features – orientation, complication, climax, a happy ending and a moral. Bianca observed that storytelling was effective because it 'brings you fully into the classroom' (p. 43). Her comment is supported by Palmer's (1998) claim that 'good teaching cannot be reduced to technique; good teaching comes from the identity and integrity of the teacher … personal identity infuses their work' (p. 10). Bianca's desire to express and define her Chinese heritage through the act of oral storytelling was a way for her to explore her identity in the classroom, to share part of herself with her students. But this was more than sharing a story; by developing skills of a storyteller Bianca found ways to tell the story using artistry. Eisner (2002) discusses the importance of artistry at the heart of teaching:

Teaching profits from – no, requires at its best – artistry. Artistry requires sensibility, imagination, technique ... Good teaching depends upon artistry and aesthetic considerations ... Artistry is most likely when we acknowledge its relevance to teaching and create the conditions in schools in which teachers can learn to think like artists. (pp. 382–84)

The aesthetics of oral storytelling

As discussed earlier, self is central to the storytelling encounter. Personal authenticity is enhanced in oral storytelling because it allows for the natural language, grammar, syntax and physicality of the storyteller. To model oral storytelling a teacher needs to become comfortable to stand, or sit, in front of a group of children and tell a story. It is an art form, but, as Kuyvenhoven (2009) reassures us, 'it is the lightest of arts' (p. 195). Storytelling, like drama, draws heavily on the aesthetic of theatre, yet it has its own unique aesthetic that is underpinned by the predominance of the storyteller's personality and identity.

Birch (2000) describes the difference between acting and storytelling as follows:

> *Storytelling is most interesting when the storyteller is not acting out a part, but rather doing two things simultaneously. Through verbal and nonverbal clues, effective storytellers bring out nuances, both large and small, which delineate characters within the story and direct the point of view of an audience toward the characters. Actors may use sense memory to bring the character to life, but they submerge their own selves in service of character. Storytellers are not hidden.* (pp. 20–21)

The assertion that storytellers are 'not hidden' recognises and accepts that oral storytelling is dependent on the personality of the teller. The concept of self is clearly at the heart of the experience. The teller is allowed to express their viewpoints and personality as they slip between narration of events and demonstrating character. It gives power back to the teller as they find their own voice, their own rhythms, their own gestures and personal references to bring the story to life for themself and their listeners. This is as true for adults as it is for children. When teachers develop their artistry in this way, they also encourage their students' artistry and skill as storytellers and provide learning communities that enable the ongoing development of children's already powerful imaginations.

Creating storyworlds

This section offers some guidelines and encouragement for those interested in incorporating oral storytelling as part of their pedagogy. The most important thing to be mindful of is that, like children, adults too get better with practise. There are no hard or fast rules, because oral storytelling, like all creative enterprises, is open to the shifting dynamics of early childhood environments.

One of the first steps is to find a story to tell. Those working with very young children may like to start with a simple nursery story, such as *The giant turnip* or *The three little pigs*. Tales such as these have a repetitive rhythm and pattern that appeal to younger children. Older children who are entering school may enjoy the more complicated narrative aspects of the fairytale or folktale; for example, *King Midas* or *Rumpelstiltskin*. Children in their first or second year of school may like to engage with myths and legends, such as the Celtic myth of the *Selkie* or the story of *Arachne* from ancient Greece. As stated, these are not prescriptive; indeed, there have been experiences where older children enjoy returning to simple stories, while younger ones slip deeply into the classical myth or legend. When choosing a story to tell ensure that it evokes an imaginative and pleasurable response; a storyteller needs to enjoy the story they are telling! This will also enhance listener engagement. For Kuyvenhoven (2009), the most important part of choosing a story is

> *from the first encounter the teller feels the story needs to be shared. The story might be ridiculous, perplexing, awfully sad, or have an ending that is too good to be true. In all cases the first impulse is, 'Oh! What a good story. I like it'.* (p. 197)

This is the place to start.

Learning the story for telling

After choosing a story the teller will need to develop confidence to orally tell it. There are many approaches to learning a story, and everyone will develop their own individual style. Often an appropriate place to start is to reflect on the key moments of the story. Many storytellers like to think of these critical moments as the *bare bones* or *skeleton* of the story, which they will *flesh out* with their unique way of telling. Here is an example of the bare bones of a version of the story of *King Midas*:

- King Midas loves gold; he is greedy.
- A genie appears and grants him a wish.
- He wishes that everything he touches would turn to gold.
- His wish comes true – he is happy.
- He accidently turns his daughter to gold (a statue) – he is miserable.
- The genie returns and tells him how to undo the magic.
- He follows the genie's instructions – everything is restored.

The complete story does not have to be memorised; in this way the storyteller is free to use their own words, grammar, syntax and rhythms to bring the story to life for the listeners. However, the storyteller is usually encouraged to memorise the first and final lines of a story, since this assists in reducing anxiety, particularly in novice tellers. Experienced storyteller Solis (2006) provides a poetic recommendation on what to do next:

> *Start at the beginning and thread images together. What happens? Then what happens next? What is the next image that comes to your mind about what happened? Connect these images like pearls on a necklace. Or even like stepping stones across a river. Each image leads to another, moving the story along.* (p. 9)

One of the most important things to remember is that the listener is also actively engaged in helping create story images. While the storyteller *fleshes out* the story using their own individual style, each listener will also create unique images prompted by the words of the teller.

Helping children become storytellers

After telling an oral story the teacher can build on the experience by using the strategies discussed below to help children develop their ability to retell and develop their own versions of the story.

Of course stories can be read too, but with an oral tale the listener is actively engaged in co-creating the story.

Advance–detail: Retelling a story with a partner

Students have the opportunity to retell the story using their own words. There is no right or wrong way to tell the story. However they need to include the characters and sequence of events – the narrative structure provides the 'holding' form from within which they can improvise and/or play. Before starting this activity decide on the key moments, or plot points. As a whole class or in small groups, depict these on A4 pieces of paper (or a whiteboard) with a sentence accompanied by an image (children can draw these). Arrange the story in narrative order. These will serve as visual prompts for young storytellers.

Partners sit opposite each other. One child tells the story, while the other child listens. The child listening also directs the story by saying either 'advance' or 'detail'. When *advancing* the teller moves forward in the story, following the plot line. When *detailing* the teller stops, or drills down into the story adding detail, such as colour, shape, size or smell. Halfway through the story the children swap roles: the child who was telling becomes the listener/director, the child listening and directing becomes the teller (adapted from Johnstone, 1989). For younger children 'forward' or 'description' may be more appropriate words.

Tandem storytelling

In the 'advance–detail' activity the children were improvising within the narrative structure of the story. They had an opportunity to *play* within the story, to explore, extend and become familiar with it. Now is a good opportunity to develop their storytelling skills for an audience. Have the children stand in front of the class and tell the story in pairs or larger groups, with each child in the pair or group contributing one or two sentences in turn until the story is finished. The teacher can slowly bring awareness to, and encourage, use of gesture, facial expression and eye contact – qualities that bring the story to life for the listeners.

These learning experiences allow students to kinesthetically and imaginatively engage with the story. This is not only an effective and enjoyable way to develop learning; it is also an efficient way of working toward the often difficult outcome of children confidently being able to orally retell a story. Success depends on allowing students to improvise within the given structure of the story, and by doing so to make personal connections with the text. Children are at the centre of the learning experience as they take ownership of the story and make it their own.

Conclusion

In general the research indicates that young children need to be given opportunities to *story*. There are several areas that call for more focused research if interested educators in this country want to mount a grounded argument for the inclusion of quality oral storytelling in early education. An area ripe for investigation is how teachers as storytellers affect early childhood classroom communities and learning through imaginative engagement with oral story. A second theme worthy of exploration is the implications of young children learning to tell traditional tales with a focus on the aesthetics of oral storytelling as an art form.

Oral storytelling is a form of artistic expression requiring both the storyteller and the listener to cross over a threshold into a boundless world of imagination – where people, places and events come to life within the confines of the everyday classroom. It is an efficient, natural and pleasurable way to enhance learning. When children develop their storytelling abilities they are involved in a form of play, making enjoyable and meaningful connections with previous learning and experiences. And when teachers develop their own storytelling skills they gain the potential to model an explicit form of narrative language for young learners. When adults provide these playful spaces, regardless of who is telling or listening, young children are given rich opportunities to discover who they are in relationship with others.

Behold:
Art appreciation
in the early years

Lea Mai

As I follow the path towards the M – preschool on a late autumn day my eye delights in the pinks, whites, and burgundies of the native flowers that flow from the edges of the cobblestones into the garden. Through the branches and buds I see a stone sculpture of a boy, perched on a weathered plinth. The winged cherub seems to be chasing an imaginary bird through the trees that line the periphery of this aesthetically rich preschool.

As I arrive at the front gate a cartwheel of colours invites me into the main spaces of the preschool. These welcoming hues come from a series of glass mosaics, framed and mounted to the west wall. Created by the children and one of the artists-in-residence, the abstract mosaics are intricate reflections of life inside the classrooms.

At the entrance to the Kookaburra room, large printed panels inform the reader of the many projects in which the children are engaged. One set of photographs, annotated, and organised neatly, shows how a small group of children is investigating marine life on the Great Barrier Reef. Neighbouring the panels, papier-mâché models of tropical fish and turtles swim alongside models of anemones and sea horses. These objets d'art – mounted on stands – are displayed on a pristine white shelf. Each artwork is labelled with the young artist's name, the title of the work, the date and the materials used. In one sentence, the artist gives an insight into their model. Hung on the wall behind the models are three photographs of underwater scenes from the reef by photographer Gary Bell.

As I open the door, Julian, one of the teachers, is leading a group of four children out of the room. Today they are heading to a small independent gallery to investigate the work of Fiona Tan. As I move past the children and open the door to the main Kookaburra space I recognise the notes of blues legend B.B. King's ode to his guitar, *Lucille*. Inspired by the music, some of the children are about to compose their own scores with the help of their specialist music teacher, while others will be choreographing a dance to interpret the new composition. As my eyes survey the room I notice that one corner resembles a miniature art museum. On three white plinths and on the two cream walls, artworks by the children are presented as if in a gallery. I can see a title for the exhibition stencilled on the wall: it reads 'The Art of Lines'. Looking more closely I notice that the artworks all deal with lines in different ways and in various media. Each artwork has a label next to it and space around it. As I scan the rest of the room I notice carefully curated sets of artworks on the walls. One set is a mounted series of self-portraits of the children and the teachers, above self-portraits by Frida Kahlo, Vincent van Gogh, Rembrandt van Rijn and contemporary artist Huang Yan. On the opposite wall a set of photographs shows contrasting wild and human-made landscapes. A lunar, dusty desert is framed next to a view from a mountaintop of air and clouds. A metropolis is juxtaposed with the thick greenery of a rainforest. From the labels I learn that the photographer is one of the teachers at the school.

Below these impressive scapes is a sequence of photographs of the children in costume performing a play about a small creature from outer space who lands on earth and goes exploring through these places to find the one she likes the most. As I move out of the room I am farewelled by the vibrant, organic sounds of the children's blues composition taking form.

What stays with me is how the artworks have been arranged. The walls are a neutral colour so that the focus is on the art. The teachers have taken care to frame, mount, and label both the children's works and those of professional artists. The space around the works is clean and uncluttered. There is a lack of mass-produced images in favour of authentic art.

The preschool feels like an art gallery steeped in everyday life.

Connecting with the Arts occurs through both making and appreciating art. While making art is often a central part of the preschool years, appreciating art as part of the everyday life of young children is rarer (Eckhoff, 2010) – even though research shows that aesthetic understanding is a 'vital aspect of artistry' (Meiners, 2005, p. 38).

As teachers, you can incorporate art appreciation in the classrooms in a number of ways. By bringing original works of art into the preschool, art appreciation can become a part of everyday arts practice. Curating exhibitions of their own

work with the children recognises their efforts. Showing high-quality, artistic, age-appropriate documentaries can be an introduction to new topics, places and projects. Incursions from artists and performers connect children with professional artistic practice and allow them to appreciate new works. Award-winning, high-quality illustrations from children's literature are readymade artworks already present in many preschools. Aesthetic experiences can be designed with children as collaborators and, where possible, as project leaders. As Vea Vecchi (2010), one of the original *atelierist* (artist–educators) from Reggio Emilia suggests: 'let children be authors of their own projects to the greatest extent possible' (p. 41). For when children actively shape their aesthetic environment they connect to it and make the preschool their own. Presently, issues of access, roles, and spaces may limit the exposure that young children have to original works of art. It is possible, however, for teachers and parents to enrich children's aesthetic lives by gradually introducing aesthetic elements and experiences in preschools and at home.

The question, then, is: what can children, teachers and parents do to bring regular and varied aesthetic experiences into their worlds?

Aesthetic experiences in the preschool

The teachers' role

Art appreciation is recognising the work of others for what it meaningfully and beautifully communicates about us and our world. This means teachers recognising the work of children; children appreciating each other's work; and teachers and children recognising the work of professional artists. Art viewing lends itself both to solitary contemplation (as seen in Figure 4.1) and enthusiastic collaboration (as seen in Figure 4.2). In taking the time to see and hear the art made by others we connect to our community and we are inspired in our own artistic practice. Viewing and discussing artworks with children can become part of your daily routines. Asking simple questions to interrogate any artwork, from a high-quality book illustration to a marble sculpture in a gallery, develops visual literacy in children and adults.

Elements of art appreciation

Great art is arresting, challenging and memorable. It can also be personally meaningful. Museum educators at the Tate Britain work across four categories of art appreciation:
- art appreciation as visual representation
- art appreciation as symbolism
- art appreciation as critical reflection
- art appreciation as self-development (Arriaga, 2011).

Figure 4.1 Solitary contemplation at the exhibition, *Contemporary art for contemporary kids*, 2010, Sherman Contemporary Art Foundation

Figure 4.2 Children and carers engage with the installation – *In-Flight* (Project: Another Country), at the opening night of the exhibition, *Contemporary art for contemporary kids*, 2010, Sherman Contemporary Art Foundation

In-depth art appreciation needs time; so you may want to interrogate a work of art again and again. You can ask any or all of the questions below. Let your discussion be guided by the children, and let them set the pace.

Visual representation

- What do you see?
- Who can you see?
- What is happening?
- Where is this place?
- What did the artist use to make this artwork?
- What type of artwork is this? (painting, sculpture, installation, photograph …)
- Let's look at the lines, form, colours, shapes, spaces and textures, and describe them:
 ◊ **Lines**: create space, outlines or patterns, and suggest movement, mass or volume
 ◊ **Shapes**: both geometric and organic
 ◊ **Form**: how the different elements of the work come together
 ◊ **Space**: the areas around, between or within objects
 ◊ **Texture**: how an artwork feels to the touch
 ◊ **Colour**: *hue* – the names of colours – not just red, yellow and blue, but also aqua, scarlet, ecru, verdigris and vermilion; *intensity*, which refers to vividness; and *value*, which is the lightness or darkness of a colour. Value is important for works in black, white or greyscale.
- How long do you think it took to make this artwork?

Symbolism

- What story can you see? How do you know?
- Why did the artist make these shapes/lines/marks?
- How did the artist make this work?

Critical reflection

- What does this artwork make you think of?
- What is the artist trying to tell us?
- Is something or someone missing?
- Why did the artist make this artwork?

Self-development

- How does this artwork make you feel?
- Does it remind you of something or someone?
- What else can you tell me about this artwork?
- If you were going to make an artwork, what would you put in it?

- Would you like to be inside this artwork? Why/why not?
- What could you hear/taste/smell/see if you were inside this artwork?
- Why do you like, or dislike, this artwork?

Compare and contrast

You can also compare and contrast two or more artworks by asking:
- How did each artist make their artwork?
- Did the artists use the same lines, form, colours, shapes, spaces and textures?
- What can you see that is the same/different in these two works?
- Which artwork is bigger?
- Which one took the longest to make?
- What stories are the artists telling us?
- Which is your favourite? Why?
- If you could take one home, which work would you choose?

Authentic objects

By bringing original works of art and sculpture into the classroom you can encourage children's visual literacy. First, you can engage children in a discussion about the artwork using the questions suggested in the previous section as a starting point. The children can then decide where and how the artwork should be displayed. You can show children how to label works, and encourage them to show and discuss the artwork with their significant adults. By exhibiting artworks of cultural significance you can make links with the children's own or others' cultural backgrounds, enhancing feelings of inclusion and promoting diversity. Exposing children to original works of art informs them about the unique physical properties that make artworks valuable to our society. Mass-produced reproductions and commercial posters are not the same thing (Tarr, 2004). Exposing children to authentic objects is the aim, because they 'invite engagement, wonder or imagination' (Tarr, 2004, p. 89).

Original artworks can be rented from ArtBank (see <www.artbank.gov.au/index.html>) or borrowed from local practicing artists. High-quality, limited edition prints can be purchased from sites such as 20x200 <www.20x200.com>. Preschools can seek donations towards the purchase of artworks from parents, friends, and the local community. Organise fundraising events specifically for the purchase of artworks. Ask your local and state government about community grants to support the purchase of artworks for your preschool. If, after all this, original works of art are still not available, use high-quality illustrations from books as artworks.

The preschool gallery

Just as many preschools today have a 'home corner', you can also have a 'gallery corner'. Having a space that maximises how art is presented sends an important

message about the value of children's artistic practice and the value of art in their lives. Art galleries are adroit at presenting art – you can use them as your inspiration. For instance, neutral colours on walls allow the art to stand out – as does proper illumination. Empty space between works gives each work its own importance. Hanging works at child height respects children as art viewers. Art galleries are also free of visual intrusions such as clutter, mess, furnishings and non-art objects, which serve to heighten the importance of the artworks and allow the eye to focus on one thing at a time. Labelling is critical, as it recognises authorship and artistic process. Mount a card next to the artwork with the artists' name, the date the work was created, the medium used, the work's dimensions, its title, and an annotation for the work by the artist. You may also extend labels to include some documentation of this process.

Once you have your gallery set up and your curatorial standards in place, it's time to start curating. Curating exhibitions of children's work for the preschool community recognises the importance of children's artistic output. The works need to be arranged as a show in a gallery; that is, centred around a theme, which can be on a specific project or on a style of art. Children are capable of making many curatorial decisions. You can let them decide what to include, where to hang, how high and for how long. Involving children in creating exhibitions and displays enhances visual literacy and communication (Tarr, 2004). Exhibitions can be hung for two to three months, and then changed over. An exhibition opening – where you invite parents and children from other classes – recognises the work you have put into your gallery. A short catalogue of each exhibition is an excellent way of documenting and archiving the children's efforts at aesthetic production and appreciation.

Media arts

Showing high-quality, artistic, age-appropriate documentaries and short films can generate much follow-up interest and discussion for new projects. Many artists today work in the media arts – film, documentary, photography and digital art. Some talented artists, like Australian Oscar winner Shaun Tan, travel seamlessly between media – from illustrating, to writing, to theatre, to short-film animation (see <www.shauntan.net>). Many arts-based websites offer an array of excellent digital content. Sites like The Design Work <www.thedesignwork. com> collate excellent examples of contemporary media arts. Posts like 'Video art: 20 great experimental short films' (see <www.thedesignwork.com/video-art-20-great-experimental-short-films/>)are an excellent place to start, while sites like ArtInfo <www.artinfo.com/> and Young People and the Arts Australia <http://ypaa.net/> will keep you in touch with the arts industry generally. Let the children view a range of age-appropriate content and tell you what speaks to them, thus giving them choice and control over their aesthetic connections.

Illustrations

It is important to select books not only for their literary merits and subject matter but also for their aesthetic value. While children listen to a narrative they are also focused on 'reading' the illustrations. Children get clues to the narrative from the illustrations, but they are simultaneously able to engage in an aesthetic experience if the quality of the images is high. Discussing books with children, then, should include a discussion of the illustrations. Researchers have found that if children are given the chance to discuss picture books and then document their responses by creating their own works, they develop skills in art criticism and appreciation (Evans, 2009). Thus the illustrations inform and extend the children's creativity. As the dialogue moves from the printed page to the children's own creations, the ideas presented by the book are internalised and given new form.

Children's book illustrations are part of a long history of art in books. The *Book of Kells* (c. 800 AD) in Ireland, for example, and many other illuminated manuscripts from Chinese, Islamic and Western traditions are now considered to be priceless works of art. Today there are a number of awards that promote excellence in illustration and are a good source for bringing the very best illustrations into the preschool. In Australia, the Crichton Award recognises new illustrators (see <www.cbca.org.au/crichton_winners_2010.htm>), while in the UK the Kate Greenaway Medal is awarded yearly for outstanding illustration (see <www.carnegiegreenaway.org.uk/greenaway/>). The Caldecott medal is awarded yearly to the most distinguished American book for children (see <www.ala.org/ala/mgrps/divs/alsc/awardsgrants/bookmedia/caldecottmedal/caldecottmedal.cfm>). The Hans Christian Andersen awards recognise the oeuvre of an illustrator and a writer every two years (see <www.ibby.org/index.php?id=273>).

Integrated art appreciation

Art appreciation can also enhance meaning-making when it is integrated into other areas of the preschool curriculum. You can integrate art viewing with art-making by looking at artworks before commencing an art project (Eckhoff, 2011). This can be a source of inspiration, and an introduction to new techniques and materials. Through investigations of how artists have represented the world, abstract concepts or distant objects become tangible. Searching for mathematics in the Arts, for instance, engages minds, and is enjoyable. Height; width; 'many, few and none'; 'small, medium and large'; shapes and patterns are all to be found in many artworks. For example, you can ask children to count the fish, birds, people, clouds, or eggplants in Guan Wei's work (see <www.visualarts.qld.gov.au/linesofdescent/works/guan.html>). There are many great photographers who are dedicated to capturing the natural world in artworks that are artistic, accessible and emotive – such as those awarded in the Nikon Small World Photomicrography Competition

(see <www.nikonsmallworld.com/>). Contrast these with the work of Richard Barnes, who presents animals in startling contexts (see <www.richardbarnes.net/>), or Andy Goldsworthy's interventions in nature (see <www.rwc.uc.edu/artcomm/web/w2005_2006/maria_Goldsworthy/TEST/index.html>).

With some forward planning aesthetic experiences can be incorporated into what is already happening in the classroom. For instance, many preschools already do a self-portrait activity, especially at the start of a new year, to foster both self-identity and belonging. Self-portraiture has a long and rich history in the art historical cannon. So the children's work can be informed by what others have attempted to communicate through self-portraiture. Rembrandt made many self-portraits at different ages, in different clothes, displaying different emotions. Self-portraiture is an obvious link between the children's work and the wider artistic society. Your role is to show them what's out there, to make them feel like they are contributing to an ongoing artistic dialogue. The children will almost certainly get new ideas from looking at other people's work, which can extend their projects in new directions. Researchers have shown that children who appreciate artworks are more attentive to their own art production (Honigman & Bhavnagri, 1998). In other words, art appreciation enhances art practice. Curating an exhibition of these self-portraits, including references to famous self-portraits, is a natural conclusion for this project.

Infants appreciating art

Much as children understand language before they can speak, very young children can appreciate art even before they can engage in artistic production. Recent research has confirmed that infants as young as two months are able to demonstrate aesthetic preferences through body language 'such as a visual fixation, a smile, a giggle, or reaching for the image or object' (Danko-McGhee, 2010, p. 366).

For childcare centres that cater for children under two, the aesthetic environment is a critical part of the care experience. Teachers should be aware of what infants can see, touch, and hear, and carefully manage the environment to create aesthetically engaging spaces. In this way, access to original works of art and sculpture in a childcare setting can become a child's first connection with the Arts. These works can be produced by older children, parents, teachers and artists-in-residence if funds are not available to purchase works of art. Sculptures should be sturdy enough to withstand a lot of climbing and touching or, if fragile, placed out of reach. While Australian infants seem to prefer black and white schematics when looking at artworks (Danko-McGhee, 2010), it is impossible to predict what an individual child's aesthetic preferences will be, so it is important to offer a variety of art objects and let the children choose their favourite works.

Satisfying the Early Years Learning Framework

Literacy in the Early Years Learning Framework is much more than reading and writing. Literacy incorporates a range of communication including music, movement, dance, storytelling, visual arts, media and drama. Creativity is also an aim of the Early years learning framework.

Art appreciation can address both visual literacy and creativity, and it can also support the Early years learning framework's five learning outcomes. Aesthetics can:

- provide a sense of identity by allowing children self-determination in making decisions about what to view and for how long
- let children connect to the world by viewing works from non-Western traditions
- foster a sense of wellbeing – art fills emotional, physical, and social needs we all have
- allow children to become confident and involved learners when others listen to their thoughts and feelings about artworks
- create effective communicators – when children incorporate what they have viewed into their own artistic production (Eckhoff, 2010).

Bringing art into the preschool makes the environment more diverse, more authentic and more beautiful. The aesthetic preschool then satisfies the Early Years Learning Framework requirement of creating welcoming, rich, responsive and vibrant learning environments (DEEWR, 2009, p. 15).

The benefits of art appreciation

When preschools provide young children with opportunities for connecting to their artistic and cultural heritage, they satisfy the children's right to full and free participation in cultural life and the Arts as provided for by Article 31 of the United Nations' Convention on the Rights of the Child (OHCHR, 1989). Participation in cultural life and the Arts was possibly included in the convention because of the many benefits we get from engaging in the Arts. Aesthetic appreciation enhances the quality of early years education because it:

- enriches learning (both cognitively and emotively) by making visual connections with the contemporary and historical world
- offers new perspectives and ideas to young children, thus broadening their world view
- challenges children to observe, assess, critique and synthesise artworks. As Eisner (1985) wrote, 'great art … enlightens in a special way and stretches the mind' (p. 65).
- informs children's own art-making by demonstrating what is possible
- connects children to their community through social interactions

- favours non-verbal communication
- celebrates multiple perspectives and teaches children there is more than one solution to a problem (Eisner, 2002)
- develops autonomy and self-direction, when children choose how to engage with artworks
- builds awareness of children's own and other cultures
- makes children's spaces more beautiful and more vibrant; for 'beauty … constitutes an important element in our humanity; a primary need' (Vecchi, 2010, p. 10)
- may lead to 'flow'. Flow is a state 'where all of one's mind and body become completely involved in [an] activity. Attention is focused and … the depth of involvement is enjoyable and intrinsically rewarding' (Csikszentmihályi & Hermanson, 1995, p. 36).

The parents' role

Art needs an audience, and parents and other family members can be that audience. Attending exhibitions curated by their preschoolers, and being active art viewers, is an important role for parents in the aesthetic life of their children. An active art viewer is genuinely interested in how the artist made the work and in what they are trying to communicate. You can have this discussion with your child about their work, and about all the artworks on display at your preschool. As one parent from Reggio Emilia expressed it: 'you really participate in what the children have been doing' (Fontanesi, Gialdini, & Soncini, 1998, p. 152). Parents and carers are also the conduits of cultural heritage. Make sure you share the artistic heritage from your culture with your children 'through images, legends, stories, myths, songs, music and dances' (Piscitelli, 2005, p. 6). If you are trained in the Arts then it is vital to organise shows and performances of your works for the preschool community. Through incursions by parents who are arts professionals to the pre-school and through artist-in-residence programs children can collaborate with artists to investigate new artistic media, generate new knowledge of artistic processes, give art the time it needs, and extend their practice (Eckhoff, 2011). This allows children to understand the end-to-end process from creating an artwork to presenting it to the community.

Aesthetic experiences in the community

The teachers' role

In traditional societies art was both a part of everyday life – as seen from the earliest cave drawings and portable figurines – and a marker for important community sites and rituals. Over time, however, art became largely segregated

into museums for reasons of preservation and conservation (and some would say elitism (Hein, 2004)). This means we must make more of an effort to connect with our cultural inheritance. Fortunately, many museums have recognised that it is important to connect young children with artworks. Increasingly, museum education departments are catering for young children. So with a little planning, young children can connect with their cultural heritage and build relationships with their cultural institutions that may last a lifetime.

You can help your children connect to art by organising excursions to art galleries and museums, big or small. You can contact the education department of your local museum, and begin planning an introductory visit based on the children's current interests. Initially you can start with a small pilot group of four children, a teacher and a parent. A small group means that the children will have a more individuated experience, as there is more opportunity to let them follow their own interests. Before the visit, talk to the children about where you are going, what you will be doing, how you will get there, where you will have lunch, who you will meet, and how you will get home. These advance organisers are important in making the excursion manageable and enjoyable for children (Piscitelli, Weier, & Everett, 2003). You will have already worked with the museum educator to ensure that the visit is shaped around the children's interests. Storying, play and the ability to handle objects have been identified as powerful mediators of learning and enjoyment (Anderson et al., 2002), and can be incorporated into the visit. It's also important to give the children a chance to co-lead, affording them choice and control over what to view and for how long (Piscitelli, Weier, & Everett, 2003). Fifteen minutes of free exploration, following a child around a gallery, always reveals surprises, and often results in the child stumbling upon an artwork with which they have an immediate and deep connection. Such a connection took place between one artwork, *Beauty*, by internationally acclaimed artist Olafur Eliasson, and Elly (three-and-a-half years) at the Museum of Contemporary Art in Sydney.

Elly and Olafur

Olafur Eliasson is famous for his light installations, which seem to transform time and space. The following vignette is drawn from a diary I kept of a three-and-a-half year-old girl's engagement in an extended viewing experience with Eliasson's work *Beauty* (1993) at the Museum of Contemporary Art in Sydney, Australia in 2010. Over a number of visits, Elly's self-directed, immersive interactions with the artwork displayed the cognitive, affective, creative, kinaesthetic, imaginative, vocal and communal aspects of her aesthetic engagement.

Visit 1, 31 January, 2010: Down a dark tunnel, with jagged walls of black concrete on each side, Elly betrayed no fear as we travelled towards the main chamber of the artwork *Beauty*. Elly and I entered a completely black rectangular space, with high ceilings, the floor and walls covered in impermeable soft-fall material. Two-thirds of the way into the room, illuminated by a single spotlight, a mist fell to the ground, like the most ephemeral of waterfalls. Elly was intrigued by the play of colours formed by the light hitting the mist, and as soon as she entered the mist her true delight was sparked … During her time with *Beauty* – which she renamed *Sprinkler* – Elly improvised a sequence of play that allowed her to continually enter and exit the watery space. While adults entered the room and stood back or tentatively placed their hand in the mist and pulled it out before they got too wet, Elly was enjoying herself too much to stop just because she was getting wet. In fact, getting wet – her hair soaked, droplets of water running down the side of her face – was part of her connection with the artwork.

Elly used her skills and senses to engage and sustain the experience. She used her voice in its full range: she screeched, hollered, roared, sang nursery rhymes, whispered, and chatted to me about the artwork. She stuck out her tongue and tried to drink the mist, she held her face up to let the mist hit her features; she tried to catch hold of the mist, her arms and hands getting wetter and wetter. Elly jumped, hopped, walked, tiptoed, performed ballerina swirls and ran, ran, ran and ran again in and out of the mist.

Elly then turned to her skills of make-believe. She created sequences of pretend-play with frogs hopping, mice squeaking, and monsters stomping through the mist. She crouched, walked on her hands and feet, and hopped, as she told me her stories. Finally Elly became still; standing in the middle of the mist, arms wide open.

Visit 2, 7 February, 2010: Today there is a sign: 'This exhibit is temporarily unavailable'.

'The Sprinkler is closed today', I explain.

'Why?' Elly looks confused, disappointed. 'Why?' she asks again.

'Maybe it's broken,' I speculate, 'or the floor got too wet and it had to dry out'.

'Or maybe it turned off', she offers, considering the formal properties of the artwork.

 As we leave the exhibition, after looking at some other artworks, I reflect: 'I wonder what happened to the Sprinkler?'

'It maybe broke. This is my sad face', Elly replies, demonstrating both her theories and her emotions.

'Shall we come back another day?' I ask.

'Yeah. Let's come back. Let's come back another day. Let's come back another day', she says, her repetition emphasising her desire to re-experience *Beauty*.

Visit 3, 27 February, 2010: Elly moved quickly and effortlessly from action to voice to imagination today, switching often between games in an effort to experience the artwork in as many ways as possible. She scraped her shoes along the soft-fall floor. 'I'm skating' she stated. A reference to the figure skating she has seen on television. The skating soon

gave way to the feeling of water on her body. 'It's water time' she announced, then connected the mist with the sensation on her skin: 'I'm wet'. While continuing to move in and out of the mist and through the tunnel and back into the main chamber Elly took the time to understand how the Sprinkler works. 'Where does the water come from?' she asked. Before I could answer she looked up and confirmed 'Up there'.

Post visit, 29 May, 2010: Two months after our last visit to the MCA I asked Elly if she would like to make an artwork about the Sprinkler. She was immediately enthusiastic, taking possession of the artist's paper and water soluble colour pencils that I offered. In an intense creative flourish lasting about 15 minutes, Elly produced her artwork (see Figure 4.3), which she titled *Sprinkler*. It is a highly creative, transformative piece that encapsulates the formal features of *Beauty* but also the spirit, the joy and the continuous movement of her unique engagement with Eliasson's artwork.

After a museum or gallery visit, it is important to integrate what you saw back into the curriculum to foster reflection and learning. Follow-on activities are needed to sustain the spark of inquiry that started in the museum (Ansbacher, 1998). Work with the children to integrate their museum experiences into their daily activities. For instance, try using the colour range of a painting you saw. Or create sculptures with the same subject matter as those in the gallery. At group time, let your gallery visitors tell their classmates about the gallery. If the visit was a success, you can extend excursions to the rest of the group.

Often excursions to a museum are a one-off activity. But regular attendance brings many benefits. In fact, John Dewey suggested that museums should be a

Figure 4.3 Elly creating her work *Sprinkler*
in response to Olafur Eliasson's work *Beauty*

'part of the active learning network of any school' (cited in Hein, 2004, p. 418). In getting to know each other, the children and the museum staff can design programs together. Ideally, you can aim for medium- to long-term involvements with accessible arts spaces based around projects of interest to the children and their favourite works of art.

Museums can add an important dimension to children's learning. They can provide learning which is 'object-based, experiential, thought-provoking, and problem-solving' (Hein & Alexander, 1998, p. 45). On their part, children bring their previous knowledge, life experience, interests, innate curiosity, and playfulness to the museum. To maximise the value of a museum visit you need to link it to the children's prior life experiences (Anderson et al., 2002).

Researchers have shown that there are three ways in which we, children and adults, engage with a museum – social, personal, and physical (Falk & Dierking, 2004). So don't worry if a child's most memorable experience seems to have been the bus ride there, or if they are more interested in their friend than the art. Sometimes we visit museums for the social interaction. Sometimes we are absorbed in the physical environment. At other times we make a deep connection between the art and something in our life story. These are all valid interactions. Giving the children the opportunity to visit a gallery more than once lets them experience different types of visits, builds familiarity, and offers multiple opportunities for learning. It gives them chances to experience the museum in different ways. To see different things. To occupy the museum space with confidence. And to integrate the artworks into their life narrative. Repeat visits build the children's expertise in art appreciation and make the museum a real part of their lives (and yours). Repeated contact with artworks also allows children to build deep knowledge over time, by revisiting and reconsidering their ideas.

The parents' role

Parents can reinforce and extend their children's museum life in different ways. They can:

- accompany their children on excursions to arts venues and, if needed, mediate between museum educators and the children. Often young children prefer to gain art historical information from a significant adult who can connect it with their personal history, rather than an unknown educator (Mai & Gibson, 2009; Piscitelli, 2005)
- take their children back to the same museum to give them time to revisit and reassess their ideas outside of preschool hours
- keep an art diary with their children about the artworks they liked
- discuss the children's favourite artworks before and after the museum visit using the art diary – did something new emerge?

- support their children's aesthetic choices, and accept multiple interpretations as valid
- encourage their children to share their experiences with other members of the family; for example, by co-creating art at home in response to artworks from the museum, and then sharing these with relatives
- bring the Arts into the home through displaying artworks (including those of their children)
- read books with their children about going to museums and galleries, such as *Miffy the artist* by Dick Bruna (2008); *Dog's night* by Meredith Hooper (2000); *You can't take a balloon into the Museum of Fine Arts* by Jacqueline Priess Weitzman (2002); and *Babar's museum of art* by Laurent de Brunhoff (2003).

Issues of roles, access and spaces

Roles

Creating aesthetic experiences requires adults to view children with a presumption that they are able to be art critics, appreciators, participants, investigators and audiences. Dunne (2006) describes the predispositions of the early years as the

> *freedom from debilitating self-consciousness, from the fragmentations that can cause painful conflict between mind and body, thought and feeling, self and others; greater readiness to feel, and greater trust to express, the 'here and now' quality of experience; an immediate and alert presence to the sensuous world that is all the fresher and more intense for being less under the mediating influence of conceptual and linguistic schemes.* (p. 11)

These are also the best qualities for art appreciation. In fact, young children may be intrinsically equipped to be our greatest art appreciators. What they require are extended opportunities to exercise their aesthetic engagement. An image of the child 'who is curious and capable of creating and contributing to the culture within [their] environment' (Tarr, 2004, p. 89), then, is the foundation of the aesthetic preschool.

Adult members of the aesthetic preschool also need to practise their own aesthetic appreciation and be role models for the children. Bringing works of art into the preschool and displaying them correctly is vital. Perhaps the most important aspect of art appreciation is the quality of the interactions with and between children. These need to be 'as rich, interesting, engaging, satisfying, and meaningful as we can make them' (Katz, 2003, p. 21). Perhaps the most important role for adults is to take art appreciation seriously, and use it to create a high-quality ambience for children.

Access

John Dewey (1980/1938), in his essays entitled *Art as experience*, argued for a return to the Arts as a part of everyday life. Dewey was concerned about the Arts being segregated and inaccessible, because he favoured direct experience for learning. For Dewey, experience of an art object is informed by the viewer's previous knowledge, and in turn sets off a cycle of inquiry that shapes future knowledge (cited in Hein, 2004). Today, much as when Dewey was writing, the Arts continue to be largely segregated from the daily lives of most children. But preschools in Reggio Emilia, Italy, and those around the world that follow their pedagogical approach, have heard Dewey's call. Vea Vecchi (2010), of Reggio Emilia, urges us to bring aesthetics

> *back to an experience of life and relations, removing it from perhaps too solemn an area and returning it to the everyday processes which help us to sense how things dance together with one another.* (p. 15)

Children deserve to be in direct contact with high-quality artworks through practical, daily interventions and activities. This will help to make Article 31 of the Convention on the Rights of the Child a reality in the lives of children.

Spaces

For art to become a part of everyday life, it needs to break through the walls of the art museum. Art can be appreciated within the spaces that children occupy on a daily or weekly basis, such as the preschool and the home. Research has shown that environments 'decorated with attention to aesthetic dimensions had a favourable impact on [children's] visual perceptual skills and measures of creativity' (Feeny & Moravcik, 1987, p. 10).

Museums will remain, however, our greatest troves of art. Thus we need to work with the arts community to create opportunities for aesthetic experience through long-term projects that build familiarity between young children and arts venues (Piscitelli, 2005). While building such partnerships has been a long-stated goal of the arts community (Piscitelli, Weier, & Everett, 2003), too often full and free participation in art museums in early childhood is still the exception rather than the rule (Mai & Gibson, 2011).

But exceptions are often rewarding. In Brisbane, for instance, the campus kindergarten collaborated with the University of Queensland's Art Museum to create and curate an exhibition with young children. Initially the children viewed and critiqued seven works from the university collection. The children worked closely with both teachers and gallery staff to familiarise themselves with the artworks and the gallery space. Over a number of weeks and visits the children

created their own works in response to the original artworks. The project, entitled Big Art Small Viewer, culminated in an exhibition in the gallery of the children's works, hung alongside the original artworks from the collection. The preschool and the arts community were invited to an opening ceremony and afternoon tea (Gibson & McAllister, 2005). Along the way the museum became a space in the lives of these children.

Conclusion

Art appreciation is a sensory, narrative, emotive and cognitive way of engaging with the world. In this chapter I have tried to offer some ideas for integrating this aesthetic 'way' into the lives of young children. I hope that you will try some of these ideas and shape them into aesthetic experiences that are meaningful and memorable. You may discover many benefits. For art appreciation enriches children's lives, informs their practice, connects them to their culture and community, and fulfills their international right to freely and fully participate in cultural life and the Arts. In short, art appreciation improves the quality of our lives. Behold.

Playing with literature: A place of wonder

Robyn Ewing, Heather Blinkhorne, Janelle Warhurst and Gretel Watson

One of the greatest gifts we can give to our children is that of story – by which their imaginations will be nourished and the world will become a place of wonder. (Saxby, 1997, p. i)

Five-year-old Alexander sits transfixed by the performance of *Hairy Maclary*. He knows each of the stories that are retold through narrative and song based on Lynley's Dodd's series of books. They have been favourite bedtime stories since he was very young.

Noted historian, author and children's literature enthusiast Maurice Saxby makes the point in the quotation that opens this chapter that story should be gifted to all children. While in Chapter 3 Victoria Campbell concentrates on storying and storytelling (Lowe, 2002), this chapter focuses on exploring literature with children. Children are born with the desire to make meaning, and learning language is critical for them in developing meaningful relationships as well as in understanding their culture and context. From birth, children will delight in hearing stories and having stories read to them. This chapter is also closely linked with the chapter on dramatic play (see Chapter 2), and should be read in conjunction with both Chapters 2 and 3. Early childhood teachers and parents of babies and children of all ages need to create a happy and secure environment for sharing books – a language-rich environment. Adults who enjoy reading themselves provide an example for children, and help them understand that reading is a way of being and becoming part of the world (see Figure 5.1).

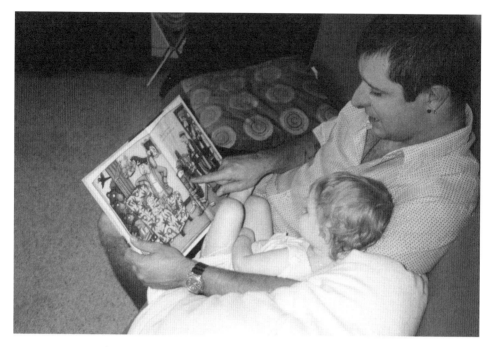

Figure 5.1 Alia was introduced to quality literature at an early age

Never too young for books

New Zealand born Dorothy Butler (1980) witnessed first hand the way books provided comfort and pleasure for her disabled granddaughter, Cushla, and ultimately transformed her life, and she recorded the experience in *Cushla and her books* (1975). She asserted that it is never too early to read to a child, and concluded that 'it is not possible to gauge the width and depth of the increase in a child's grasp of the world that comes with access to books' (p. 23).

Even when accomplished as readers, many older children and adults find it is pleasurable to be read to, and it is no different for the young child. At first the attraction will be the uninterrupted attention, as well as the lilting sound of the human voice and the patterns of language that a baby will enjoy. They will soon begin to respond with vocal interaction and gesture – well before they can speak. And research demonstrates unequivocally that children are empowered by literature in a number of important ways (see Butler, 1980; Krashen, 2010; Meek, 1988; Saxby, 1997). Literature encourages children to see their own thoughts and concerns articulated through the lives of others – but at the same time helps them to imagine possibilities beyond their own worlds. Through stories children can learn compassion, tolerance and empathy (and how they might deal with anger, frustration, jealousy and conflict).

Literature 'lessons'

We should never forget that sharing literature is about enjoyment. Award-winning Australian author Nadia Wheatley reminds us that we can 'do a book to death' by over-reading it or using it only as a literacy or moral tool. The intimacy of sitting together to share a story at any time of day with adults and siblings or friends, and snuggling down under the covers to read together before bedtime, cannot ever be replaced. The many films, DVDs, computer games and television programs readily available for children today are also important experiences that should be offered to children, but they should not displace books.

By listening to a range of different stories, children not only explore meaning: they learn about narrative structures (including time, place, setting, characterisation and plot sequence). Margaret Meek (1988) illustrated clearly how sharing books together helps children become literate in her monograph *How texts teach what readers learn*. Through her research with young children Carol Fox (1993) also demonstrated how those children who were read to often learned to 'talk like a book' when telling their own stories. This 'oral literacy' was an important transition, as confidence orally often tended to relate to confidence with reading.

A child's ability to think imaginatively is extended as they create mental pictures and evoke feelings through interacting with words and images and sharing these with others. Stories take children to places they have never travelled to and introduce them to interesting characters they would not necessarily meet in their everyday worlds.

Stories for all children

It is therefore really important that all children are able to find themselves and their lives reflected in stories. Stories from a range of different cultures and traditions should be read and explored. Aboriginal dreaming stories should be shared alongside creation stories from other cultures. Care must be taken to ensure that the age, stage and interests of all the children are accommodated in the selection of stories to be read. Myths and legends and traditional tales from around the world will help children build a rich intertextuality that they will be able to draw on throughout their lives.

Early childhood centres and classrooms can emulate shared parent–child reading time by ensuring there is a well resourced book corner and a regular story time. Time must be allocated every day for this purpose. Teachers and childcare workers need to ensure that books become part of the lives of children who are not familiar with books and stories in their own homes. Shared story time sessions with parents can also be scheduled from time to time. Such opportunities can help create a sense of security and belonging for children and their families from all backgrounds (DEEWR, 2009; Munns, 2007).

Starting early

Babies and toddlers will enjoy books with lots of repetition and rhyme. They will delight at finding things hidden under flaps or within other images. Janet and Allan Ahlberg's *The jolly postman* (1986) is perhaps the most well developed example of this.

Young children will often surprise the adult with how much they want a particular book to be read over and over again. They should be encouraged to join in with the sound effects, gestures and movements and, in time, they will often add in the repetitive phrase or sentence as they learn it by heart. Pamela Allen's *Who sank the boat?* (1984) and her *Mr McGee* (1987) series are excellent examples.

A range of well-loved early childhood authors are listed at the close of this chapter on page 79–80.

Quality literature should be shared with children every day in different forms, including picture books, nursery rhymes and poems, song lyrics, graphic novels and visual texts. Children should be encouraged to select the books they would like to read and have read to them. Shelves well stocked with books need to be accessible as soon as babies can crawl. Comfortable cushions or pillows should be in close proximity. Visiting libraries and bookshops should be mandatory. Parents, caregivers and teachers also need to share the stories that they love – even including those from their own childhood if they are available. Their enthusiasm for a particular book will be infectious (no matter how dated the book may be).

Playing with language and literature

Educational theorists such as Vygotsky (1978) and Bruner (1990) have theorised about the interdependent relationship between thought, language and cognitive development. Quality literary texts are wonderful models for a child's developing language skills. Listening to an accomplished reader also provides a less experienced listener with a model of how words can fit together seemingly effortlessly to make meaning.

In his monograph *Reading aloud to children*, Bill Spence (2004) provides some excellent principles for reading aloud (p. 2). These include:
- familiarity with the book before it is read aloud
- creating interest in the book by first exploring the front and back book covers
- encouraging prediction as the story progresses
- reading expressively
- involving the listener
- talking about the story after the reading.

Playing with voice through manipulating individual words, names, rhymes, songs, nonsense syllables and jingles while reading together is another fun way to explore language and develop vocal skills. Young children love the opportunity to repeat

favourite words and phrases over and over again, delighting in rhythm, rhyme and onomatopoeia. For example, Alia, not yet three, has really enjoyed Libby Gleeson and Freya Blackwood's *Amy and Louis* (2006) on many occasions. One afternoon soon after, Alia was walking hand-in-hand with her dad and grandpa through a large tunnel in the city. Suddenly, appreciating the echo in the tunnel, she stopped, smiled and yelled 'Coo-ee Amy. Coo-ee Louis.' Her delight at the echo was palpable, and she repeated her cooee. Both her father and grandfather shared in her laughter. They knew that she was remembering this call of friendship from two friends in one of her favourite stories. Moreover, she was also demonstrating her growing understanding of how stories in books link with things that happened in her own life.

By four or five many children will be able to identify letters, words and phrases in their much loved stories. Take, for example, the rendition that appears on nearly every page in Michael Rosen's *We're going on a bear hunt* (1989):

> *We can't go over it,*
> *We can't go under it,*
> *We'll have to go through it!*

Children can join in and experiment with changing the meaning of the same phrase or sentence or rhyme by varying the inflection and thinking about what the punctuation is advising:

> *We're <u>not</u> scared<u>?</u>*
> *<u>We're</u> not scared!*
> *We're <u>not</u> scared.*
> *We're not <u>scared</u>!!*

They can also experiment with pace, tone and pitch by pretending to be in different contexts. For example:

> *I'm whispering because I don't want the dragon to wake up.* (*The paper bag princess*, Munsch, 1989)

or

> *I'm speaking very quickly because I'm so worried this witch might cast a spell on me.* (*The frog prince continued*, Scieska, 1991)

or

> *His mother called him: WILD THING!!* (*Where the wild things are*, Sendak, 1967)

In doing so, children are delighting in the joy of language and understanding that it is a resource for making all kinds of meanings. Their motivation and engagement in learning to read will be sealed. Saxby (1997) suggests that pitching story time just a fraction above the child's level of linguistic mastery encourages growth, while revisiting favourite stories reinforces and consolidates existing language skills.

Talking about literature

Talking about the stories we share is crucial for extending our understanding and helping us see things from a range of different perspectives. Margaret Meek (1988) suggests that we should talk about reading using the terms 'dialogue' and 'desire'. In his book *Tell me*, Aidan Chambers (1993) provides a whole set of potential questions that can provide an approach or framework that complements Spence's criteria listed on page 68. Once adapted for the age of the child and for a particular context, these questions can provide a starting point for talking with children about a book being shared. For example, Chambers suggests that adaptations of the following questions might be discussed after a story:
- Was there anything you liked about the book?
- Was there anything you disliked?
- Was there anything that puzzled you?

Selecting quality literature

Award-winning and much loved children's author Katherine Paterson (1995) reminds us that as parents and educators we must always give children 'works of imagination – those sounds deepest in the human heart, often couched in symbol and metaphor' (p. 173). This is because these works won't provide a formulaic answer to life's questions. Instead they will 'invite children to go within themselves to listen to the sounds of their own hearts.' In this way, their imaginations are being stretched, they are making sense of their own lives and being encouraged to reach out toward people whose lives are quite different from their own. As the Early Years Learning Framework (DEEWR, 2009) notes, enabling young children to understand diversity is an important step in being inclusive.

Quality literature reflects the best thinking of its time, and it can be read at different levels, depending on the experiences of the readers. Real literature will make children sit up and take notice and/or laugh; but, above all, it takes them to a place of wonder. Good books avoid stereotyping and prejudice (Butler, 1980).

The following principles can be useful for teachers and parents when choosing picture books for the home, early childhood centres and classrooms. Ask yourself whether the book is:

- interesting and engaging – does it merit multiple readings and trigger lots of 'why' questions?
- genuine – is the language used real (rather than contrived to limit the vocabulary)?
- multilayered (rather than one-dimensional)?
- relatable to the children's interests and experiences?
- rich and evocative of a range of different communities/worlds/cultures/ways of being?
- do the images contribute to or grow, rather than merely support, the meanings in the text? (adapted from Ewing, Miller, & Saxton, 2008, p. 126).

Multi-modal texts

Teacher and teacher educator Jon Callow (1999, 2011) has demonstrated how the visual nature of the world in which children are immersed makes it important to help them examine the interplay between image and the written word. He explains that:

> *Multimodal texts make meaning because all the elements work together to create a whole text. This is the case for picture books, using only image and text, or for the video and multimedia, where image, gesture, movement, words and sound all work together to create the final piece.* (Callow, 2011, p. 1)

Picture books provide an excellent way of demonstrating to children how visual features work with the text and how the meeting of the image with the word works together holistically. Consider, for example, how the gorilla who visits Hannah to take her to the zoo in *Gorilla* (Browne, 1983) fits perfectly into her father's coat, and how the shadow of the father is exactly the same as that of the gorilla.

Developing understanding in the early years of school

Iser (1989) suggests that really understanding a text must involve *actualising* or performing its meaning. The child draws on their own experiences and cultural knowledge, together with previous texts they have read or listened to (*intertextuality*) to position themselves as a reader to interpret and negotiate meanings (Crumpler, 2006). Teachers and parents can thus provide opportunities for children to enter texts in a range of different ways, as demonstrated in Chapter 2. They can, for example, talk to one of the characters, or discuss whose story it is – and whose it isn't (Doonan, 1993). Rich and evocative language and images can provide a

stimulus for children's own imagination and creativity, and this can be encouraged through art-making in other arts disciplines including drama, dance, music and visual arts. The different arts disciplines can therefore help children into the text and beyond, and enable them to examine a range of other possibilities rather than simply what is there on the surface. This deeper understanding will be evident in their oracy and literacy.

Of course an additional criteria is a child's reaction to particular books – they will want to read some over and over, or may focus solely on a particular topic for a considerable period; for example, fire engines or dinosaurs.

Using picture books as a starting point for readers' theatre

As children learn to read in the first few years of school, readers' theatre can become a valuable strategy for bringing talking, listening, reading and writing together. 'Readers' theatre' is a term used to refer to scripting and reading adaptations of literary texts. The term 'theatre of the imagination' is applied to readers' theatre because it enables students to use their voices, facial expressions and simple gestures on the spot, to explore different readings of the same words (Cusworth, 1991; Ewing & Simons, 2004; Hertzberg, 2009). This is exemplified in the example from *We're going on a bear hunt* on page 69.

Through scripting a chosen story or poem, students will find that their interpretations will sometimes differ from others. They will develop a clearer understanding that all readers bring their own past experiences to the meanings they make from texts. Picture books can provide a useful beginning for the scripting process. Sometimes the use of font types, the text size and even the organisation of the text on the page can provide a particularly helpful beginning in understanding what the author intended. Lauren Child's *Beware of the storybook wolves* (2000) and *Who's afraid of the big bad book?* (2003) are very helpful when introducing scripting to children in early childhood classrooms. Once again, such an activity usually engages children with the text in a highly meaningful way.

Sharing literature across ages and stages

The unit of work described below builds on an idea discussed by Jill Bennett (1991) in her book *Learning to read with picture books*. The unit was developed by Janelle Warhurst's Year 5/6 class in November 2011. These ten- and eleven-year-old children wanted to find a way to share a book they had enjoyed, *Look! A book!* (Gleeson, 2011), with their kindergarten buddies. They wanted the kindergarten children to have the opportunity to step into the shoes of the characters and investigate the multiple meanings in the story.

As well as helping the younger children who are developing their knowledge of literature and literacy, this opportunity focuses the older children's attention on the nature of quality texts and how they are multilayered.

A shared literature unit: *Look! A book*!
(Gleeson, 2011)

Janelle Warhurst and Year 5/6W, Curl Curl North Primary School

Initially the Year 5/6 class looked deeply into the book themselves. The activities they developed for kindergarten are listed in sequence below. They planned open-ended questions and creative activities to help kindergarten explore the story, characters and meaning. The activities planned by the older class were based on their own understandings and the strategies they often used to explore texts in depth. They wanted the kindergarteners to use fun and creative activities and visual and performing arts, and to involve the younger children in their own art-making. Some piloted the questions they had developed with their younger siblings.

1. Children look carefully at the cover of the book.
 What do you think the story is going to be about?
 Children make predictions from studying the cover:
 e.g. *The children are finding a book.*
 They are looking at a book.
2. In small groups children depict the scene on the front cover, either as a frozen moment or a short sequence. Discuss how the children might have got there.
3. Read the book together.
4. On the first page, the two children are walking along together.
 Ask the children to think about what they may be thinking, saying and doing.
5. Ask the children to draw the two child characters and add captions or thought and speech bubbles to represent what they are saying/thinking.
6. Hotseat some of the characters. Questions that might be asked of the grandmother/old woman include:
 – *Do you realise that you are dropping things out of your trolley?*
 – *Why aren't you picking them up?*
 – *Who was the book from? How did you feel when you saw the book?*
 – *Do you know these children?*
 Questions that could be asked of the children:
 – *Where do you live?*
 – *Do you like your life?*
 – *Where are you going?*
 – *How did you feel when you saw the book?*

7. After reading the book, the children create an artwork that expresses how the story made them feel.

8. Divide the class into groups of six. Two children become the children in the book. The rest of the group will enact a scene from a popular fairytale, and the two children will react to the story as they do in the book.

9. In groups of three, children act out their favourite fairytale or popular story. As a class, brainstorm how the story could be altered.

10. Each child is asked to choose a page that touches them. They illustrate this and then the drawings are laid out on the floor to make a circle. Each child in turn explains why they chose the page, and what it means to them.

11. Ask the children to think about what the children in the story may be thinking about to make them do what they are doing.

12. Children illustrate what they think are the key moments in the story.

13. Ask the children to close their eyes and imagine what they think might happen next. Encourage them to think about more 'fantastical' options. Make sure they know that there are no limits and they can think outside the square.

14. This time ask the children to imagine where they would want to go if they had a magic book that brought them into its world.

15. Other discussion questions:
 – *What are the children doing with the shed? Why? What is the meaning of the shed?*
 – *What were the boxes in the trolley that grandma was pushing?*
 – *How were the children feeling when they found the book?*
 – *What is happening to the children as they read the book?*
 – *How well do you think the children are taking care of the book?*

Some of the children's responses:

Laura (kindergarten)
The children are floating inside the teacup and they are going to dive in to get the book. It is such a special book and it is trapped in a broken bottle. There is lots of rubbish on the bottom of the water. It is very cloudy and they are sad that they have to dive down to get the book because they don't want to get wet with their clothes on.

Reece (Year 5/6)
The book is about a boy and a girl who are brother and sister, who have never seen a book in their life before because they are so expensive. They have very good imaginations. But when they start to read (which they learnt from reading the newspaper) it takes them to metaphorically faraway places and they get to make the book up and shape the story into whatever they want when they are in it. Time in the real world stops until they want to get out. When you read it is a place to let your thoughts and dreams run wild …

Ben (kindergarten)

They are sitting in the teacup because there is a lot of water around. They were imagining that they were the smallest people. The boy and girl want to take care of the book. Ben drew the scene (see Figure 5.2).

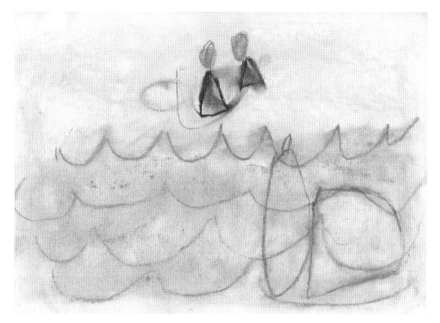

Figure 5.2 Ben's pastel drawing

Integrating literature with other key learning areas

What follows is an excerpt from a literature and literacy unit designed by Heather Blinkhorne and Gretel Watson for their Year 1/2 composite class. The unit aimed to integrate literature meaningfully (Gibson & Ewing, 2011) with a HSIE/science unit on wet and dry environments.

Using literature to explore environmental issues such as drought, flood, introduced species and pollution allowed the students to make emotional connections with the themes of the unit. Through their connections with the characters and settings of the text, students were able to understand both the impact that people have on the environment and the ways in which people are dependent on their environments.

Students also explored the way that the authors' choice of language and literary devices influenced their responses to the text.

An integrated literature/HSIE/science unit

Heather Blinkhorne and Gretel Watson

Cry me a river

1. Build children's field knowledge: visit a local place of environmental significance
 We chose the lagoon across the road from the school. Over the years it has become polluted. We arranged for an expert to talk to the students and share their knowledge about the history of the area.

2. Provide a research opportunity for the students
 We interviewed longstanding local community members. The children asked them questions about what had happened over the years. From the interviews we created an oral history film and identified the critical moments in the history of the pollution of the lagoon.

3. Create a timeline for the critical historical moments
 The children chose a moment in the timeline that they considered critical, and we used drama to deepen their understanding of this event. For example, we chose the time when the council wanted to concrete over the entire lagoon in the 1970s. We held a 'community meeting'. The children took on roles as different members of the community with a range of viewpoints about this proposal. We encouraged debate, noise and elaboration of the various perspectives.

4. Create a display of the significant place
 We used 'Smart notebook' software and 'Smart' recorder to make a digital book of the critical moments chosen by the children. Children were able to record their versions of the critical moments. They were able to manipulate objects to tell the story. We printed the notebook out and created a book.

5. Sharing the literature
 As a class we shared the story *Cry me a river* (McRae, 1991). The children used their whole bodies to focus on the descriptive language in the book. Later we discussed the similarities in this story with what had happened in our local area.
 Students were each given a different page from the story. They used different coloured highlighters to identify nouns and adjectives. Coming back together as a class, we then created word banks and discussed how the adjectives provided a deeper understanding of the nouns.
 Individually, students then used the adjectives and nouns from the word banks to write a simple poem reflecting the themes of the text. Initially they chose four nouns,

then they added an adjective to precede each noun. Finally they added a verb and an adverb. For example, would a 'murky river' flow 'quickly', 'thickly' or 'sluggishly'? Students illustrated their poems.

The story of Rosy Dock

The story of Rosy Dock (Baker, 1995) was introduced after we had used the SMARTboard to quiz children about the difference between willy willys and tornadoes; torrential rain and light showers; introduced and native species of plants, and so on.

1. The class was divided into groups of four. Each group was given a series of key images from the story, but with no text. They had to sequence the images and create a storyline that they thought reflected their sequence. Each group then presented their sequence to the class, and the class decided on the sequence that they most agreed with.

2. Students closed their eyes and imagined they were moving to a new country and had to select one precious thing with them. They were then asked to imagine they were holding this precious thing as they moved around the room. They then exchanged their precious item with a classmate's, and repeated this several times until everyone had passed and received several precious things. In a sharing circle they described the precious thing they were finally holding. A class discussion followed around what it would mean to be able to take only a few things that would remind you of home when you moved.

3. *The story of Rosy Dock* was read to the whole class by the teacher. The book relies on imagery, so it was worthwhile to discuss what was happening in the images. The class spent considerable time discussing the final image, and the effect that introduced species have on the environment. The last image needed special attention, given that many children initially believed it was a beautiful image of flowers and animals running around.

4. Students wrote a personal response to the text in the form of a letter to share with another class.

5. Because some children had difficulty understanding that the story is spread over thousands of years, the class jointly constructed a timeline of the first few events. Relevant sentences from the book were displayed on the board, and students worked in pairs to continue the timeline. Later these were shared and discussed.

6. The class examined some well known introduced species and their effects on the environment. The teacher divided the class into small groups and provided each group with key information on well and lesser known introduced species (flora and fauna) and the effects they have had on an environment. The groups ranked the introduced species in order from most to least impact. They then came together and discussed their choices to see whether they could reach a class consensus.

Rain dance (Applegate, 2000) and *Where the forest meets the sea* (Baker, 1987) were also introduced as part of the unit.

An example of the children's words and artwork from this unit is shown in Figure 5.3.

Long, long ago, but not so very far away there was a soothing playground, it had water as blue as cornflowers and sandy bottom. native plants and animals loved to sip the pristine water and dip their branches in the cool clear lagoon.

Figure 5.3 The lagoon

For further thought ...

Immersing children in quality literature will often lead them to their own story writing. The authors and illustrators provide a model that is an excellent starting point. Gretel Watson writes about how this process emerged seamlessly for her class:

Once upon a time there was a class of 1/2W children who loved to stroll through the pages of books and ponder over the 'wow' words. They walked in the shoes of the characters and gave them voices and ideas. 1/2W shared their responses through 'frozen moments' and by acting out critical parts in the story. 'Writer in role' became a favourite of the class. The children loved extending what the characters said using thought and speech bubbles. The illustrations of the stories provoked great discussions and inspired the children to draw and create.

The children devoured the figurative language and used it in their own writing, impressing all who read their stories. Adjectives and adverbs were hunted down and used to convey meaning to the reader. 'Surreptitiously' became a favourite word of the class, and many class authors used it successfully (even spelling it correctly) while writing.

After reading many stories and dramatising critical moments, the time came to do what real authors do and write! But first the children had to draw, draw, draw and draw some more, and share their plots, characters and themes with their classmates. Lots of discussions took place as the children inspired each other and shared ideas about the settings, characters critical moments and finally the resolution.

The children had complete ownership of their story and begged to begin. As soon as the writing started, scrolls of draft work spilled over the tables. Discussions continued as

the children worked on writing, editing and flow. Hours passed and the children worked on. 'Can I work on my story?' was a frequent question. They helped each other and asked questions and complimented their fellow authors.

In addition to this, the children scanned their pictures and developed storyboards for the movie version of their story. The future Steven Spielberg is here! Finally the drafts were typed, edited, re-edited and formatted to create a wonderful book.

Some children's authors and illustrators to explore with young children

There are many books written especially for young children. While it is always dangerous to make a list such as the one below, the following authors and illustrators could provide a starting point. Forgive the omissions! In addition there are a number of publications that parents and educators can turn to for guidance until they have more confidence in making their own selections. The Specialist Children's Booksellers, for example, publish *Don't leave childhood without*. In addition, each year the Children's Book Council announces a list of distinguished books including those for younger children.

Janet and Allan Ahlberg	Anna Fienberg	Jan Pienkowski
Jez Alborough	Mem Fox	Donna Rawlins
Pamela Allen	Jackie French	Michael Rosen
Jeannie Baker	Simon French	Jeannette Rowe
Graham Base	Kim Gamble	Axel Scheffler
Aaron Blabey	Theodor Geisel (Dr Seuss)	Ken Searle
Freya Blackwood	Libby Gleeson	Maurice Sendak
Quentin Blake	Bob Graham	Lane Smith
Raymond Briggs	Emily Gravett	Shaun Tan
Ron Brooks	Eric Hill	Chris Van Allsburg
Anthony Browne	Russell Hoban	Julie Vivas
Dick Bruna	Shirley Hughes	Martin Waddell
John Burningham	Pat Hutchins	Jenny Wagner
Rod Campbell	Mick Ingpen	Bruce Whatley
Eric Carle	Robert Ingpen	Nadia Wheatley
Chris Cheng	Ann James	Margaret Wild
Lauren Child	Oliver Jeffers	Brian Wildsmith
Babette Cole	Edward Lear	Mo Willems
Helen Craig	Alison Lester	Charlotte Zolotow
Terry Denton	Jill Murphy	
Lynley Dodd	Matt Ottley	
Julia Donaldson	Helen Oxenbury	

Conclusion

Real literature helps young children understand authorship, audience, illustration, interpretation of symbol and much more. Stories often embed metaphors for life issues and dilemmas and opportunities for young and old to question, interpret and challenge them. Much loved author Katherine Paterson (1995) provides us with a powerful conclusion to this chapter. She writes:

> *The imaging, the imagining, the spying of the heart – the deep connection of those images that comprise the inner life with corresponding images in the world outside ourselves – and the language or the artistic skill with which to express this connection – these are what must grow and develop. We start this process of nurturing the imagination when we read to children while they are still far too young to understand the words.* (p. 205)

Literature is often neglected as an art form. Sharing authentic children's literature is a wonderful way for young and the not-so-young to continue to foster imagination and creativity while learning to be literate.

Playing with music and movement

Amanda De Lore

The power of music to exalt the human spirit, transform the human experience and bring joy, beauty and satisfaction to people's lives. (Pascoe, 2007, p. 8)

As Lilly's parents eagerly awaited her imminent arrival, little did they realise her introduction to the world of sound and music had begun some months earlier; for instance, in the way she settled when she heard the soothing voice of her mother from about the time of seventeen weeks in utero. Peaceful music also produced pleasant vibrational frequencies that encouraged restful periods for Lilly, whereas loud or unfamiliar noises made her startle and respond with active movements.

When Lilly finally entered the world she was confronted with a cacophony of sounds. The one most distinguishable and comforting was the familiar lilt and pitch of her mother's voice. Soon Lilly would recognise and respond to other sounds and rhythms. These included the excited babble from her grandparents that made her smile, the drumming of cicadas carried on the wind and the pitter-patter beat of the rain on the roof. Lilly's stimulating and nurturing environment enhanced the development of her auditory skills, and her innate musicality flourished in time. Lilly's mother often sang her to sleep and taught her lively songs to which they would both clap along, producing much laughter in the process. As she gradually became more mobile, Lilly often responded to and expressed her emotions through music and movement.

Lilly had been given a gift that would last a lifetime.

Those of us who teach music and movement to young children, as well as the parents of students involved in a quality music and movement program, need

no convincing of its benefits. The results are clearly visible in the growing self-confidence and developmental progress of the children in our care.

Having been a classroom teacher for more than 20 years, my professional experiences are diverse. I have taught music in many different contexts, including preschools, primary schools and at TAFE across a range of geographic, cultural and socioeconomic settings, as well as during the aftermath of a critical incident. In all of these situations, teaching music and partnering music with movement have been invaluable tools in reaching challenged and difficult learners and crossing cultural and language boundaries. They have also helped children to achieve some outstanding academic and affective outcomes.

A substantial body of research data now supports the role music and movement play in children's development, both physical and mental. Some of this research is briefly discussed in the next section.

Music and movement and the development of young children

Music is an art concerned with combining vocal and/or instrumental sounds for beauty of form or emotional expression, usually according to cultural standards of rhythm, melody and, in most Western music, harmony. Movement is the 'raw material for dance' (Stinson, 1988, p. 11). Joyce (1994) asserted that the very act of growing was movement.

The starting point for learning with most young children is their bodies. Their focus then shifts to the space around them to include those closest to them, and finally, to other people. A program that encourages creative movement stimulates growth in many areas of development and helps children learn to trust each other (Heath, 1999).

Music, especially when combined with movement, has a profound effect on the development of young children. Its impact on the intellectual, academic, social, emotional and physical wellbeing of the young child cannot be overestimated. Both music and dance occur in a wide range of cultural contexts. Early dance experiences play a crucial role in the formation of gender identity. Sensitivity is required towards gender issues, because in some Western cultures socialisation from an early age means that boys may identify some forms of dance as a feminine activity.

This chapter first provides a brief overview that considers the research and writing about the critical role that music and movement should play in the lives of all children. It then discusses how music and movement can be introduced into the early childhood classroom, with practical activities and suggestions.

Music and movement as ways of knowing

From early times many philosophers have advocated the need for harmony between body and mind. Howard Gardner (1983) asserted that both music and bodily-kinesthetic intelligences were ways of knowing and making meaning, just as valuable as the more traditional, logical ones such as mathematical and linguistic intelligences.

In fact, instead of separating the mind and body, in the last decade there has been a return to an emphasis on an integrated or holistic understanding of the mind and body (Schiller & Meiners, 2011). Levinowitz (1998) also links making music and walking as basic life skills, along with talking. Making, listening to and moving to music enable children to express emotions and ideas. Young children also observe cultural rituals or rites of passage celebrated through song and dance. Dance, it has been asserted, enables both a sensory and an aesthetic way of knowing the world through our bones, nerves and muscles, and exercising our imaginations (McKechnie, 1996).

Before a child learns to verbalise, movement is one of the only ways they are able to communicate. Young children innately move with music; you can observe this as their bodies bounce up and down in a movement akin to dancing. An effective music and movement program will give varied opportunities for both *locomotor* movements (such as crawling and hopping) and *static* or *non-locomotor* movements (such as crouching, stretching and twisting), thereby assisting children to develop their gross motor skills, coordination and flexibility.

Creative movement gives children a greater awareness of their physicality, in terms of what their bodies can do and the space in which to do it. The concept of personal and shared space is reinforced. Children who are more aware on this level are less likely to bump into objects and are generally less clumsy. Young children involved regularly in movement activities also display improvements in balance, hand–eye coordination and *laterality* (awareness of left and right).

Music, movement, and emotional and social wellbeing

Music and movement bring joy into children's lives. Music has a direct bearing on our emotional state. Engaging students early in a quality music and movement program gives them a lifelong gift. Lively music often makes us feel happy, whereas slower music played in minor keys has the reverse effect. Happiness is the underlying core of every successful learner (see the Early Years Learning Framework, DEEWR, 2009, p. 63).

As a tool for creating different moods, music is extremely useful: it can be soothing or, alternatively, can be used to stimulate children's imaginations. A study by Hubbard (2001) showed that tones at a faster tempo were rated happier, brighter, faster. High pitched tones and ascending tones were similarly rated.

Music with these characteristics can be used very effectively to calm a disruptive classroom, most are beneficial during rest or quiet time, or when concentration is required. Or it can create a lively atmosphere for drama or art purposes. This emotional response carries over to the physical.

Researchers also argue that participation in music and movement helps to build young children's self-esteem and self-confidence (Bredekamp & Copple, 1997).

You only have to observe the enthusiastic look on young children's faces to realise that music takes them to another place; one where they are completely caught up in the moment. In my experience, students who are often withdrawn at the beginning of a music session soon forget about their self-consciousness, and their focus shifts to active participation in the activity. Regular music sessions also bring confidence, and when familiar with an activity, these same withdrawn students will perform for others with pride.

In her study of after-school dance programs, Shirley Brice Heath (2001) cites a range of evidence about the learning benefits that result in a number of areas. These include interdependence, growing intercultural awareness and planning and design skills.

Academic benefits of music and movement

Music, when it is effectively taught, requires a high level of listening and concentration from the student. It requires the student to have a capacity to work in the abstract, an ability to work across several skill areas simultaneously and the ability to rationalise this verbally (Gill, 2011). The Nemours Foundation, a non-profit organisation based in the USA (see <www.nemours.org>), has found that children who are actively involved with music, who play or sing or listen or dance regularly:

- perform better in reading and mathematics when they start school
- are better able to focus and control their bodies
- play better with others
- have higher self-esteem.

Some research suggests that there is a direct correlation between the study of music and academic performance:

> *Many preschool teachers would agree that songs, movement and games are superb neurological exercises. Dee Coulter, Director of Cognitive Studies at Naropa Institute in Boulder, Colorado argues strongly for the relationship between patterns in music and those necessary for proper neurological development … the combination of auditory and kinesthetic stimuli and teaching approaches make for strong development in language, social skills, self-management and internal dialogue.* (Jensen, 2000, p. 42)

In Australia, Peter De Vries (2004) conducted a study on the extra-musical effects of a music program implemented in a preschool classroom over a period of six weeks. He concluded that:

- involvement in music activities allowed children to release energy
- engagement in music–movement activities developed motor skills in children
- a variety of music activities promoted opportunities for student socialisation
- music activities provided opportunities for children to express themselves
- music contributed to sociodramatic play
- music listening activities focused children's listening skills.

Music and language learning

Music assists students with language acquisition. It is particularly beneficial to students from culturally and linguistically diverse backgrounds (Cummins, 1997). Students with language-processing problems also benefit, especially when the music is combined with movement. Many students are aural learners, so songs and rhymes that have a high degree of repetition build on this auditory memory. When songs are combined with movement, this has the added effect of assisting those who are visual learners.

Music, movement and coordination

Involving young children in a creative movement and music program gives them a sense of rhythm. A person who has a good inner sense of rhythm and timing is often graceful. A planned intervention program of rhythm can be successfully employed with children who are *asynchronous*, and can also help them to gain emotional control and learn to socialise (Arnheim & Sinclair, 1975).

Rhythm may be thought of as the *ordering of energy*. *Rhythms* are patterns of movement joined together in a synchronised way to produce efficiency in movement, whereas *timing* involves the experience of duration (Bateman, 1968). Rhythm and timing are interdependent.

Playing percussion or a tuned instrument aids in the development of hand–eye coordination and, when combined with *beat*, assists in developing concentration skills.

Allowing a student to interact with a piece of music or play an instrument in the way they choose stimulates their creativity and imagination – often in unexpected ways.

Working together

Creating movements with other children in the same space provides ample opportunities for socialising and working collaboratively. At first, students concentrate on mastering the activity independently. As their self-confidence grows, they are encouraged to use their imagination and work together to explore

movement. Combining music and movement provides a multisensory experience. The children need to use their senses of sight, hearing and, often, touch. When imagination also comes into play, there are many cognitive processes at work.

Music and children with special needs

Music is an excellent tool for desensitising autistic students – and those across the autistic spectrum – to noise. To achieve maximum results these students need to participate in integrated lessons, where the other children act as role models. Such opportunities also assist in developing socialisation skills. At the beginning of a music program, I have observed that some autistic students will cover their ears to avoid any loud or unusual sound. However, students exposed to a quality music program with a high level of auditory activity, movement and interaction with other students will soon feel more confident and accepting of these sounds.

Teaching music and movement in the early years

The Early Years Learning Framework has at its core a very child-centred approach, which recognises each child as an individual with their own unique set of needs. It focuses on the teacher as the *facilitator* of learning.

Observing and analysing what a child can do and understand forms the basis of the learning framework, from which springs ongoing learning opportunities through guided discovery and explorative activities. From this process a continuous cycle of planning, documenting, reviewing and assessing of the child's development is generated.

As educators, our ability to facilitate and create engaging learning environments for children and families is ultimately determined by our own values and beliefs. If our teaching practice is to be guided by the five key principles of the Early Years Learning Framework, we must first understand what drives our practice as a music and movement educator.

The five principles are:
- secure, respectful and reciprocal relationships
- partnerships
- high expectations and equity
- respect for diversity
- ongoing learning and reflective practice. (DEEWR, 2009, p. 63)

These principles form a broad framework for the teaching of music and movement The activities described from page 87 create a wealth of opportunity for an explorative approach.

In any early childhood centre, preschool or classroom there will be children who demonstrate a wide range of interests, knowledge and skills in the areas of music and movement. Every child, however, can participate regardless of ability, from special needs through to those gifted in music and movement activities. Music and movement programs have something to offer everyone.

Facilitating music experiences: Some principles

The following principles for facilitating quality music and movement experiences are useful for parents at home trying to provide optimal music and movement activities for their children, as well as for teachers working in group settings.

- Learning should be fun and take place in a non-threatening environment.
- Self-worth is crucial in optimal learning.
- It is important to nurture the whole child.
- Children learn best when they see themselves as learners and are supported to take risks with their learning.
- A happy learning environment is crucial to risk-taking.
- Passion is infectious! Teachers and parents need to lead by example. If you really love doing something, others (particularly children) will love doing it with you (DEEWR, 2009, p. 63).

Getting started at home

Listening to music is not only good for you as parents but also for your baby. Classical music provides some excellent choices, as does singing to your baby, particularly when you are trying to help them get to sleep. Don't worry if you don't think you can sing – your baby won't mind!

If you can play an instrument, play it often in front of your child. As they grow older, teach them how to touch the instrument with respect – gently – and you will find them taking an active interest. You may even be able to teach them a few notes.

As your toddler grows you will find them responding to music by moving up and down. Encourage this, and dance along yourself. Hold their hands and clap the beat with them. Later, they can move using pom-poms or streamers. Moving scarves to music, for example, helps to reinforce the concepts of fast and slow (tempo).

Sing with your child as often as possible. Nursery rhymes and finger plays are great for reinforcing rhythm and word patterns. Short songs from good children's CDs (e.g. Playschool, The Wiggles, Hi 5) are great for improving auditory memory. You will be surprised at how fast your child learns new songs.

Expose your child to different styles (genres) of music. You can listen to everything from classical to ballads (songs that tell a story) to rock, pop, jazz and blues. In this way children learn to appreciate all types of music.

Make your own music. Give your toddler a wooden spoon and pots or any other suitable and safe kitchen implements, and let them experiment and discover different tones (sounds). You can also play a piece of music and let them play along, helping to reinforce the concept of beat.

As the child grows older you can make instruments together. An empty juice container with uncooked rice inside makes a great shaker. A can with a burst balloon stretched over the top makes a drum; elastic bands stretched over the bottom of an empty cardboard box make a guitar. There are lots more ideas in books and on the internet. Opportunities to perform in front of family and friends generally delight children.

There are several home music programs advertised on the internet for purchase that include a CD and lesson ideas. Examples include Melody Movement (storybook and music CD), Musicare for children between 18 months and six years, and Playsongs for babies. The Good Sites for Kids website <www.goodsitesforkids.org/> has excellent free interactive activities and games.

Listening and aural skills

All music skills involve listening, so developing good listening skills is vital. Children need to be taught how to actively listen. This has ramifications for later schooling, as a student who possesses keen auditory skills will generally find learning easier.

Listening skills include:

- Aural **awareness**: an awareness that sounds differ greatly and are generated from a variety of sources. This means opening up our ears to the world, and recognising, for example, the difference between artificially produced sounds and those from nature.
- Aural **discrimination**: the ability to distinguish between sounds of varying *dynamics* (volume), *pitch* (high, low or in between) and rhythm.
- Aural **memory**: the ability to recall a series of sounds.
- Aural **sequencing**: the ability to place sounds in a given order; for example, highest to lowest or softest to loudest.
- Aural **imagination**: from the ability to predict what will come next in a series of sounds, to creating stories from sounds; for example, students might create soundscapes such as a thunderstorm from percussion instruments.

The activities described below each contain at least one of these features. They are based on the theories of Zoltan Kodaly (1974), who believed in intense aural training, and Carl Orff (1950), who maintained that music combined with movement created the most effective learning method.

Kodaly was a Hungarian composer who developed a music system in the 1930s. His program went on to be implemented in all Hungarian schools, and was later adopted worldwide. It is based on the premise that the voice, being the one instrument everyone is born with, is the best instrument for beginning musical training. He combined this approach with the use of hand signals based on the *solfege* system.

The German composer Carl Orff developed his approach in the 1920s. It combines music, movement, drama and speech into lessons that simulate a child's world of play.

Putting theory into practice in the early childhood classroom

Getting started

Begin each day with a catchy song that sets a positive tone in the room. Examples include, *The good morning song* and *The welcome song* (these and other Kodaly songs can be downloaded from <www.kodalydownloads.com.au/songs.aspx>). Similarly, end the day with song (e.g. *The good afternoon song* (Kodaly). You can add movements and body percussion so that children begin to gain an understanding of *beat*.

Introducing beat

Beat is the basis of all music and movement. You can introduce this by showing the students a drum and asking them: 'What is it? What do you think it is made of? What shape is it? How do you think I play it? Can anyone tell me how it makes the sound?' In this way you can extend vocabulary and use different questioning techniques to elicit answers. Then tell them: 'I am going to play a beat! Can you copy me?' Get the students to copy the beat by clapping, then change it.

The children are then asked to find the drum beats in their names. The teacher goes first. *Man-dy*, for example – that's two drum beats. Each child takes a turn with the help of the teacher to clap the drum beats in their names. With practise the children will be able to stand up when you ask: 'Who has one drum beat in their name? Let's check – are they right? Yes. Who has two?' This brings the concept of beat down to a personal level, and it is reinforced every time their name is used. It also assists in teaching one-to-one correspondence.

Listen to music every day

Listening to music is also very important. If you are studying a theme, ask the children to listen to a related song, then ask them questions about it. Immersing students in the language of the theme through music and literacy activities is a very powerful learning tool.

At other times, playing background music can also help children concentrate – although if you do play background music, check to see whether there are any children who find this difficult or distracting.

Responding to music

Music conveys emotion. Classical music can be used to elicit various responses from students. Play a piece of soothing music to the children, then ask them to draw what they imagine is happening. When they have finished, ask them to verbalise their response. In another session, play a contrasting dynamic piece and have students again draw their response and discuss it. Impress upon the students that there is no right and wrong – everyone can draw whatever they like.

This is a great activity for developing auditory imagination. Classic stories such as *Peter and the wolf* (set to music by Sergei Prokoviev) and *Carnival of the animals* (set to music by Camille Saint-Saens) can be read to the children. The students can recreate the stories with drama, then listen to the music and try to identify the characters.

Clapping

Clapping is another useful strategy. Clap a simple rhythm and ask the children to clap it back. Change rhythms often and, with practise, make them more complex. Use this as a lesson breaker or when you need the children to listen to instructions. Demonstrate two patterns together, saying: 'This is pattern one, this is two. Which one am I doing now?' With increased practise and greater familiarity with counting, you should be able to increase the number of patterns to four. As the children learn their songs by rote, you will be able to clap the rhythm pattern of the words and the children will be able to guess the song you are thinking of.

Teaching songs

The most effective way of teaching a song is to sing it in its entirety, then break it up into phrases that the students echo. Repeat the phrase before, then add on the next one.

The first song I teach my students is another Kodaly song, *I'm a peanut*. It's a great song to start with as, like most Kodaly music, it is designed to stick in the child's auditory memory. The children can sing the song a few times a day – as lesson breakers, before they go out to play, whenever there is an opportunity.

This song is actually a *cannon* (a round). Once the students have learnt it very well, you can divide the group into two, with one teacher taking each group. Then you can move onto three groups, then four. You can select the more competent students to actually take a group themselves. The aim, after a few terms, is for the children to sit in groups of six and sing the song themselves, as a round.

Always teach a song with actions. It helps to commit the song to memory and convey meaning. If you want to teach a new song and it has no actions, make them up. A new song can be added to the repertoire each week, but practice is the key.

The Australian Broadcasting Commission *SING* books are a wonderful resource. Order them each year as they include the song book, teachers' resource book and CDs containing backing tracks for performances. Many of these songs are ideal for thematic work.

Percussion instruments in the classroom

Percussion instruments can be played by every child, regardless of their musical background or abilities, and a range of them should be available in every early childhood classroom.

Getting the most out of your percussion instruments

Start with a song the students are familiar with – *I'm a peanut* is a good one to use. Introduce the term 'instrument', explaining that an instrument is anything we use to play music. Introduce the claves, or tapping sticks (see Figure 6.1). Explain that these are percussion instruments. Any instrument that is hit or shaken is a percussion instrument.Set the ground rules the first time you use the instruments. The students need to know that the instrument stays in front of them and they don't pick it up unless instructed to do so.

Sing the song first, then clap out the beat. Demonstrate the correct way to hold the sticks, then have students pick up their claves and tap them in time to the teacher's clapping.

Repeat the activity at least two or three times.

You can then move on to other familiar songs. When they know the beat really well, divide the group into two and have each group play the beat in turn.

Figure 6.1 Children playing the claves

Now other instruments can be introduced. This is when the instruments can be used for vocabulary extension and language development.

Take out the instruments one at a time. Examine them closely. Ask the students: 'Does anyone know the name of the instrument? What is it made of? Can you tell me its shape? How does it make the sound? What type of sound does it make? Is it loud or soft? Does it make a sharp sound, rattling sound, tinkling sound?'

Use this process to examine all the usual instruments such as the tambourine, triangle, castanet, maracas, woodblock, cymbal and bells. You can then introduce more unusual instruments such as the guiro, didgeridoo, rainmaker and bull roarer. Tell the children to close their eyes and ask them to describe what they think of when they hear the sound made by each instrument.

Games with percussion instruments

Move like the instrument

Ask the students to close their eyes, then select an instrument from the box.

Play it and tell the children to move how it sounds. Select three students (who all have different moves) to come out the front and demonstrate. Repeat this with the other instruments. You will be amazed at the variety of the students' responses. Once they are very familiar with the instruments you can ask the students to close their eyes and guess the name of the instruments by sound.

Can you guess?

Students sit in a circle with the instruments all laid out in the centre. Describe an instrument; for example, 'It is round, it is made of wood and animal skin, it has metal bells on the outside'. Select a student to go and choose the instrument you are thinking of.

Playing the instruments

After playing the games, give the students percussion instruments to play. Be specific about how the children should hold and play them.

Select a well-known song, then ask the students to play along to the beat. Then group the students, with all the tambourines sitting together, all the triangles, castanets, woodblocks and so on. Then each group can play a section of the song, while the other groups listen.

The key is practise and familiarisation. When children are confident with a learnt piece they are happy to perform it for others. Remember, most children love to perform and show off what they have learnt (see Figure 6.2).

Figure 6.2 A range of percussion instruments

For further thought ...

Like the students we teach, we also need a stimulating learning environment. As educators we need to review our practices and inject fresh ideas whenever we can. Below are some ideas on how to remain energised as an educator teaching music and movement.

- Inviting dance performance and music groups to your school or centre will provide lots of opportunities to build on the skills learnt. These groups often leave support material for you to use in later lessons.
- Keep up your professional development by attending courses you are interested in. A highly recommended one is the Kodaly course, because it is based on the premise that the voice, being the one instrument everyone is born with, is the best instrument for beginning musical training. Kodaly combined this approach with the use of hand signals based on the *solfege* system (doh ray me). There are Kodaly courses available throughout Australia.
- Orff courses are available in most states. For more information check the Orff website <www.ancos.org.au/main/index.php>.
- Book suppliers and music stores have books on the Kodaly and Orff methods. Or attend a course.

Figure 6.3 Music and movement

- The Dalcroze method, also known as Dalcroze Eurhythmics, is another approach music educators use to foster music appreciation, ear-training and improvisation while improving musical abilities. In this method, the body is the main instrument. Students listen to the rhythm of a music piece and express what they hear through movement. Simply put, this approach connects music, movement, mind and body. Information on Dalcroze and suitable courses are available online.
- Nursery rhymes and poems are excellent for developing rhythm and beat, so scour old bookshelves for some less frequently used examples. Children love the certainty of poetry and predicting what word comes at the end of each line. And they can make up new ones of their own.
- Make sure that you have enough instruments for all students and that you have multiples of each instrument type. This allows for group work later on. Try to purchase some of the more unusual instruments. These are very useful for developing the concept of tone. Look for some multicultural instruments as well, especially if you are studying the background cultures of the students in your centre.
- Be a keen observer! If you hear a song on the radio, see children present an item on TV, attend a dance or singing concert and see something you like, store it in your

memory for future use in your own music sessions. Many of the best performance ideas have been inspired from something seen on places such as YouTube.

- Finally, don't be afraid to try something new. Have a go and enjoy it. You will pass this enthusiasm on to your students … the joy is infectious.

Conclusion

A centre, home or classroom that embeds music and movement at its core is one that is both welcoming and stimulating. Children and adults alike will benefit from such an environment.

Playing with paint, clay and other media

Robyn Gibson

By learning and practising art, the human brain actually wires itself to make stronger connections. (Bower, 2004, p. 23)

Eleanor, the early childhood teacher, was exploring colours with her group of attentive four-year-olds. She held up a scarf and asked 'What colour is this?' Tom, who was sitting nearby, responded 'It's red.' 'No! It's not!' interjected Beau. Eleanor looked intently at the child, smiled and asked, 'Well, Beau. If it's not red, what colour is it?' 'It's more a burgundy colour' was the response.

Young children need to express themselves and communicate with others who share their world. They fulfil these intrinsic needs through personal expression, creative exploration and play. Art provides concrete experiences in which children of all ages may encounter and interact with their world in ways that are unique and have meaning to them. By physically manipulating art materials by, for example, painting a picture, modelling with clay or pasting a collage, young children become involved in the sensory pleasures of the *creative process*. Through this process, they are able to connect to their own feelings and inner thoughts and begin to make sense of the world around them. This creative and artistic process is truly inviting to young children. There is no right or wrong way of doing things, simply an opportunity to experiment, explore and discover for themselves:

> *When children feel a sense of accomplishment and self-confidence through artistic exploration, they experience feelings of personal satisfaction and positive self-image. Nurturing the arts in the early childhood classroom should be considered essential simply because of the richness it brings to children's lives.* (Edwards, 2002, p. 3)

Creativity and the creative art process

Young children are just beginning to discover the world of visual arts, and their creative efforts need to be acknowledged and respected. In order to foster each child's creative potential in art-making, it is imperative that they are in a supportive and nurturing environment that values both creativity and the creative process. But why is creativity so important?

We live in an age of rapid technological change. Today's children will face contemporary issues that we cannot envisage. Moreover, solutions to these problems do not even exist, and it is only through educating creative individuals that humanity can continue to advance. Richard Florida (2002), in *The rise of the creative class*, argues that creativity is inextricably linked to technological innovation and economic prosperity. If we hope to 'produce individuals who will succeed in our complex and rapidly changing world [then] the focus must remain on creativity as an essential capacity' (Gibson, 2010, p. 612).

So, what is creativity in relation to the visual arts? Historically creativity has been associated with Plato's visitations of the muse, or serendipitous inspiration. If we were to follow behaviourist B. F. Skinner's theories, when children are painting or drawing or sculpting then we would simply wait for something that we judge is creative to happen, and then reward it with stickers and stamps. While there is no definitive definition of creativity, we do know that in any area it involves boundary-pushing, inventing, boundary-breaking and aesthetic organising (Eisner, 2005). Creativity involves the ability to create meaningful, new forms. It 'uncovers, selects, re-shuffles, combines and synthesises already existing facts, ideas, faculties and skills' (Koestler, 1964, p. 120).

Csikzentmihalyi (quoted in Levinson, 1997) maintains that

> *creativity refers to people who experience the world in novel and original ways … individuals whose perceptions are fresh, whose judgements are insightful, who make important discoveries that only they know about.* (p. 447)

Perkins' (1988) explanation is perhaps more encompassing of the average person, since he believes creativity is simply 'using ordinary resources of the mind in extraordinary ways' (p. 36).

While there is no agreement on what exactly creativity is or, in fact, where it comes from, we do have an exhaustive list of characteristics and personality traits associated with creative individuals. E. P. Torrance's (1970) uplifting 'The creative spirit profile' should resonate with those working in early childhood classrooms:

> *Creative children look twice, listen for smells, dig deeper, build dream castles, get from behind locked doors, have a ball, plug in the sun, get into and out of deep water, sing in their own key.* (p. 24)

Unfortunately some parents and caregivers do not always look favourably on the behaviours we often associate with creative individuals, individuals who usually want to 'do their own thing.' What is more discouraging is the burgeoning research that documents the decline in creative thinking as children advance through their school years. Citing Ken Robinson's (1999) report: at the age of five, a child's potential for creativity is 98%; by the age of 10, this figure has dropped to 30%; at 15 it is just 12%; and by the time we reach adulthood, our creativity has plummeted to a mere 2%.

How do we as teachers combat this decline? We begin by

> *valuing creativity and using it as a high-placed criterion for sorting out what goes in and should come out of curricula – curricula currently too jam-packed to allow substantive creative meaning making.* (Cornett, 1999, p. 23)

According to teacher Alane Starko (1995):

> *The most reasonable course of action is to support and encourage characteristics associated with creativity whenever possible. At the very least, our classrooms should be more flexible, responsive, attuned to the wonder around us. At best, we may make a difference in the creativity of a young person who may one day bring greater knowledge or beauty into the world.* (p. 93)

Why include art in the early childhood curriculum?

Ernest Boyer (1987), of the Carnegie Foundation for the Advancement of Teaching and acknowledged expert on the Arts, views art as

> *one of mankind's most visual and essential forms of language, and if we do not educate our children in the symbol system called the arts, we will lose not only our culture and civility, but our humanity as well.* (p. 16)

Children are social beings who

> *are intrinsically motivated to exchange ideas, thoughts, questions and feelings, and to use a range of tools and media ... to express themselves, connect with others and extend their learning.* (DEEWR, 2009, p. 38)

Art is an important means of self-expression in the young child, since it encourages play, experimentation, spontaneity and imagination. Art-making is emotionally satisfying, as it can communicate unconscious impressions otherwise unsayable

(Feldman, 1996). Children can express joy and happiness, or fear and frustration, through their art activities. In terms of cognitive processes, they can use art to clarify concepts, develop problem-solving skills, enhance memory and observational skills and begin to use language systems to record their representations of their unique world. It permits each individual, in Maxine Greene's (1995) words, to create 'as if' worlds, places where we see the world afresh. But art is also concerned with physical activity and will hone children's fine motor skills as they manipulate crayons, brushes, clay and an endless array of art materials. According to Linda Carol Edwards (2002) 'each child responds to art materials in ways unknown and unexperienced by anyone else' (p. 157).

Art pedagogy

Art-making continues to be a volatile topic within early childhood education. According to Felicity McArdle (2003) 'the old taboos around directed instruction in the Arts ... are powerful and enduring' (p. 35). Many teachers find themselves faced with a pedagogical dilemma. Should they allow children freedom for self-expression, or should they offer instructions in art skills and techniques? The laissez faire or non-interventional model remains attractive to many teachers working in the early years. In adopting this approach, teachers are adhering to the belief that a child's creativity may be dampened, if not retarded, by adult intervention. As a result, young children are simply presented with an assortment of art and craft materials and left to 'explore.'

The fear that giving children explicit art instruction may conflict with 'natural' art development has been countered by a number of art educators. Mona Brookes, founder of the art teaching method *Monart* (see <http://monart. com>) differentiates between symbolic art development and the ability to create representational art. She believes that most children will not 'automatically' discover the artistry of making realistic drawings without direct instruction.

If children are to use art to make sense and express meaning, then teachers need to know and teach basic art concepts. But as with any of the Arts, visual arts needs to be experienced before it is deconstructed into its component parts (Cornett, 1999). It is only after children have been fully engaged in the process of discovering the visual arts, and their desire to learn more has been whetted, that teachers may consider introducing elements and principles such as lines, shapes, textures and colours found in picture books, in illustrations and in the natural world, when natural opportunities arise.

A number of basic visual arts concepts are illustrated in Figure 7.1:

- **Colour**: specific hues. It has three properties – *chroma*, *intensity* and *value*.
- **Line**: continuous linear mark. All lines have direction, such as *horizontal*, *vertical* or *oblique*.

Figure 7.1 Visual arts concepts

- **Shape**: a two-dimensional, self-contained area of *geometric* or *organic* forms.
- **Texture**: the surface quality of an object, either *tactile* or *visual.*
- **Space**: the area an object takes up (*positive space*) and that surround shapes and forms (*negative space*). (Gibson & Ewing, 2011, pp. 138–9)

The term 'art basics' should not, however, be confused with what Jenkins (1986) calls *dictated art*. Exercises in copying, colouring-in and the use of stencils and templates should be viewed as activities masquerading as art (Gibson & Ewing, 2011). In fact, research on the effects of such practices has found that children who engage in them too frequently lose sensitivity, creativity, self-confidence and independent thinking. Where is the creative problem-solving involved with 'staying inside the lines'? Where is the sense of pride and achievement when the decision-making options have been removed? If such materials are to be used *occasionally* then we should not term them 'art.' Early childhood teachers should also consider making creative adaptations to this 'fill-in art.' For example, teachers can

> *encourage adding lines, using unconventional colours, tearing off sections, pasting materials on, adding captions or titles, and scrunching the paper to [create] texture.* (Cornett, 1999, p. 54)

There is little doubt that early childhood teachers require a sound theoretical and philosophical foundation for art education before they can take on the role

of facilitator and helper and provide authentic art experiences that assist young children to develop their artistry.

Why do children draw?

> *Artistic learning should grow from kids doing things; not just imitating but actually drawing … on their own.* (Brandt, 1987, p. 32)

Drawing is a natural form of human communication. Often children draw because they lack the words to communicate their thoughts and feelings. They are also very clear from an early age that drawing is very different from writing. Art provides a non-verbal language for self-expression for the young child. According to Edwards (2002), the answer to the question 'Why do children draw? is not as important as the fact that they *do* draw, they *do* paint and they *do* glue things together' (p. 156).

That said, children's drawings provide evidence of brain growth and development. Rhoda Kellog's (Kellog & O'Dell, 1967) research into children's artistic development is noteworthy in that she spent 20 years collecting and analysing over a million samples of children's drawings from around the world. She found that the artistic journey from random scribbles to the formation of enclosed shapes to the use of graphic symbols is universal and predictable. She concluded that 'all children everywhere draw about the same things in the same way at the same age' (p. 95).

Likewise, Viktor Lowenfeld's work in *Creative and mental growth* (Lowenfeld & Brittain, 1987) has significantly influenced how we understand the artistic process. Lowenfeld & Brittain (1987) extended Kellog's research and identified stages of development that occur naturally in all children. These stages are often referred to as *scribbling, pre-symbolism, symbolism* and *realism*. The first three stages are discussed in some detail in the next section, as these relate specifically to children in the early childhood years.

Stages of artistic development

Scribbling

Beginning around one and a half years of age, *scribbling* represents the child's first self-initiated encounter with art. Initially children scribble in a random manner simply by moving their arms and making marks on a surface, as illustrated in Figure 7.2.

Figure 7.2 Random scribbles

When children discover the relationship between these movements and the marks on the paper, they gradually begin to control their scribbles and combine lines with shapes to create various patterns and designs, as illustrated in Figure 7.3. Letters, often those associated with the child's name, may also be incorporated into these early drawings.

Figure 7.3 Controlled scribbles

As the child gains control, they will begin to engage in imaginative play by naming their scribbles; for example, 'This is my baby sister.' To adults, these drawings may be unrecognisable, but to the child making them, they have meaning:

> *Just as the babbling child makes the sounds that will, in combination, become words, the scribbling child makes the lines and shapes that will, in combination, become recognizable objects.* (Wilson & Wilson, 1982, p. 2)

Pre-symbolism

At about three or four years of age, children begin to draw 'tadpoles', that is, combining a circle with one or more lines to represent a human figure, like those in Figure 7.4. These 'tadpole' drawings gradually become 'head–feet' symbols.

There are a number of theories as to why young children omit body parts in these *pre-symbolism* drawings, and there is considerable evidence to suggest that children who draw such figures are certainly able to identify body parts when asked to do so. However, the concept of creating a realistic likeness of a person has not yet occurred to them (Wilson & Wilson, 1982), and will not surface until the age of seven or eight.

Children of four or five will begin to experiment with various ways of drawing the human figure. Often the head is drawn larger, because that's where the important functions of eating and talking occur. Things that are important to the child are larger, more detailed, elongated, like the floating head in Figure 7.5.

Figure 7.4 'Tadpoles'

Figure 7.5 A floating head

Given the egocentric nature of this age group, the subject of the drawing will often be the child themselves. Thus art becomes a crucial tool whereby emerging concepts of self can be expressed.

Symbolism

Around five or six, children enter the *symbolism* stage. That is, they have developed a selection of symbols for objects in their environment that are important to them. Once a child has developed a definite symbol or *schema*, it will be repeated over and over again. Consider, for example, the smiley sun in Figure 7.6.

Prior to this stage, objects are seldom drawn in relationship to one another but typically seem to 'float' on the page. At five or six, children begin to use a *baseline* in order to organise objects in space. To show that these objects have a definite place on the ground, the child will line up people, buildings and trees along the bottom of the page. Later, they will draw a line across the paper to serve this purpose.

Another feature of this stage is the emergence of the *X-ray drawing*. This type of drawing is typically done when the inside is of greater importance than the outside. Children will often use this technique to show the inside of their homes or vehicles (see Figure 7.7).

Figure 7.6 Symbols

Figure 7.7 An X-ray drawing

The significance of stages of artistic development

It is important to stress that teachers should use these stages as a guide to understanding children's artistic development. Although the stages have been linked to chronological age (particularly from 18 months to six years), any number of factors may affect a child's development. To expect that a child at a certain age should be at a certain stage of artistic development is therefore inappropriate.

In fact, some researchers have challenged this view of developmental stages. Gardner (1999), for example, has postulated an art development in *waves* rather than stages. He believes that waves of knowledge become higher and higher in a specific intelligence area which results in it spilling over into another intelligence area. To illustrate, by the age of five children begin *digital mapping*, which involves the careful observation of numbers of fingers, legs and arms in their drawings.

Beginning with the simple element of line, toddlers soon discover how art tools such as crayons, markers and paintbrushes extend their hands and fingers to make marks, initially (at least) to the delight of their parents and caregivers. 'Drawing is the easiest medium for children to master, and quickly enables them to explain things with precision and detail' (McArdle, 2003, p. 49). Young children's drawings contain symbols of things that are important to them and as such serve as a communication tool closely linked to linguistic growth. As teachers, when we encourage children to draw and engage them in dialogue about their artwork, we are acknowledging that their marks have value and meaning.

Teacher activity

Collect samples of children's art from a number of age ranges. Examine them for clues such as stage/growth of development, use of media, graphic symbols, use of digital mapping or original notation. This will offer strategies to further understand why children of the same chronological age may produce very different drawings.

Process versus product

While there may be occasions when a finished product is the intended outcome of an art experience, this should not be the case when working in an early childhood environment. With young children, it is important to emphasise 'the process of knowing' (Cornett, 1999, p. 53), and allow adequate time for children to explore and experiment with materials and techniques. Linda Edwards (2002) proposes the following: *Throw out your old habits: It's the process that's important!*

- Put away the patterns – that is, the templates and stencils.
- Put the colouring books in the back of the cupboard, or better still, throw them away.
- Promise yourself that you can survive for a month without formula-laden, 'cookbook' art activities.
- Enjoy the freedom that basic art materials provide.
- Have faith in your own efforts, and in the creative attempts of your children.
- Acknowledge children's work, encourage the creative process and let your children know that you value their art in its own right.
- Place the emphasis on the process and the inherent joy children feel as they create.
- Remember that creative expression comes from within the child. (p. 160)

Edwards' last point should be highlighted. Engaging in the creative process enables young children to make sense and express meaning; its purpose is not to entertain parents or teachers. 'It is the inner audience that children need to learn to please' (Cornett, 1999, p. 53). The teacher or parent might also want to re-engage in the process too – get in touch with how it feels to paint, sink your hands into clay again and think about how it makes you feel.

Talking to children about their art

Given that your role is to offer authentic art experiences to your students, it seems incongruous that this should be described as 'teaching without teaching' (McArdle, 2001); but that is exactly what should occur in the early childhood classroom. You will be both observer and facilitator. You will be helping young children find art materials and assisting them when any problems arise. You will interact with them as they engage in their very personal art-making without passing judgement or insulting them by asking them to 'name' their drawing or painting (Thompson, 1990). So, if your role is that of helper, what do you say when talking to children about their art? How do you foster substantive communication? How do you encourage children to talk about their art and the artworks of others so that they become literate viewers?

Traditionally, a number of strategies have been and continue to be used by teachers in an attempt to elicit verbal comments from children about their art (Gibson, 2002). Robert Schirrmacher (1998), in *Art and creative development for young children*, has identified six of the most common approaches used by adults to respond to children's art (see Gibson & Ewing, 2011, pp. 136–8, for a summary of these strategies). Researchers have identified concerns with each of these 'art dialogue' approaches. For example, much of children's art is private and egocentric. Smith (1983) and Thompson (1990) argue that it is unwise

and may even be harmful to ask 'What is it?' of children who are making non-representational art. Lowenfeld (1968) maintains that a teacher's corrections or criticisms do not foster children's artistic growth but rather discourage it, while Schirrmacher (1998) believes that questions such as 'What is that supposed to be?' are abrupt and often very difficult for young children to answer. While early childhood teachers may occasionally use the probing technique – 'Tell me about your art', or 'What can you say about this?' – we would recommend that rather than looking for representation in children's art, teachers focus on the abstract, design qualities, or the 'syntax' of the art. With very little effort, teachers can use the aesthetic elements of design (see page 49) as a framework for talking to young children about their art (Gibson & Ewing, 2011).

Gardner's spatial intelligence

The role of the early childhood teacher is to provide children with a range of activities and art materials that encourage intellectual growth and support the development of spatial intelligence. Spatial intelligence involves the ability to perceive the visual–spatial world accurately (Gardner, 1983). Architects, engineers, sculptors, painters and navigators are occupations that we commonly associate with a significant measure of spatial intelligence. This intelligence includes a sensitivity to line, colour, shape, form and space, the relationship between them and a comprehension of two- and three-dimensional shapes, objects and relationships (Gardner, 1983). It is not surprising that spatial intelligence is particularly evident in the visual arts:

> The enterprises of painting and sculpture involve an exquisite sensitivity to the visual and spatial world as well as an ability to recreate it in fashioning a work of art. Certain other intellectual competencies … contribute as well; but the sine qua non of graphic artistry in the spatial realm. (p. 196)

The children in our early childhood classrooms are already artists. As Picasso so famously remarked: 'All children are born artists. The problem is to remain an artist as we grow up.' By immersing young children in programs of artistic expression, we are not only supporting the development of their spatial intelligence, we are also providing them with an opportunity for self-expression, an emotional outlet and a truly rewarding experience (Lowenfeld & Brittain, 1987).

Materials for the visual arts

'Children advance tremendously in fine motor co-ordination through consistent, concerted use of a wide variety of art materials' (Armistead, 2007, p. 89). Early

childhood teachers need to provide the materials and the time for children to explore and experiment with them. When selecting art materials for early learners, we must ensure that they are accessible, plentiful and safe, allow for a variety of uses, and fit the developmental levels of the children (McArdle, 2003).

Drawing

For drawing, large *crayons* are ideal as they lend themselves to the fine motor skills of young children who need to practise holding art materials. Give children opportunities to explore differences between, for example, wax crayons and oil pastels. Large *markers* are also excellent as they are available in bright colours, are easy to hold and move smoothly across a surface. *Chalk* is another wonderful medium for expression outside the classroom, on paved areas, brick walls and so on. While there is a tendency in many art rooms to use white paper as a basis for drawing, remember that young children do not have any perceived ideas about what a drawing 'should' look like. Children should feel free to experiment and take risks in their artistic pursuits. Paper should therefore vary in colour, size, shape, weight and texture. Give them opportunities to think about the colour of the paper they are choosing, and why. Talk with them about how different colours make them feel.

Likewise, drawing does not necessarily need to be done flat on a table. Children can stand at an easel, or sit outside with a drawing board. After a trip to see the Sistine Chapel, one innovative preschool teacher taped art paper under the children's desks and had them draw lying underneath them in order to experience firsthand Michelangelo's process!

Painting

Although we may wish to expose children to all the art materials available, the aim of a quality art program is to empower children with a sense of mastery and control as they represent their knowledge in a tangible form. When painting, *tempura* paint is an appropriate choice as it can be mixed to a thick consistency so that it will not run down and off the page. *Watercolours*, on the other hand, tend to run together, and are difficult for young children to control.

Like drawing, painting can occur at an easel, at a tabletop or on the floor. As painting can become messy, wearing an old oversized T-shirt can be liberating. Children need to learn about palettes for mixing, clean water, the care of brushes, and cleaning up. When they understand the components of the artistic process, children can begin to take responsibility for their own actions rather than relying on their teacher to tidy up for them, or remove their paintings for drying.

Modelling

Clay provides young children with an opportunity to engage in the tactile pleasures of three-dimensional work. Commercially produced earthenware clay

is an inexpensive material that has a pleasant texture, ideal for sculpting and modelling. Many early childhood centres do not have a kiln for firing finished objects, but hand-built clay can be left to air-dry, painted with bright acrylic paints and then 'varnished' with a mixture of PVA glue and water. Once again, young children need to learn the routines of working with clay; for example, leftover clay can be rolled back into balls and sealed in plastic for future use.

Collage

While collage is popular in many preschools, early childhood teachers need to look at the rationale behind art activities that are designed for an end-product. Gluing and pasting is a learned skill, and it can be a difficult and frustrating process for very young children. However, many children enjoy the sensory and tactile experience of smearing glue, sticking their fingers together, smelling glue and even tasting it! Early childhood teachers need to be patient with young learners and provide them with unstructured pasting exercises, such as tearing coloured paper and gluing the pieces to larger pieces of paper or cardboard, until they have mastered this complicated process. Children aged four and over can be given paper that is easy to tear such as old magazines, telephone books and used wrapping paper to explore texture, colour and form in their artworks.

On creating representational objects, Edwards (2002) offers the following advice:

> *Remember that if you have to give more than introductory suggestions for using these materials, your idea is probably inappropriate for the skills your children need to handle the material. Select art materials because they are closely related to the child's level of development, and certainly not for the purpose of making cute, stereotypical products to be displayed with 20 or more others that look very much the same.* (p. 166)

Suggested art activities for the young child

It is somewhat problematic to offer art activities, since some teachers may mistake them for tried-but-true recipes, never moving away from the security they offer or valuing their own creative ideas. However, with a strong theoretical base early childhood teachers will see that what are suggested below are open-ended activities that can be adapted to suit children with varying developmental needs. If our aim is to engage the 'child as artist', then we must continually remind ourselves that the value of the art experience is in the *process* (Edwards, 2002).

Drawing

According to McArdle (2003), 'drawing should not be a one-off, succeed-or-fail exercise. We all learn to draw by drawing, and the more we draw, the better we get' (p. 50). It seems that human beings were born to draw, and young children are no exception. But as with any skill, such as learning a second language or playing a musical instrument, drawing requires practise to improve.

Regular drawing time

Set aside 10 minutes at a regular time each day for children to draw. Provide a limited range of drawing materials so they are not overwhelmed by choice, and encourage them to look at and talk about each other's drawings.

Teacher activity

Try the above activity yourself. Draw for 10 to 15 minutes each day, and in the process learn a variety of techniques and skills. Brookes (1996, p. 59) suggests 'five elements of shape' which can be taught directly and used to analyse any image:

- dots in different shapes (round, oval, elliptical)
- circles in different shapes (oval, kidney, round) that are empty rather than filled like dots
- straight lines
- curved lines
- angled lines.

Squiggles

Give each child a large squiggle on a piece of paper and encourage them to add to it with crayons, markers or pastels. Remind them that the end-product does not need to 'be something', but rather their expressive use of colour, lines, shapes and patterns is the aim of this exercise.

Lines are everywhere

Drawing is linear art made with a tool that can make a mark. Encourage children to find lines in the classroom, outside in the playground and in the local area. They can take photographs of these or take rubbings using crayons. Later in the classroom, they can incorporate these lines into another artwork of their choosing.

Magnify it

Children are curious creatures so provide magnifying glasses so that they can observe the different textures on surfaces, the shapes of leaves and flowers and the details of objects found in the playground. Encourage them to look, then draw what they see through the magnifying glass.

Painting

Young children need to be given ample opportunities to explore the process of painting and painting tools as part of their artistic meaning-making.

Playing with tools

Early learners should not be limited to commercial paintbrushes. Encourage them to experiment with the interesting effects that are achieved by using old toothbrushes, hair combs, plastic knives and forks, old deodorant rollers and sponges.

Techniques: Explore dabbing, blot painting (place blobs on paper and fold in half) and straw painting (blow blobs of paint using a straw to direct the flow of air and move the paint). Add sand, soap flakes or salt to the paint to give it texture; for example, salt creates a bubbly effect.

Mural painting

This is an excellent outdoor activity for young children. Give them buckets of clean water and large paintbrushes and allow them to 'paint' on an outside wall. Observe the interactions. Some children will paint in their own space, while others may engage in a more collaborative group activity.

Clay

Children enjoy the tactile and sensory pleasures of manipulating clay. And while many early childhood centres offer playdough and plasticine activities, far fewer afford their students opportunities to learn about *form* through claywork. As children work with clay, they will explore its qualities by pounding, rolling, pinching, flattening and squeezing and thereby acquire a 'language of hands' (Kolbe, 2001, p. 22).

3D structures

Ask each child to build the tallest structure they can using their ball of clay. Here they are learning about mass, height, weight and balance. Take photographs of both the child's process and the product. This documentation can then be added to the child's ever-expanding art portfolio (see below).

Textures

Encourage the children to make their clay ball into a slab either using their hands or a rolling pin. How might they create texture on the surface using only their hands, ie. pinching, pressing, scratching, etc? Now, how might they create texture using only an icy-pole stick, etc?

Inside out

Claywork offers children opportunities to learn about space. Ask them to move in and out of various spaces in the classroom. For example, make a circle around the chairs, sit under the table, etc. Then using their clay make something inside something else.

Teacher activity

Create art portfolios for each child in your class. Join two pieces of coloured cardboard together to create a folder. Take a photo of each child, enlarge to A4 size and paste on the front of their portfolio. Collect samples of artworks over the year. Date each and make notes about the methods the child uses as a means of self-expression. Photographs of any 3D work and of the child's artistic process should also be included.

For further thought …

Even young learners appreciate the interactivity of digital mediums. Encourage your children to experiment with interactive web-based programs that allow them to draw, colour, add pattern and manipulate images. Use a digital camera to capture children engaged in the creative process or the products of their art-making. These can form the basis of class books or displays, which both the children and their parents can appreciate.

Conclusion

We are all born with creative abilities, and young children are just beginning this creative journey of discovery. As early childhood teachers, we have a responsibility to value imagination and creativity in these early learners. Providing them with an array of art materials and leaving them to magically 'discover' their artistry should no longer be accepted as appropriate early childhood arts education practice. There is little doubt that in order for our students to grow up to become visually literate, creative problem-solvers, we must ensure that discovery, play and creative expression take centre stage in our curriculum.

CHAPTER 8

Playing with puppetry

Robyn Gibson and Victoria Campbell

Our teaching and education is to be built, then, on imagination. (Steiner, 1995/1924, p. 30)

I once ran a puppet 'playtime' workshop at a community outreach event in Sydney, where children (mostly four- to seven-year-olds) made various sea creature puppets and spent the afternoon playing with them behind a transparent screen. One of the boys was particularly outgoing with his shark puppet – after the session his mother told me it was the first time she'd seen him 'come out of his shell'. It seems that he was so engrossed in performing with his new character that he'd forgotten he was shy! (Kay Yasugi, puppeteer, personal communnication, September 28, 2011)

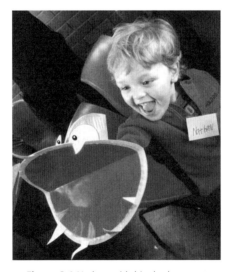

Figure 8.1 Nathan with his shark puppet

Puppets are like fantasy characters – they pretend to be alive. As a form of expressive theatre, puppets invite the early learner to invent, animate, act-through and identify with real and imaginary situations. In this very personal world, the child becomes the master as he controls what the puppet becomes, does and says (Linderman & Linderman, 1984).

Often puppets enable the expression of our innermost selves and feelings, through exaggerated action. When we watch young children play with puppets, we can catch glimpses of their true feelings, fears and imaginations in truly unique ways. Even 'shy' Nathan, or the child with language difficulties, can come alive through their puppet and its pretend world.

Puppets defined

A puppet is simply any inanimate object brought to life through movement and/or voice. A tea towel dragged from the oven door becomes a mermaid; a stick and a leaf engage in a heated debate about who shall be king; a sock becomes a sick dog needing help. These are but a few examples that illustrate how children engage in dramatic play through puppetry, and how they become puppeteers without adult prompting, from a young age. The appeal of the puppet for young learners is the way in which the puppet becomes the focus of attention, thus giving the child some distance from the dramatic experience and thereby allowing him or her to feel safe (Ewing & Simons, 2004). Working with puppets provides an arena for playful expression that may not be experienced in other forms of imaginative play; for instance, through a child taking on a *physical* role themselves in the drama. Supporting this view, Ewing and Simons (2004) maintain that

> *working with puppets encourages people to express their feelings, and it can provide a release valve for some students … encouraging children to share things that they may be unable to express directly'.* (p. 53)

The educational value of puppets

> *Puppet shows draw the young child into a story as they watch it unfold, grow and change.* (Dancy, 2000, p. 186)

Like oral storytelling (see Chapter 3), puppetry is a regular activity in many early childhood centres and schools because it provides 'a living play', imbued with imagination and fantasy. In a discussion about George Latshaw's *Puppetry: The ultimate disguise* (1978), puppeteer and educator Judith O'Hare (2005) states that:

115

Puppetry offers children the 'ultimate disguise' … The puppet becomes an extension of the child, yet separate from the child. The puppet speaks loudly, forcefully, aggressively, angrily, kindly, etc. It offers the child anonymity and provides an imaginative environment for shaping and reshaping experiences and accumulated information into a dramatic presentation. (p. 64)

Well-known art educators Earl and Marlene Linderman have detailed the many educational objectives associated with puppet-making. The following has been adapted from their text, *Arts and crafts for the classroom* (1984), a valuable book still found in many early childhood and primary libraries.

- Puppets encourage inventive, open and spontaneous communication.
- Puppets enable the acting out of social situations and cultural differences.
- A child can work through family and sibling relationships through puppet theatre.
- Puppets encourage the expression of personal feelings including anger, love, hope and secret wishes.
- Puppets can be used as an instructional tool to answer questions the child might have.
- Puppets encourage the building of self-confidence through the expression of ideas.
- Puppets provide opportunities to practise art learning through, for example, designing, modelling, painting, sewing costumes and building stages.
- Puppets help in the use of small muscle and hand–eye coordination.
- Puppets can be used as a tool for improving speech and verbal skills. For example, it has been found that children who usually stutter do not stutter when speaking through a puppet character.
- Puppets can be an introduction for the child to the world of the theatre arts.

Research has been conducted into the therapeutic aspects of using puppets with young children (Gronna et al., 1999). And puppetry has been used as a research tool to elicit talk with children (Epstein et al., 2008). Puppets can also provide a vehicle for deepening empathy and understanding for those challenged by physical, mental or emotional impairments (Gelineau, 2003)

Australian actor and educator Olivia Karaolis established the UCPlay Project in Los Angeles to work with children diagnosed with autism spectrum disorder and other developmental disabilities (see <www.ucpla.org>). Olivia uses a range of process drama forms and strategies to enable preschool, primary and transition students to find their voice, develop social skills and connect them with classroom learning. Not surprisingly, one of her key tools to enhance self-esteem, self-confidence and personal expression is the use of puppetry. She writes about this in Chapter 9.

Research indicates that imaginative play using puppets assists children in dealing with medical trauma and in processing emotional or social problems. In fact, a puppet becomes a risk-free channel for releasing a child's fears, aggressions or frustrations, and this can result in greater self-confidence and enhanced self-worth. Although the therapeutic aspects of working with puppets is well documented (see Bernier & O'Hare, 2005), there is limited research, particularly in the Australian context, into the effects that puppetry has on early childhood learning and development.

One study that sought to address this imbalance was an investigation by Veronicah Larkin (2000), which looked at how puppetry was incorporated into early childhood programs by teachers and caregivers in long day care centres in Sydney. Forty children between two and five years old, and six caregivers, were involved in the project over a five-month period. Findings from the study indicate that young children, when given the opportunity to explore all areas of puppetry from the creation of puppets, to animation of puppets, to scripting puppet performances, can

> *use puppetry to think through problem-solving issues associated with the design, construction and staging of puppet shows. They can also use puppetry to think through and resolve the challenges associated with shared dialogue, conversational interaction and narrative. Importantly, young children can observe, plan, debate, experiment, reflect, revise, reassess and revisit a range of puppetry experiences as they think through puppetry.* (p. 110)

Larkin observed that multiple layers of learning occur when puppetry is included in early childhood programs. However, she warned that 'a puppetry curriculum strongly directed towards the fulfilment of specific adult expectations may lead to a limited and constricting curriculum for young children'(p. 110). Furthermore, Larkin emphasised that one of the powerful ways in which children engage in the world of puppetry is the 'strong belief in the separate identity of the puppet' (p. 110), and that caregivers need to understand the reality of the puppet, even if it is a found object rather than a structured puppet as such.

According to Rahima Baldwin Dancy (2000), a Waldorf early childhood educator, puppets and puppet shows provide many advantages for the early learner:

> *When stories and fairytales are translated into cartoons or movies, they lose their evocative quality and are often too powerful ... for young children. But when stories are acted out in front of children using stand-up puppets or marionettes, the experiences have a very calming and healing effect.* (p. 187)

Types of puppets

There are many different types of puppets. Some require very simple construction, while others are too complicated for young children to make or master. The following list has been adapted from Ewing and Simons' *Beyond the script: Take two* (2004, pp. 54–5) and the Puppet Studio website.

- **Finger puppets**: These simple puppets are often most appropriate for early learners. Old cloth or rubber gloves can form the basis for the puppet, they can be constructed from felt or they can be knitted. They can be decorated in various ways using markers, threads or found objects. Another version involves creating the puppet's torso from stiff card; two fingers then become the puppet's legs. Simple stages can be made from large shoeboxes.
- **Pop-up puppets**: This puppet has a cone and a rod through it. By attaching the puppet to the top of the rod and then putting the rod through the cone, the character appears and then disappears.
- **Jumping Jack puppets**: Jumping Jacks have four stings running from the four limbs of the character. These strings are joined at the base of the puppet. When the strings are pulled, then released, they bring the arms and legs of the puppet up and down.
- **Hand** or **glove puppets**: One of the most popular and versatile types of puppet construction is the hand puppet. Usually three fingers on one hand become the neck and two arms. Heads can be made from a variety of materials, such as papier mache, old tennis balls, polystyrene balls with features glued or pinned on, potato heads with vegetable features pinned on or egg carton sections fastened together. These puppets are 'probably the best to use for scripted plays, when stages, scenery, etc. can be used as well' (Ewing & Simons, 2004, p. 55).
- **Sock puppets**: Fingers are placed into the toe section, while the thumb is placed into the heel of the sock. By making and releasing a fist, the puppeteer brings the puppet to life. Begin with an interesting old sock – consider an unusual texture, pattern or colour. A mouth, teeth, a tongue and other facial features can be added using scrap materials.
- **Rod puppets**: In most cases, the controls of a rod puppet come from below. Sticks, dowel or wire manipulate the puppet's neck and hands. Although too complicated for young children to construct, rod puppets offer insights into other eras and cultures. For example, *Bunraku*, a traditional puppetry of Japan, uses nearly lifesized figures. Each puppet requires three puppeteers, who wear black and hoods, to manipulate it.
- **Shadow puppets**: These puppets are made flat and fastened to rods or sticks. They cast a shadow when the puppeteer manipulates them between a light source and a screen. As the puppeteer moves the puppet in and out of the

light, its silhouette grows and shrinks. A simple way to begin is to work with an overhead projector. Figure 8.2 shows an Indonesian shadow puppet.

- **Marionette** or **string puppets**: Marionettes are probably one of the most difficult forms of puppetry to manipulate effectively, since the puppets hang on strings and are worked from above. A well-designed marionette has eight basic strings in order to create plenty of movement and action.
- **Ventriloquist figures**: These sophisticated puppets are often seen on children's television programs and are used as learning aids in early childhood classrooms. Although ventriloquism takes lots of practice, young learners enjoy interacting with puppets that can talk!
- **Masks**: Masks have been included in this list since 'they serve as inanimate representations of people or ideas drawn from life' (Ewing & Simons, 2004, p. 55). Masks can be quite complicated and time-consuming – for example, papier mache masks – or relatively simple, including full-face, half-face or eye masks constructed from cardboard or stiff coloured paper and then decorated with various materials. For example, when creating 'My Australia' masks for a multicultural unit, children incorporated rice (Asian), tea (English), dried pasta (Italian), red, black and yellow fabric (Indigenous) and corrugated cardboard (to represent corrugated iron – Outback), into their highly individual masks (see Gibson & Ewing, 2011, p. 188).

Figure 8.2 Indonesian shadow puppet

Puppets and cultural understanding

Throughout civilisation, puppets have been used for entertainment, communication and social commentary. The term 'puppet' is derived from the Latin *pupa*, meaning 'doll.' Many countries had touring puppet theatres. Perhaps the most famous in Western culture is *Punch and Judy* which was first performed in England in 1660. The story of Punch fighting his opponents and knocking them out, although violent, has delighted children of all ages for centuries.

Puppets are still an integral part of many cultural activities around the world. By exposing young learners to the artistry of traditional puppets, we can begin building bridges to cultural understanding and appreciation. Here are a few examples:

- Czech Republic: marionettes
- England: *Punch and Judy* hand puppets
- Indonesia: *Wayong Kulit* shadow puppets
- Italy: Venetian carnivale string puppets
- Japan: *Bunraku* (see page 118).

Erth, a physical and visual theatre group, uses a unique blend of puppets, visual effects and multimedia to take audiences to the 'mysterious heart of Australian imaginings' (see <www.erth.com.au>). Performances such as *The Nargun and the Stars* (2009) and *I, Bunyip* (2011) introduce children to authentic stories passed down in Indigenous communities for hundreds of years. According to the company's artistic director, Scott Wright (2012, para 3), 'these stories are part of people's lives, the fabric of their community and identity'.

The cultural significance of puppets is further acknowledged by Kay Yasugi (personal communication, September 28, 2011), a puppeteer who runs puppetry workshops and performances through her company, Pupperoos. Here she describes her experience working on a community arts project in Cambodia:

> *A highlight was the Giant Puppet Project ... where I worked with children from various schools and charities. One particularly memorable experience was making 'Judge Rabbit' (a beloved character in Cambodia). The group included young children from expatriate families as well as children from the Landmine Museum. Building the puppet together became our one goal, despite language barriers, age (we had children as young as three participate) and physical disabilities (some of the children were landmine victims) ... Even though the conversations consisted of French, English, Khmer (and some pantomime), we all understood each other ... This project showed me that puppetry can be an invaluable way to connect with people of all ages as well as giving them a unique platform for creative expression. Puppetry also has the power to unite people while opening up opportunities for communicating between different cultures and celebrating our differences along the way.*

Figure 8.3 Judge Rabbit

Dramatic play and puppetry

The Early Years Learning Framework states that

> *play provides opportunities for children to learn as they discover, create, improvise and imagine ... play provides a supportive environment where children can ask questions, solve problems and engage in critical thinking ... In these ways play can promote positive dispositions towards learning.* (DEEWR, 2009, p. 15)

There are numerous forms of play that engage children's imaginative responses. Dramatic play using puppets is one that provides children with opportunities to investigate the world and develop learning through enactment. Children explore both fictional and non-fictional situations by taking on a role within a dramatic context. Mendoza & Katz (2008) define dramatic play as

> *play that involves pretending or the use of symbols that stand in for that which is real: one child becomes a dog and another child its owner; a puppet speaks for a child; a pile of blocks represents a cave for bears.* (p. 1)

Incorporating puppets is a highly effective way to engage young children in dramatic play.

Using puppets in dramatic contexts

Most educators would agree that puppets can be used in a variety of ways to increase learning in the early childhood classroom. The desire to playfully communicate through the puppet often sees children exaggerate vocal and physical forms of communication as they bring the puppet to life. Puppets used in this way provide a unique tool to develop young children's expressive communication skills. The Early Years Learning Framework suggests 'puppetry, role play and dramatic play are vehicles through which young children reflect on, represent and communicate their experiences' (DEEWR, 2009, p. 2). Furthermore, for children who are shy, withdrawn or less verbal than other children, puppetry is a means to increase participation in early childhood environments (Salmon & Sainato, 2005).

Storytelling with puppets

Teacher storytelling

When puppets are used in oral storytelling activities they provide a unique form of visual stimuli that readily engage young audiences. They enable teacher-storytellers to explore new dimensions of creativity while assisting narrative understanding in the early childhood classroom. Because attention is focused on the puppet rather than the teller, first-time teacher-storytellers can gain confidence as they develop their storytelling skills. And when the teacher uses puppets in storytelling, they are modelling ways to bring puppets to life for their students.

There are several ways a teacher can integrate puppets into a story. First, the teacher can simply use a puppet as the central character in any story. For example, a *wolf* puppet may be used in the traditional telling of *The three little pigs*. The teacher as narrator tells the story and also takes on the role of the pigs; however the puppet, as the wolf, delivers lines such as 'I'll huff and I'll puff and I'll blow your house down!' (Of course, the teacher could also incorporate *pig* puppets, so that the pigs and wolf act out the story, leaving the teacher in the role of narrator.)

Second, the wolf puppet in this story could be used to interject, interrogate and/or tell the story from his point of view. For example, he might say 'Let me tell you about what those three little pigs did to me!' This approach draws attention to the narrative structure and 'the invisible voice of the other' (for an example of this type of story see Scieszka & Smith, 1996). In this example the puppet is a type of story *provocateur*, a catalyst for audience participation as children enter into debate with the teacher and the puppet about how the plot should unfold. Here critical thinking and critical literacy skills are being developed as children 'play' with the story.

Children storytelling

As already stated, the use of a puppet draws focus away from the storyteller. The puppet can assume vocal qualities and character traits that may be difficult for children to adopt if telling a story in the usual manner. This provides an opportunity for a child-storyteller to develop their storytelling skills, because a puppet offers them space to play within the story, knowing attention will not be fully on them. Puppets can be used by the individual child-storyteller, in small groups of children or as a whole class. They can be used to act out, tell, or improvise scenes from various stories.

Tiddalik: A classroom activity

Here is an example of edging students into storytelling with puppets using the Australian Aboriginal legend of Tiddalik (Troughton, 2004). This is a teacher-led, small group or whole class activity.

First, divide the class into groups of three children. Each group is given a critical moment from the story to perform. In this learning experience, one child is responsible for manipulating the Tiddalik puppet, while the other two children take on physical roles within the given scene and interact with the puppet. Here is an example of the *bare bones* of the story – although there are several different versions, essentially the narrative plot points remain the same:

- Tiddalik, a giant frog, wakes up thirsty.
- He drinks all the water in the billabongs, creeks and rivers.
- The animals suffer as the land becomes drought-ridden.
- The animals try to make Tiddalik spill the water from his mouth by making him laugh.
- Many attempts are made by various animal groups, but all fail.
- Finally an eel, platypus or other animal (depending on the version of the story) make him laugh.
- Water returns and Tiddalik is punished; he is either turned to stone, or shrinks and hides in the river rushes.

If there are seven critical scenes, seven chairs, one for each of these scenes, are placed in a circle. The groups are arranged in chronological order around the circle. The child from each group who is responsible for manipulating the Tiddalik puppet sits on the chair. The other two children take on the role of the other animals suggested by the scene. For example, in one key moment the kangaroos attempt to make Tiddalik laugh. The teacher narrating might say, 'The kangaroos tried to make Tiddalik laugh by singing a song'. The two children in that group take on the role of the kangaroos singing while the student

holding the Tiddalik puppet uses voice and movement to bring grumpy, greedy Tiddalik to life. An example of his response might be 'stop that terrible singing … you are not funny … go away!' As the teacher narrates the story each group performs/improvises their scene in order around the circle while the other groups observe. The teacher encourages students to improvise dialogue and to explore various movements and vocal qualities to bring Tiddalik, the puppet, to life.

Creating puppets for other animals in the story can extend this technique, allowing the children to tell the story entirely through the use of puppets. Other extensions might include:

- Groups of three or four children tell the Tiddalik story with puppets.
- Individual children tell the story by themselves using puppets.

For this activity to be effective, the children need be familiar with the narrative structure and/or the *bare bones* of the story (see Chapter 3, 'Playing with storytelling'). This provides a secure framework for their improvised puppetry experiences.

Making simple puppets with young children

By making puppets from a wide range of found and/or recycled materials, young children can begin 'to develop their awareness of how an animate object can symbolise a particular character or concept' (Ewing & Simons 2004, p. 53). Making puppets does not need to be expensive; readily available materials can easily be transformed into a character. For example, Gary Friedman and Sharon Gelber run puppetry workshops that use nothing apart from brown paper and a light source to create engaging puppetry performances.

Puppet-making activities with young children

Here are a few examples of simple puppets that have been used successfully with young learners.

Newspaper puppets
Status is explored in this very simple 'any object can become a puppet' activity. The dramatic tension inherent in the master and servant scenario leads to effective motivation and engagement through improvisation.

Children take a piece of newspaper and fold, scrunch or rip it in anyway they like to create a puppet. Sitting in pairs, facing each other, they give their 'newspaper puppet' the role of either the king or the servant. The child who is king commands the servant to carry out a number of tasks; for example, sweep the floor, polish shoes, wash dishes, bring

food! The servant must obey. The children then swap roles. The caregiver can encourage or model the use of voice and movement to suggest the different characters. For example, a loud deep voice combined with slow deliberate movement may be an appropriate for the king. To create more tension the servant may be lazy and unwilling.

Paper-plate puppets or masks

Often paper plates are used to create simple masks. Make sure that the position of the eyes is cut before the young child decorates their mask. Masks can focus on a specific theme or topic currently being studied in the classroom. For example, when focusing on 'feelings', young children could use warm colours, such as red and orange, to signify anger, while bright colours like yellow could represent happiness. It is important to keep in mind that colour symbolism is culturally specific, which in itself is an interesting topic for classroom discussion.

Pieces of fabric, strips of leather, lengths of crepe paper and so on can be used to create arms, legs or a tail, thereby changing the mask into a puppet. A wooden chopstick or ruler can be attached to the back to enable movement.

Paper-bag puppets

Paper bags come in all sizes. Paper-bag puppets can be as simple or complicated as you like. The bag can be used in two ways: the base end has a flap that becomes the mouth, for a bird or fish, for example, or the flattened end of the bag is folded over and the face is drawn on the flat bottom of the bag. The edge of the folded bag then becomes the mouth (see Figure 8.4). The bag can be decorated with crayons, markers, paint, coloured paper and all kinds of scrap materials.

Bottle puppets

Like paper bags, plastic bottles come in a range of interesting shapes and sizes. Select a plastic water bottle, soft drink bottle or detergent bottle (ensure that it has been

Figure 8.4 Paper-bag puppets

thoroughly rinsed out). Facial feature such as eyes, eyebrows, nose, ears and mouth can be made from coloured paper, buttons, egg carton sections and so on, and pinned or glued onto a polystyrene ball or old tennis ball to form the puppet's head. The puppet can then be 'dressed' using fabric scraps, pieces of lace or ribbon, used gift wrapping paper and the like. At this stage, it is important for children to invest their puppet with a name and begin the process of exploring particular ways of speaking and moving that will become the essence of their character (Ewing & Simons, 2004).

Cutlery puppets

As already mentioned, puppets can be made from just about anything. For example, in the recent Sydney Theatre Company production, *Mr Freezy*, real food, kitchen utensils and packaging were transformed into believable characters.

- Drawing materials can be used to change a wooden spoon into a simple puppet (see Figure 8.5). Its long handle makes it ideal for exaggerated action and movement.
- Use a plastic spoon as a base. A face can be cut from a magazine and attached to the curved part of the spoon. Wool, raffia, cotton wool and so on can be glued on to represent hair.

Figure 8.5 Cutlery puppets

Making puppet show stages

Any structure that will cover the puppeteers as they perform is a puppet stage. It is a great idea to have a puppet stage permanently set up in the classroom so that the young child can play with their puppet and practise the tone and pitch of their puppet's voice, how it moves and how it interacts with other puppets. These performances can be impromptu, or time can be devoted to staging a play.

Making stages

Probably the simplest stage is a curtain stretched across the corner of the classroom that is tall enough for the children to stand behind. But there are any number of suggestions for stages:

- A cloth can be hung in front of a table and the children can sit under the table. This is a good alternative for hand or rod puppets.
- Use a doorway with a curtain extended across it.
- Turn a table on its side. The puppeteers perform behind the tabletop, holding their puppets above the edge of the table.
- Use a long piece of dowel, or a broomstick. Staple a cloth to it horizontally and hang it between two chairs.
- Cut off the fourth side of a large appliance box and open two of its sides. Cut the stage from the other side.

Presenting puppets

Young children need lots of opportunities for spontaneous play and experimentation with puppets before they will be ready to stage a planned performance. Encourage them to explore larger-than-life movements such as up–down, side-to-side, in a circle and bending forward and back. Allow small groups of children to work together to invent a simple plot. Professional puppeteers have suggested that certain dual characterisations can often be very successful – silly/serious, cowardly/brave, kind/selfish. Puppet needs are dictated by these roles and these needs can change instantly. For example, a 'silly' puppet will have different needs from a 'serious' one and this will then dictate their roles within the puppet play developed by the children themselves. R. Phyllis Gelineau (2003) maintains that:

Children enjoy telling more about their puppets … allow puppets to be asked questions by other puppets. Silly is fine. Some children are particularly fond of puppets that are not too bright. (p. 134)

For further thought …

Think about how technology could be involved with puppetry. For example, the children could be filmed as they introduce their puppets. This could be played afterwards and discussed.

As Lea Mai writes (see Chapter 4), puppets are about exploring and building relationships. Watch the following video about the interaction between a 'puppy puppet' and a little girl: <www.neatorama.com/2011/10/03/puppet-puppy>.

Conclusion

Much of the enjoyment and surprise in puppet-making is in the creation and the discovery of what will take place. Which activity is more fun, inventing the character or manipulating it? Young children are drawn to the magic of puppetry, whether the puppet is just a paper plate or a sock, since 'a mere suggestion has caused the puppet to be filled with life and exert a universal appeal' (Educational Drama Association, 1981, p. 1). In the early childhood centre and classroom, puppets can introduce new topics, impart information and even exert a little discipline when appropriate. Educators in various settings use puppets to teach topics ranging from science to vowel sounds. But, most importantly, puppets allow young learners to express their thoughts and feelings.

Robyn Gibson and Victoria Campbell warmly acknowledge Kay Yasugi's contribution to this chapter.

Playing, the Arts and children with special needs

Olivia Karaolis

Don't hang your dreams in a closet … I want teachers, decision makers, education bureaucrats and governments to dream of the possibilities for special needs children … (Comte, 2009, pp. 64–5)

William circled the room during our creative arts classes. When his behaviour interventionist bought him into the group he would cry and wriggle out of his seat until he could return to his pacing – going back and forth across the classroom. In his hands he held onto favourite belongings that he had brought from home. On the fourth class he joined the group for a sensory activity, and for a brief second we made eye contact and he smiled. As soon as the exercise ended he hopped up and left the group. For our next class I decided to introduce the gathering drum, hoping William might join in by walking to the different rhythms. Well, he did more than that! He was so drawn in by the instrument that he joined the circle without encouragement. He particularly loved the drumsticks – especially once I gave him two to hold. (I had observed his desire for having things in both hands.) Most importantly he *really* played the drum, and later played a drumming game with another student. The drum helped William find his creativity and come out and play!

This vignette illustrates the importance of exposing children with disabilities to creative experiences. William has a severe autistic spectrum disorder that affects his ability to speak and interact with other people. School can be a very stressful and foreign place for him because of his sensory sensitivities. The abundance of visual and auditory information is often too overwhelming for him, leaving him feeling confused and terribly upset. He will withdraw and engage only in repetitive activities – all of which take him away from us and to what I can only imagine

as a very lonely place. Drama classes became a gentle way to introduce him to some group activities, expand his interest in activities and objects, and give him ways to connect with his peers. They also revealed to us a tremendous amount of information about William. We were able to see the extent of his capabilities and learn about his interests. He became our teacher.

The Arts provided us with different ways of giving William methods of self-expression. He was able to share his feelings and connect with another person without fear or a need for repression. He was able to express himself in *his way*.

The importance of the creative arts when working with unique populations

'All people have creative abilities and we all have them differently' (Robinson, 1999, p. 7). Children love to play, to create and to make up alternative worlds. Children with special needs are no exception. Young children with disabilities are highly imaginative and very creative. Just like all other young children, they enjoy the freedom to discover the world for themselves and to build their own understandings.

This chapter focuses on how to use the creative arts to make it easier for young children with developmental disabilities to learn to play, communicate, and experience the joy of relationships and creativity. The creative arts give endless ways for you to include students with disabilities into your classroom or centre program.

How to make creative learning environments for every child

As teachers, part of our work is to create learning environments that are stimulating and meaningful for our students. Edwards and Springate (1995) have some wonderful suggestions that foster creativity in the classroom. They include *time, space, materials, climate* and *occasions*. I think their suggestions are equally valuable when working with students with disabilities. They will help you to make the classroom what I call 'familiar', and build an environment that will help children attend, engage, understand and have the freedom for different forms of creative expression.

Time

Edwards and Springate (1995) remind us that creativity comes to us spontaneously, when we are inspired and stimulated. They urge teachers to recognise these moments and not to hurry or interrupt students when they are deeply involved in the creative process. Because of the many ways a disability can affect the way a

person feels and functions from day to day, it is very important for teachers to be attuned to when a student is engaged in making a piece of work. The other side of that coin is not to 'push' a student when they do not respond to a particular creative activity. Wait, and reintroduce at a better time.

Space

The learning environment is also a very important consideration when developing creativity in children with special needs, and especially those with an autistic spectrum disorder. Like other children, they will work best in a peaceful, attractive atmosphere with natural instead of fluorescent light. You may also want to use visual cues or signs placed around the room to help students associate different activities with certain areas and to help them to locate places for different materials. Many people with an autistic spectrum disorder or with language delays will be 'visual thinkers'. Using pictures for showing the daily schedule and to sequence creative arts activities will make it easier for some students to follow all instructions and to know what happens next.

When working with music it is good to be aware that some children will be very sensitive to the sounds of musical instruments and music levels. Carefully observe each student's reaction during music sessions to gain an understanding of their preferences. In many cases children will work better in all creative experiences if music is playing softly in the background. Most children love drumming, as the physical movement helps them to gain a sense of their body in space. Rarely, some children may find loud drums or cymbals distressing and they will block their ears. Continuing exposure to a variety of music and instruments gives children an opportunity to learn how to use them as a form of expression. *The magic maracas* and the *Name game* described on pages 134–5 is also a fun way for children to use instruments as forms of communication.

I think a nice addition to the classroom environment is a quiet, comfortable place that can serve as a retreat if, or when, the day-to-day action of the classroom gets too much. The focus required for creative endeavours can be very demanding for young children with a disability. For this reason, having an area designated for letting off steam, such as a trampoline in a corner, is equally important. By making these spaces you acknowledge the sensory needs of your students and give them an easy way to regain their equilibrium and then rejoin group activities.

Materials

Giving children access to materials and resources and real objects inspires their creativity (Edwards & Springate, 1995). The authors offer beautiful ideas for children. For children with sensory issues the most appealing of these will often be sculpting materials such as *playdough*, *clay*, *goop* and *shaving cream*. I would recommend introducing shaving cream first as it is a wonderful way for children

to discover texture. Its lightness is easy on young fingers – especially those who may be hesitant to experiment or who are tactile defensive. From shaving cream you can move on to heavier textures, like playdough and clay.

Another idea is *touchable bubbles*. Kids can reach for them and balance them on their fingers. Blowing bubbles is also great for developing the muscles in the mouth!

Squeeze toys, *stress balls* or *fidgets* are terrific to use in drama or movement (see Figure 9.1). Children love the feeling and the appearance of these toys, and they are often used to help kids relieve stress or pressure and maintain attention in class. I use them to motivate children to participate in drama games. I find ones in funny shapes, or that light up, or that look like an alien or an animal. Children are drawn to these objects, and you can capitalise on this interest to bring about social interaction and to develop movement, gesture and dramatic play. The *Pass the fidget* and *Wonder walk* games on page 135 will provide you with some ideas to incorporate into your lesson plans.

For children with sensory sensitivities and complex disabilities the sense of touch can be one of their most reliable and preferred methods of receiving information. A piece of *fabric* about four or five metres in length can be used in movement and drama to create imaginary worlds or to stimulate dramatic play. The material should have a satin texture and be in a pastel colour. Children will love the way the material feels on their skin. One very calming activity is to ask the children to lie on the ground and to wave the fabric above them. This exercise works best when you play soft music (Cat Stevens is a good choice) in the background. The *Boo* game on page 136 is another example.

Figure 9.1 A stress ball or 'fidget'

Ashley Judd (2010) writes that 'god lives in the space between people' (para 12). Judd's quote makes me think of the beautiful ways children with special needs relate to puppets.

Puppets delight young children and offer a funny and pressure-free opportunity for interaction. A puppet will give you an alternative method of communicating with students who find it difficult to understand or use spoken language. I believe this is because puppets are easier to 'read' – they do not have the complex expressions and emotions of adults or other children. A puppet can be a simpler version of us. I find that I can connect to a child through the puppet, and it will help you build a relationship with your students. Children can speak with a puppet first – when they are ready, they can begin speaking with other people.

One suggestion that I have for using a puppet is during newstime or show-and-tell. Children are much more likely to respond to questions and speak to the group if they are talking to a friendly puppet. Puppets can also be used in role-play during drama to foster interaction with other children. The children can communicate with one another using the puppets to gain a deeper understanding of feelings and social behaviour.

Climate

One of the greatest challenges of teaching children with a disability is creating a positive environment that focuses on achievable goals, as opposed to deficits. The creative arts offer children an authentic method of participating in their own learning, initiating ideas and creating something independently. Such opportunities are all too rare for individuals with a disability, and especially for younger children. The pressures of different therapies and interventions can take priority, and the wonderful parts of childhood like creative play can become overlooked. I think it is terribly important for *all* children to experience the pleasures of the creative process, to have time for creative play, to feel the satisfaction of creating something that is uniquely their own, and to have their accomplishments recognised.

It is a mistake to think that children are unaware of their differences. Most of the children I teach demonstrate a tremendous desire to please their parents and teachers. Art is a means to do this as there is no 'right' answer, giving them what Dorothy Heathcote (1984) describes as the 'penalty free zone'.

You want to create an atmosphere where both you and your students believe in themselves and their ability to be creative and to learn. The relationship you have with your students is going to be the most critical factor in developing their creativity. Doris Shallcross (cited in Craft, 2000) describes this as making the right *mental climate* for the children and the classroom. All people need to trust and feel safe if they are going to express themselves, try something new or take a risk. They need teachers who are able to give them experiences that match their interests and

levels of ability. They also need teachers who are going to respond, to what at times may be unusual responses, positively and without judgement. A teacher who enjoys the process of making art and who gives themselves permission to have fun and be creative is going to inspire the same qualities in their students.

Knowledge of your students and faith in their abilities will bring out the amazing abilities in every child.

The best way you can communicate this to parents is by the way you display the children's artwork in the classroom (see Lea Mai's suggestions in Chapter 4). And when you send work or projects home to parents, make sure they know that it is their children's work. Parents *know* when artwork has been done by an adult. This communicates to them your lack of belief in what their child can achieve.

All parents love their child's artwork – and see it as precious. When you show parents their child's work they will know that you think it is precious too.

Occasions

Edwards and Springate (1995) remind educators that children need 'concrete inspiration' to be creative. Our role as teachers is to inspire and support children's expressions of creativity. Children with special needs will need you to share your skills and abilities with them until they have a complete understanding of their own power. It is not uncommon for children with autism or a developmental disability to fixate on certain things. Use these interests to motivate different forms of expression, perhaps in drawing, painting or sculpture. A child with a disability may find it difficult to symbolise their ideas. Teachers can help children by providing real objects, or pictures of what they may wish to illustrate. Self-portraits can be done by lying the student down on a piece of paper and tracing around their body. The children can then colour themselves, and add hair using wool.

Many children with special needs may find it difficult to make a gesture or create an action with their body. When asking the class to fly like a butterfly, accept any movement, even if it is a slight intake of breath, to represent that student's butterfly and say what you see: 'Your butterfly took a big breath and flew'.

Games

The magic maracas
Materials: A maraca or shaker. Attach a ribbon to give it powers!
Learning focus: Developing students' collaborative skills, awareness of their bodies in space and understanding of different rhythms and pace.

Make a circle with the children seated on the floor or in chairs. Invite one student to join you in the middle. Introduce them to the magic maraca, describing it as having

magical powers that move people in different directions. The student working with you has to watch the maraca and move their body in the direction of, and in time with, the maraca. If the maraca points 'up' they must stretch up high; if the maraca moves towards the floor they must move down low too. They also need to pay attention to how far the maraca is shaking, and move their body at the same speed. This is a very fun game that does not require any spoken communication; all communication is through the instrument. This game can be done as a whole group exercise, with one student holding the instrument and conducting the entire class.

Name game

Materials: Drum and mallets

Learning focus: Interacting with others, receptive language.

Introduce the class to the drum. It should be big enough to allow two children to sit opposite one another and play together.

Invite two children to play. When one of the two students hears you call their name, they drum, while the other student holds their mallet and waits. When you say the second student's name it is their turn, and the first student must freeze.

This game uses the drum to develop the children's attention and receptive language. They need to listen very carefully so that they do not get caught out playing when it is not their turn. It is always helpful to model the game with another teacher or student first.

Pass the fidget

Materials: Stress ball

Music suggestion: *Punk-Rock-Nelly the elephant* by The Toy Dolls

Learning focus: Developing the skills needed to participate in drama games. Drama requires cooperation and an ability to work with others.

This is a version of pass the parcel or hot potato. The only variation is that this game involves passing the stress ball to music (I like punk music for this activity). When you stop the music the child holding the ball gets to fidget with it for a few seconds.

You can complicate this game by asking the students to turn the fidget into something when the music stops. A hat, a cat or a baby are some possibilities.

Wonder walks

Materials: Stress ball

Learning focus: Developing students' understanding of how to use their bodies and their voices to create characters.

Form a circle. You start the game by joining the group and holding the fidget. Decide on a character (dinosaurs are usually very popular), and explain to the class that you are going to become a dinosaur (or whatever your character is) and walk your baby egg (fidget) over to another student.

Walk across the circle to one of the students as a dinosaur, then, using a dinosaur voice, say 'This is my baby dinosaur egg!' Young children who are without spoken language can roar! Then that student takes their dinosaur egg over to another person in the group.

Boo
Materials: Satin fabric
Learning focus: Developing imaginative play

Ask the students to sit in a circle of chairs or on the floor and wrap yourself up in the fabric. On the count of three, leap out of the material and say 'boo!' After modelling the action, ask one student to come and join you. Wrap the student, standing, in the fabric. Once the child is hidden in the material ask the group to call out the student's name, saying, '[name of student] … where are you?' When the child is ready they jump out of the fabric and say 'boo!'

A creative arts lesson

The creative arts lesson described below is inspired by the beautiful book by Eric Carle, *The very hungry caterpillar* (1970). This is a great story to work with for all children because it draws on their innate interest in insects, uses very little language and offers children an opportunity to develop their creativity and interpretive skills. After reading or listening to the text children will explore the story through music, movement, improvisation and visual art. By working together to make the world of the caterpillar, children will build their knowledge of a variety of insects, food groups and the caterpillar's life cycle. By performing their own version of the story, they will build confidence in working as part of a group and learning new forms of self-expression.

Activities based on *The very hungry caterpillar*

You will need:
- a copy of *The very hungry caterpillar* by Eric Carle
- a piece of satin fabric
- music – *Bedouin dress* by Fleet Foxes is a good choice
- a spool of yarn like the pom-pom brand from loops and threads
- puppets of caterpillar and butterfly, if you like.

1 Read the story

Read the story of *The very hungry caterpillar* to the class. To help the children engage with the text ask them to identify insects, foods and colours from the pictures. You can stop the reading and make a caterpillar with your finger and have him inch up your arm. Invite the children to imitate your finger play. You can also make butterflies with your hands. The intention with this kind of reading is to support spoken words with pictures and actions, giving the children multiple ways to make sense of the story.

2 The caterpillar/butterfly yoga pose

Learning focus: This movement sequence is a way to help students use gesture to recall and retell parts of the story using their bodies.

Stand in front of the class and ask the group to copy a sequence of movements.

First, curl up tight as a ball, just like the caterpillar when he was an egg. Once the class is in this pose, hold it for three breathes.

Next ask the class to lie on their tummy like the caterpillar. Hold for three breathes.

Finally, come to a standing position and slowly flutter your arms like wings, one flutter per breath for three breaths.

3 Cocoon

Learning focus: This activity will help students distinguish the difference between imaginary situations and their own lives, as well as stimulating their social imagination.

Place the satin fabric on the ground and ask the class to make a circle around you.

Ask the class to tell you what happened to the caterpillar after he ate all his food. Then invite one of your students to take on the role of the caterpillar and feel what it is like in his cocoon. Ask them what kind of insect they think the caterpillar will change into when he comes out of the cocoon. Ask the student to lie on the floor and roll them up in the fabric. If you have a student with an autism spectrum disorder they will probably prefer to leave their head out of the fabric, as might some other students. A student who is medically fragile may need to be lifted onto the material and rolled, with you and a teaching assistant supporting their head.

When the student is completely rolled up you can help them to unroll, then ask them to fly back to their spot in the circle like a butterfly.

For students who are really enjoying the dramatic play, you can introduce the dramatic element of tension. I do this by creating a problem for the children to solve. I tell the class that the butterfly is stuck in the cocoon and needs some magic dust to come out. This small complication may lead you to find magic dust, or have the children sprinkle magic dust on the cocoon and release the butterfly. Whatever direction the dramatic play takes, you are helping the children to grasp the difference between fantasy and reality.

4 Very hungry musical statues

Learning focus: Students will learn how to use their bodies to respond to music and to portray different characters.

This is a version of musical statues, and is a great way for the children to use movement to create characters. Play some music and ask your students to freeze as the insect in various stages (caterpillar, butterfly, egg) you call out when the music stops. You can support the children's understanding of the rules of the game by asking them to model the different shapes of an egg, caterpillar or butterfly before playing the game.

As your students become more familiar with the game you can ask them to freeze in the shape of something from the book that they liked – an ice-cream, a pizza or the sun are some ideas.

5 Very hungry caterpillars

Learning focus: This activity helps children to gain an awareness of their bodies as separate from other people's, as well as to enjoy collaboration.

Ask your class if they want you to be a very tiny caterpillar, a medium caterpillar or an enormous caterpillar. As if it was clay, make your body into the caterpillar on the floor and then use the yarn to outline your shape. Some students will be able to put the yarn around for you. Stand up and move away from the yarn – children love to see the shape that has been created. Then give each student a turn at making their own caterpillar, and trace their body with the yarn.

6 Pass the picnic

Learning focus: This game helps children to recall parts of a story and learn how to use mime and gesture to express an idea.

Form a circle. Begin the game by choosing something the very hungry caterpillar ate and mime eating that yourself, then pass the ice-cream, pickle, sausage or whatever you chose around the circle. Once every child in the circle had mimed eating that particular food, ask the last person to guess what you were miming. Continue the game until everyone has had a turn.

Representing a favourite activity

After exploring the story in drama, movement and music ask the children to draw a part of the story that they liked the best. Some children will need you to work closely with them as they complete their drawing. I think this is a nice way to introduce students to visual art, as it is supported by the previous activities, and this gives them an opportunity to make the most meaningful representation. Figure 9.2 shows an example.

Figure 9.2 A child's illustration of their favourite part of the story

Conclusion

Today William said 'Boo'. Our class was celebrating Halloween, and each student was taking turns at scaring the class like a ghost. William is now in kindergarten at another school where I teach drama. At our first class he joined our circle – not seated on a chair but lying in the middle of the floor. He was without his security belongings, and smiling. I am sure he lay on the floor to prepare for the sensory fabric activity – he was happy and wanting to be part of the class. William has reminded me how deeply affected young children are by their social and physical circumstances. Art can give children with special needs the potential to learn, to have a voice and to reach other people. We have so many possibilities! One way to ensure permanent disability is to be without hope, and that is impossible for me after witnessing the magical moments that occur in classrooms.

Putting it all together

Sarah Ibrahim and Robyn Ewing

In her first professional placement visit in August 2010, early childhood teacher Sarah Ibrahim met a five-year-old boy named Asher. She was immediately impressed by his incredible knowledge about and passion for dinosaurs:

> *To say that I was amazed at Asher's knowledge about dinosaurs, his passion to describe and recreate a portrait of dinosaurs based on what he knows and can remember, and then witness his artistic talent as I saw him visually represent all the words he was saying to me, is an understatement.*

Sarah developed a creative arts portfolio of her work with Asher and his friends over the five weeks of her placement. This journal was later entered by her creative arts lecturer into the Oxford University Press Practicum Award 2010–11, and won second prize. As a way of demonstrating the authentic integration of the Arts disciplines, the following excerpts from this portfolio demonstrate how Reggio Emilia's principle of viewing children as competent learners, and engaging with them in what interests them, leads to transformative learning through quality arts experiences.

Keeping a journal

Day 2
Sarah arrived with seven picture books about dinosaurs.

Asher was SOOOO excited when he saw what I had brought in, and his enthusiasm was contagious, managing to draw in approximately eight other children into our reading corner … As we read through each book we discussed the pictures, and what they depicted about the different species of dinosaurs.

The shared reading concluded with children depicting themselves as dinosaurs, for example, Ashersaurus.

The children really enjoyed the activity and loved seeing their photographs on my camera. For me it was the perfect opportunity to integrate a number of creative activities and give the children an opportunity to express their own creativity … Asher being Asher with his love of dinosaurs took the activity one step further and began to draw pictures of dinosaurs based on what he had just seen in the picture books.

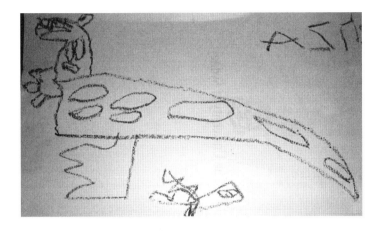

Later that day Asher created his own book about dinosaurs on large sheets of paper and related his story to Sarah, who scribed as he told the story.

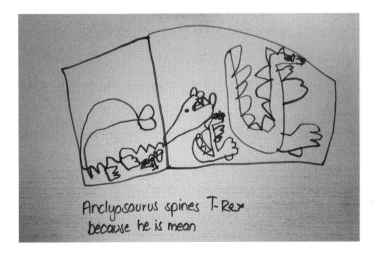

As I listened to Asher tell his story in all its quirkiness, I realised what I loved about creativity – the fact that there is no right or wrong – you could be as out there and crazy as you like, and it doesn't matter. If anything, the more imagination you show, the more creative you are, and the better.

Later in the day I found Asher extending our dancing statues activity from yesterday. He had obtained some dinosaur figurines and was mimicking the dinosaurs' movements, engaging in drama as he put the dinosaur next to him and role played how he thought the dinosaur looks and moves.

Day 3

After Asher shared one of his own favourite dinosaur books with Sarah, they engaged in drawing dinosaur images. Sarah then decided to probe a little to find out why Asher loved dinosaurs so much.

Sarah: Why are dinosaurs important, Asher; why do we need to learn about them?

Asher: Dinosaurs are important because they are bad and they died out. That's why we have to learn about them. I'm the owner of the dinosaurs. I was alive when the dinosaurs were alive.

Sarah: If you could be a dinosaur, which dinosaur would you be?

Asher: If I was a dinosaur, I would be T-Rex because he is the owner of the dinosaurs. Tyrannosaurus is the same thing but he is the owner of the dinosaurs. I'm T-Rex because I'm the owner of *all* the dinosaurs.

Later, Asher and Sarah invented a song about dinosaurs. Sarah noted that Asher carefully controlled all aspects of the words, and directed Sarah to write down what he dictated. The song demonstrated Asher's knowledge of different species of dinosaurs as well as their distinguishing features and how long they existed. He reiterated his connection to them by saying 'I am the owner of the dinosaurs'.

On the same day, Asher's friend N. showed Asher a bone he had found. Asher was convinced it was a dinosaur bone and for the next hour he, N. and some others role-played being scientists as they continued to dig for more dinosaur bones.

Day 4

Sarah listened to Asher's storytelling and marvelled at his ability to capture her imagination with his vivid descriptions:

I feel like I can continue to question him endlessly and still be surprised by the detail and depth of his responses.

She wrote about how much she had learned and, surprisingly, how interested she now was in learning about dinosaurs, from a five-year-old.

Day 5

Asher drew a detailed picture of a pterodactyl with a running commentary that demonstrated his knowledge of pterodactyls and his understanding of 'survival of the fittest'.

Later on day 5, Sarah found Asher pretending to be T-Rex in front of a mirror, using movement and facial expression to depict how he imagined the dinosaurs would have roamed the planet.

Day 6

Asher asked Sarah to bury him in the sand and place a bucket over his head so that he could pretend to be a T-Rex fossil. Sarah obliged, burying only his legs, but Asher was unhappy with the partial response and experimented himself:

Seeing what Asher was doing reminded me of the Reggio Emilia approach and how that philosophy recognised children as competent beings who learn best through their own active experimentation.

Day 7

Keen to involve Asher in physical activity, Sarah invented a game of chasings in which she became T-Rex hungry for meat. Ultimately about 15 of the preschoolers who were in role of other dinosaurs tried to escape from, or partner with, T-Rex.

The children created a trap to block me out and many engaged in make believe play as they 'poisoned' me, 'cured' me, became my 'magic princess', gave me 'potions' and did all sorts of things to either keep me away or become my ally.

Sarah recorded how Asher's engagement in the activity led to him running, jumping and crawling, despite his usually appearing uninterested in such activities.

Day 8

The children used chopped-up coloured paper in various shapes that Sarah provided to create works of art. She was once again amazed at the detail in Asher's Anklyosaurus, complete with a 'spiky spine' and a tail with two spikes. One of the other teachers also showed Sarah a 3D dinosaur hanging from the ceiling that Asher had inspired the class to create together.

In group time Sarah taught the children about fossils and the role of palaeontologists. This included a sand activity to allow them to experiment in role as palaeontologists themselves. They told Sarah about their visit to the museum, and later assembled milk crates and dinosaur figurines to create their own 'dinosaur museum'.

Day 9

Children created artworks using glitter that Sarah had mixed with glue. Asher's was a 'fossil dinosaur'. They went on to create 3D dinosaurs with multicoloured playdough. She couldn't resist joining in, and felt that the children were inspiring her to be creative. Asher used the rolled-out playdough to create T-Rex's tracks.

Day 10

Children created dinosaurs in the dirt with grass, leaves and bark. Sarah writes how this particular activity captivated one usually very quiet child for more than hour.

Day 11

At morning tea Asher turned his pancake into the jawline of T-Rex and moved it up and down in a biting motion. Later, as the children made paper chains, Asher created 'dinosaur chains' that he later used in dramatic play with his friends. He pretended to be a trapped T-Rex.

I am now starting to see how art can be incorporated in so many other elements of children's play and how art is an expression of oneself, what one identifies with and what one views as important.

Day 12

Some of the younger boys had used the dinosaur figurines to create an animal park. They had set up barriers and were sitting in the sand feeding the dinosaurs leaves because 'dinosaurs eat plants'.

Learning that Sarah would soon be finishing her professional experience at the long day care centre, Asher used his hand as a mobile phone to let T-Rex know he must come earlier than planned to meet her before she leaves.

Asher was clearly demonstrating his knowledge that drama can be representational and he demonstrated to me all the things he had learnt about engaging in a social context such as talking on the phone.

Later in show-and-tell Asher demonstrated how clay can be moulded, and proceeded to demonstrate to the class by making a dinosaur with it.

Day 13

After failing to find a dinosaur story in the reading corner, Asher made up his own:

Once upon a time there was a dinosaur, nobody could believe it, not a Tyran-o-saurus, he was pushing something out out out, it was a little bit big, it was T-Rex but something spiny came along. He was Anklyosaurus, pushing both of them and he went Rrrrr and

he grew longer arms. Tomorrow I will fight that dinosaur T-Rex, I will fight that meanie-x and then there will be meat all over and I will eat him. Then two pterodactyls came and they bent down and they eat up all the T-Rex.

Day 14

The children listened to a CD filled with dinosaur songs. Sarah asked the children to listen to the words and dance to the songs. The song about wishing to be a dinosaur caught the attention of many children. Asher began by hopping around on all fours pretending to be an Allosaurus, then upright with hands positioned as the claws of a T-Rex.

It was great for me to observe the children applying their cognitive knowledge about dinosaurs, and how they move, into their own dance and body movement.

Conclusion

In Sarah's final reflections of the five weeks she marvels at Asher's development over that time as evidenced by the changes in his artworks. It is the change in herself, however, that is also important. She now appreciates the value of close observation and documentation. Even more importantly:

> *I must admit that I used to see the creative arts as something done purely for fun, rather than for any learning purpose. Through the journey that I have undertaken with Asher, I now view the Arts not only as an important way in which children learn, but also as an important way in which children reflect on and show what they have learnt.*
>
> *I have learned just how capable children are if they are motivated and engaged in an activity that interests them … I have learnt that there truly are 100 languages of children (if not more), and as early childhood teachers we owe it to ourselves and to the children in our care to give them the opportunity to explore as many of these languages as possible.*

Sarah's journey clearly demonstrates how much we can learn as educators, parents and caregivers as we allow children to engage in imaginative and aesthetic experiences. Our own creativity and imagination can be reignited as we too re-discover the importance of play in lifelong learning.

REFERENCES

ACARA *see* Australian Curriculum, Assessment and Reporting Authority

Ahlberg, A., & Ahlberg, J. (1986). *The jolly postman and other people's letters*. London: Heinemann.

Allen, P. (1984). *Who sank the boat?* Melbourne: Thomas Nelson.

Allen, P. (1987). *Mr McGee*. Melbourne: Nelson.

Anderson, D., Piscitelli, B., Weier, K., Everett, M., & Tayler, C. (2002). Children's museum experiences: Identifying powerful mediators of learning. *Curator, 45*(3), 213–231.

Anderson, M., Bundy, P., Burton, B., Donelan, K., Ewing, R., & Hughes, J. et al. (2011). *Theatrespace: Accessing the Cultural Conversation Preliminary Report*. Retrieved from http://theatrespace.org.au/static/files/assets/8f06d6d1/TheatreSpace_PreliminaryReport.pdf

Ansbacher, T. (1998). John Dewey's *Experience and education*: Lessons for museums. *Curator, 41*(1), 36–49.

Applegate, C. (2000). *Rain dance* (D. Huxley, Illus.). Sydney: Margaret Hamilton Books.

Armistead, E. (2007). Kaleidoscope: How a creative arts enrichment program prepares children for kindergarten. *Young Children, 62*(6), 86–93.

Arnheim, D., & Sinclair, A. (1975). *The clumsy child*. St Louis, MO: Mosby.

Arriaga, A. (2011, June). *Analyzing the concepts on art and interpretation in conversations held with Tate Britain's educators*. Paper presented at the 33rd World Congress of the International Association for Education Through Art (InSEA), Budapest, Hungary.

Australian Curriculum, Assessment and Reporting Authority. (2011). *Shape of the Australian curriculum: The arts*. Sydney: Author.

Baker, J. (1987). *Where the forest meets the sea*. Sydney: Julia MacRae Books.

Baker, J. (1995). *The story of Rosy Dock* . Sydney: Random House.

Barnett, L. (1990). Developmental benefits of play for children. *Journal of Leisure Research, 22*(2), 138–153.

Bateman, B. D. (1968). *Temporal learning*. San Rafael, CA: Dimensions.

Bennett, J. (1991). *Learning to read with picture books*. Gloucestershire, UK: Thimble Press.

Bergen, D. (1998). Stages of play development. In D. Bergen (Ed.), *Readings from play as a medium for learning and development* (pp. 71–93). Olney, MD: Association for Childhood Education International.

Bernier, M., & O'Hare, J. (Eds.). (2005). *Puppetry in Education and Therapy. Unlocking doors to the mind and heart*. Bloomington, IN: Authorhouse.

Birch, C. L. (2000). *The whole story handbook: Using imagery to complete the story experience*. Little Rock, AR: August House.

Blumenfeld-Jones, D. (2010). Fostering creativity and aesthetic consciousness in teachers: Theory and practice. In C. Craig & L. Deretchin, *Cultivating curious and creative minds: The role of teachers* (pp. 22–45). Lanham, MA: Rowman & Littlefield Education.

Booth, D., & Barton, B. (2000). *Story works: How teachers can use shared stories in the new curriculum.* Ontario, Canada: Pembroke.

Bower, S. (2004). Developing a yearning for primary learning: A focus on literature and the creative and practical arts. *Australian Art Education, 7*(2), 21–8.

Boyer, E. (1987). Keynote address to the National Invitational Conference sponsored by the Getty Center for Education in the Arts. In *Discipline-based Art Education: What Forms Will it Take?: Proceedings of a National Invitational Conference.* Los Angeles, CA: Getty Center for Education in the Arts.

Brandt, R. (1987). Assessment in the Arts: A conversation with Howard Gardner. *Educational Leadership, 45*(4), 30–34.

Bredekamp, S., & Copple C. (1997). *Developmentally appropriate practice in early childhood programs.* Washington, DC: National Association for the Education of Young Children.

Bronowski, J. (1978). *The origins of knowledge and imagination.* New Haven: Yale University Press.

Brookes, M. (1996). *Drawing with children.* New York: Putman.

Browne, A. (1983). *Gorilla.* London: Julia McRae Books.

Browne, A. (1986). *Piggybook.* London: Julia McRae Books.

Browne. A. (1992). *Zoo.* London: Julia MacRae Books.

Browne, A. (1998). *Voices in the park.* London: Julia McRae Books.

Browne, A. (2011). *Playing the shape game* (J. Browne, Illus.). London: Doubleday.

Bruna, D. (2008). *Miffy the artist.* London: Tate Publishing.

Bruner, J. (1990). *Acts of meaning: Four lectures on mind and culture.* Cambridge, MA: Harvard University Press.

Bruner, J. S., & Sherwood, V. (1976). Peek-a-boo and the learning of rule structures. In J. Bruner, A. Jolly & K. Sylva (Eds.), *Play: Its role in development and evolution* (pp. 277–287). Middlesex, UK: Penguin.

Butler, D. (1975). *Cushla and her books.* London: The Bodley Head.

Butler, D. (1980). *Babies need books.* London: The Bodley Head.

Callow, J. (1999). *Image matters.* Sydney: PETA.

Callow, J. (2011). *When image and text meet: Teaching with visual and multimodal texts.* PETAA Paper 181. Sydney: Primary English Teaching Association Australia.

Campbell, V. (2008). *Tales from the liminal classroom: Preservice teachers and oral storytelling* (Unpublished master's thesis). University of Sydney, Sydney.

Carle, E. (1970). *The very hungry caterpillar.* New York: Simon and Schuster.

Carle, E. (2011). *The artist who painted a blue horse.* London: Puffin.

Catterall, J. (2009). *Doing well and doing good by doing art: The effects of education in the visual and performing arts on the achievements and values of young adults*. Retrieved from http://www.tiny.cc/Oprbg

Central Advisory Council for Education (England). (1967). *Plowden Report. Children and their primary schools: A report of the Central Advisory Council for Education (England)*. London: Her Majesty's Stationery Office.

Chambers, A. (1993). *Tell me*. Gloucestershire, UK: Thimble Press.

Child, L. (2000). *Beware of the storybook wolves*. London: Hodder.

Child, L. (2003). *Who's afraid of the big bad book?* London: Hodder.

Child, L. (2008). *This is ACTUALLY my party*. London: Puffin.

Children's Play Council, National Playing Fields Association and Playlink. (2000). *Best Play: What play provision should do for children*. London: National Playing Fields Association.

Clarke, M. (2009). Creativity – the great equalizer (Keynote address presented at the Educational Leaders Conference). *UNESCO Observatory*, April, 186–193. Retrieved from http://www.education.unimelb.edu.au/eldi/elc/unesco/pdfs/ejournals/maud-clark.pdf

Collins, R., & Cooper, P. J. (2005). *The power of story: Teaching through storytelling* (2nd ed.). Chicago: Waveland Press.

Comte, M. (2009). Don't hang your dreams in a closet: Sing them, paint them, dance them, act them … *Australian Journal of Music Education*, 2009, no. 2, 58–66.

Cooper, P. M. (2005). Literacy learning and pedagogical purpose in Vivian Paley's storytelling curriculum. *Journal of Early Childhood Literacy, 5*(3), 229–251.

Cooper, P. M. (2009). *The classrooms all young children need: Lessons in teaching from Vivian Paley*. Chicago: University of Chicago Press.

Cooper, P. M., Capo, K., Mathes, B., & Gray, L. (2007). One authentic early literacy practice and three standardized tests: Can a storytelling curriculum measure up? *Journal of Early Childhood Teacher Education, 28*(3), 251–275.

Cornett, C. E. (1999). *The arts as meaning makers*. Upper Saddle River, NJ: Prentice Hall.

Corsaro, W. (1985). *Friendship and peer culture in the early years*. Norwood, NJ: Ablex.

Corsaro, W. (2003). *'We're friends, right?': Inside kid's culture*. Washington, DC: Joseph Henry Press.

Corsaro, W., & Johannesen, B. (2007). The creation of new cultures in peer interaction. In J. Valsina & A. Rosa (Eds.), *The Cambridge handbook of sociocultural psychology* (pp. 444–459). New York: Cambridge University Press.

Craft, A. (2000). *Creativity across the primary curriculum: Framing and developing practice*. London: Routledge.

Crumpler, T. (2006). Educational Drama as a Response to Literature: Possibilities for Young Learners. In J. Schneider, T. Crumpler & T. Rogers (Eds.), *Process Drama and Multiple Literacies* (pp. 1–14). Portsmouth, UK: Heinemann.

Csikszentmihalyi, M. (1981). Some paradoxes in the definition of play. In A. T. Cheska (Ed.), *Play as context* (pp. 14-26). West Point, NY: Leisure Press.

Csikszentmihalyi, M., & Hermanson, K. (1995). *Intrinsic motivation in museums: Why does one want to learn?* In E. Hooper-Greenhill (Ed.), *The educational role of the museum* (pp. 146–160). New York: Routledge.

Cummins, J. (1997). *Negotiating identities: Education for empowerment in a diverse society.* Ontario, CA: California Association for Bilingual Education.

Cusworth, R. (1991). Using readers' theatre to explore text form. In F. McKay (Ed.), *Public and Private Lessons: The Language of Teaching and Learning* (pp. 24–32). Carlton, VIC: Australian Reading Association.

Dancy, R. B. (2000). *You are your child's first teacher.* Berkeley, CA: Celestial Arts.

Daniel, A. K. (2007). From folktales to algorithms: Developing the teacher's role as principal storyteller in the classroom. *Early Child Development and Care, 177*(6 & 7), 735–750.

Danko-McGhee, K. (2010). The aesthetic preferences of infants: Pictures of faces that captivate their interest. *Contemporary Issues in Early Childhood, 11*(4), 365–387.

Davies, B. (1989). *Frogs and snails and feminist tales: Preschool children and gender.* Sydney: Allen and Unwin.

Day, C. (2004). *A passion for teaching.* New York: RoutledgeFalmer.

de Brunhoff, L. (2003). *Babar's museum of art.* New York: Harry N. Abrams.

DEEWR *see* Department of Education, Employment & Workplace Relations

Department of Education, Employment & Workplace Relations. (2009). *Belonging, being and becoming: The early years learning framework for Australia.* Canberra: Commonwealth of Australia.

De Vries, P. (2004). The extramusical efforts of music lessons on preschoolers. *Australasian Journal of Early Childhood, 29*(2), 6–10.

Dewey, J. (1980) [1938]. *Art as experience.* New York: Perigee Books.

Dinham, J. (2010). *Delivering authentic arts education.* Melbourne: Cengage.

Donaldson, J. (1999). *The Gruffalo* (A. Scheffler, Illus.). London: Macmillan Children's Books.

Doonan, J. (1993). *Looking at pictures in picture books.* Gloucestershire, UK: Thimble Press.

Dunn, J. (2003). Linking drama education and dramatic play in the early childhood years. In S. Wright (Ed.), *Children, meaning making and the arts* (pp. 211–219). Sydney: Pearson Education.

Dunn, J., & Stinson, M. (2011). Dramatic play and drama in the early years: Reimagining the approach. In S. Wright (Ed.), *Children, meaning-making and the arts* (2nd ed., pp. 115–134). Sydney: Pearson/Prentice-Hall.

Dunne, J. (2006). Childhood and citizenship: A conversation across modernity. *European Early Childhood Education Research Journal, 14*(1), 5–19.

Eckhoff, A. (2010). Using games to explore visual art with young children. *Young Children, 65*(1), 18–22.

Eckhoff, A. (2011). Art experiments: Introducing an artist-in-residence programme in early childhood education. *Early Child Development and Care, 181*(3), 371–385.

Education Queensland. (2000). *Productive Pedagogies*. Brisbane: Department of Education, Training and Employment (Queensland). Retrieved from http://education.qld.gov.au/corporate/newbasics/html/pedagogies/pedagog.html

Educational Drama Association. (1981). *Puppetry*. Sydney: Author.

Edwards, L. (2002). *The creative arts: A process approach for teachers and children*. Upper Saddle River, NJ: Prentice-Hall.

Edwards, C., & Springate, K. (1995). *Encouraging creativity in early childhood classrooms* (ERIC Digest). Urbana, IL: ERIC Clearinghouse on Early Childhood Education (ED3899474).

Egan, K. (1986). *Teaching as storytelling: An alternative approach to teaching and curriculum in the elementary school*. Chicago: University of Chicago Press.

Egan, K. (1997). *The educated mind: How cognitive tools shape our understanding*. Chicago: University of Chicago Press.

Eisner, E. W. (1985). Why art in education and why art education? In Getty Center for Education in the Arts, *Beyond creating: The place for art in America's schools* (pp. 64–69). Los Angeles: Getty Center for Education in the Arts.

Eisner, E. W. (2002). From episteme to phronesis to artistry in the study and improvement of teaching. *Teaching and Teacher Education, 18*(4), 375–385.

Eisner, E. W. (2005). Opening a shuttered window. An introduction to a special section of the arts and the intellect. *Phi Delta Kappan*, September, 8–10.

Elkind, D. (2008a). *The power of play: How spontaneous, imaginative activities lead to happier, healthier children*. Cambridge, MA: De Capo Lifelong.

Elkind, D. (2008b). Can we play? [online article]. *Greater Good, 4*(4). Retrieved from http://greatergood.berkeley.edu/article/item/can_we_play

Elliott, A. (2006). *Early childhood education: Pathways to quality and equity for all children*. Australian Education Review No. 50. Melbourne: Australian Council for Educational Research.

Engel, S. (1995). *The stories children tell: Making sense of the narratives of childhood*. New York: W. H. Freeman.

Engel, S. (1997). *Storytelling in the first three years*. Retrieved from http://www.zerotothree.org/child-development/early-language-literacy/the-emergence-of-storytelling.html

Epstein, I., Stevens, B., McKeever, P., Baruchel, S., & Jones, H. (2008). Using puppetry to elicit children's talk for research. *Nursing Inquiry, 15*(1), 49–56.

Evans, J. (2009). Creative and aesthetic responses to picture books and fine art. *Education 3–13, 37*(2), 177–190.

Ewing, R. (1995). *The classification and framing in educational knowledge in newstime in K–2 classrooms* (Unpublished PhD thesis). University of Sydney, Sydney.

Ewing, R. (2010a). *The arts and Australian education: Realising potential*. Australian Education Review No. 58. Melbourne: Australian Council for Educational Research.

Ewing, R. (2010b). Literacy and the arts. In F. Christie & A. Simpson (Eds.), *Literacy and social responsibility* (pp. 56–70). London: Equinox.

Ewing, R., Miller, C., & Saxton, J. (2008). Spaces and places to play: Using drama with picture books in the middle years. In M. Anderson, J. Hughes & J. Manuel (Eds.), *Drama teaching in English: Action, Engagement and Imagination* (pp. 121–135). London: Oxford University Press.

Ewing, R., & Simons, J. (2004). *Beyond the script: Take two – drama in the classroom.* Sydney: Primary English Teaching Association.

Falk, J., & Dierking, L. (2004). The contextual model of learning. In G. Anderson (Ed.), *Reinventing the museum: Historical and contemporary perspectives on the paradigm shift* (pp. 139–142). Walnut Creek, CA: Altamira Press.

Feeny, S., & Moravcik, E. (1987). A thing of beauty: Aesthetic development in young children. *Young Children, 42*(6), 7–15.

Feldman, E. (1996). *Philosophy of art education.* Englewood Cliffs, NJ: Prentice-Hall.

Fiske, E. (Ed.) (1999). *Champions of change: The impact of the arts on learning.* Washington, DC: The Arts Education Partnership and the President's Committee on the Arts and Humanities.

Fleer, M. (2009). A cultural–historical perspective on play: Play as a leading activity across cultural communities. In I. Pramling-Samuelsson & M. Fleer (Eds.), *Play and learning in early childhood settings* (pp. 1–18). Dordrecht, The Netherlands: Springer.

Florida, R. (2002). *The rise of the creative class.* New York: Basic Books.

Fontanesi, G., Gialdini, M., & Soncini, M. (1998). The voice of parents: An interview with Lella Gandini. In C. Edwards, L. Gandini & G. Forman (Eds.), *The hundred languages of children: The Reggio Emilia approach – advanced reflections* (2nd ed., pp. 149–160). Westport, CT: Ablex Publishing.

Fox, C. (1993). *At the very edge of the forest: The influence of literature on storytelling by children.* London: Cassell.

Gardner, H. (1983). *Frames of mind: The theory of multiple intelligence.* New York: Basic Books.

Gardner, H. (1999). *Intelligence reframed: Multiple intelligences for the 21st century.* New York: Basic Books.

Garvey, C. (1979). Communicational controls in social play. In B. Sutton-Smith (Ed.), *Play and learning* (pp. 109–126). New York: Gardner Press.

Garvey, C. (1991). *Play (The developing child).* London: Fontana Press.

Gelineau, R. P. (2003). *Integrating the arts across the elementary school curriculum.* Belmont, CA: Wadsworth.

Gibson, M., & McAllister, N. (2005). Big art small viewer: A collaborative community project. *Contemporary Issues in Early Childhood, 6*(2), 204–208.

Gibson, R. (2002). Responding to children's art: Strategies to encourage art dialogue. *Journal of Art Education Victoria, 4*(3), 9–13.

Gibson, R. (2010). The 'art' of creative teaching: Implications for higher education. *Teaching in Higher Education, 15*(5), 607–613.

Gibson, R., & Ewing, R. (2011). *Transforming the curriculum through the arts.* Melbourne: Palgrave Macmillan.

Gill, R. (2011, February 9). Wake up Australia or you'll have a nation of unimaginative robots. *Age*, p. 7.

Gleeson, L. (2006). *Amy and Louis* (F. Blackwood, Illus.). Lindfield, NSW: Scholastic Press.

Gleeson, L. (2011). *Look! A book!* (F. Blackwood, Illus.). Lindfield, NSW: Scholastic Press.

Gonzales-Mena, J. (2008). *Child, family and community: Family centred early care and education* (5th ed.). London: Pearson.

Graue, E. (2011). Are we paving paradise? *Educational Leadership*, April, p. 15.

Green, M. (1995). *Releasing the imagination: Essays on education, the arts and social change.* San Francisco, CA: Jossey Bass.

Gronna, S. S., Serna, L. A., Kennedy, C. H., & Prater, M. A. (1999). Promoting generalized social interactions using puppets and script training in an integrated preschool: A single-case study using multiple baseline design. *Behavior Modification, 23*(3), 419–440.

Heath, S. B. (1999). Imagination actuality: Learning in the Arts during the non-school hours (A. Roach, Illus.). In E. Fiske (Ed.), *Champions of change: The impact of Arts on learning* (pp. 19–34). Washington, DC: The Arts Education Partnership and the President's Committee on the Arts and Humanities.

Heath, S. B. (2001). Three's not a crowd: plans, roles and focus in the Arts. *Educational Researcher*, October, 2001, 10–16.

Heathcote, D. (1984). Role-taking. In L. Johnson & C. O'Neill, *Collected writings in education and drama* (pp. 49–53). London: Hutchinson.

Hein, G. (2004). John Dewey and museum education. *Curator, 47*(4), 413–427.

Hein. G., & Alexander, M. (1998). *Museums: Places of learning.* Washington, DC: American Association of Museums.

Hertzberg, M. (2009). *Readers' theatre texts to improve comprehension and fluency.* E:update 09. Sydney: e:lit.

Hertzog, N. (2001). Reflections and impressions from Reggio Emilio: It's not about art! *Early Childhood Research and Practice, 13*(2). Retrieved from http://www.ecrp.uiuc.edu/v3n1/hertzog.html

HighScope Educational Research Foundation. (2005). *Lifetime effects: The HighScope Perry preschool study through age 40.* Retrieved from http://www.highscope.org/Content.asp?Contentid=219.

Hill, S., & Launder, N. (2010). Oral language and beginning to read. *Australian Journal of Language and Literacy, 33*(3), 240–254.

Hirsh-Pasek, K., Golinkoff, R. with Eyer, D. (2003). *Einstein never used flashcards: How our children really learn – and why they need to play more and memorize less.* Emmaus, PA: Rodale Books.

Honigman, J., & Bhavnagri, N. P. (1998). Painting with scissors: Art education beyond production. *Childhood Education, 74*(4) 205–212.

Hooper, M. (2000). *Dog's night* (A. Curless, Illus.). London: Frances Lincoln Children's Books.

Horn, M. (2005). Listening to Nysia: Storytelling as a way into writing in kindergarten. *Language Arts, 83*(1), 33–42.

Hubbard, T. (2001). Judgements of happiness, brightness, speed and tempo change of auditory stimuli varying in pitch and tempo. *Psychomusicology: Music, mind and brain, 17*, 1–2. Retrieved from http://ojs.vre.upei.ca/index.php/psychomusicology/article/viewArticle/780

Hughes, B. (1996). *A playworker's taxonomy of play types.* London: Playlink.

Isbell, R., Sobol, J., Lindauer, L., & Lowrance, A. (2004). The effects of storytelling and story reading on the oral language complexity and story comprehension of young children. *Early Childhood Education Journal, 32*(3), 157–163.

Iser, W. (1989). *Prospecting: from reader response to literary anthropology.* Baltimore, MA: Johns Hopkins University Press.

Jeffers, O. (2005a). *Lost and found.* Sydney: HarperCollins.

Jeffers, O. (2005b). *How to catch a star.* Sydney: HarperCollins.

Jensen, E. (2000). *Music with the brain in mind.* Thousand Oaks, CA: Corwin Press.

Johnstone, K. (1989). *Impro: Improvisation and the theatre.* London: Methuen Drama.

Judd, A. (2010). *Internally displaced person camp interview* (Interview 3) [online post]. Retrieved from http://ashleyjudd.com/writings/internally-displaced-person-camp-interview

Katz, L. (2003). The right of the child to develop and learn in quality environments. *International Journal of Early Childhood, 35*(1–2), 13–22.

Kellog, R., & O'Dell, S. (1967). *Psychology of children's art.* New York: Random House.

Kodaly, Z. (1974). *The selected writings of Zoltan Kodaly.* (L. Halapy and F. Macnicol, Trans.). London: Boosey & Hawkes.

Koestler, A. (1964). *The act of creation.* Hutchinson.

Kolbe, U. (2001). *Rapunzel's supermarket: All about young children and their art.* Sydney: Peppinot Press.

Krashen, S. (2010). The Goodman-Smith hypothesis, the input hypothesis, the comprehension hypothesis and the (even stronger) case for free voluntary reading. In P. Anders (Ed.), *Defying Convention, Inventing the Future in Literacy Research and Practice: Essays in Tribute to Ken and Yetta Goodman.* New York: Routledge.

Kuyvenhoven, J. (2009). *In the presence of each other.* Toronto: University of Toronto Press.

Larkin, V. (2000). Thinking through puppetry: Developing quality puppetry curriculum in early childhood. In W. Schiller (Ed.), *Thinking through the arts* (pp. 55-64). London: Routledge.

Latshaw, G. (1978). *Puppetry: The ultimate disguise.* New York: Rosen.

Levinowitz, L. (1998). Measuring singing voice development in the elementary general music classroom. *Journal of Research in Music Education, 46*(1), 35–47.

Levinson, M. H. (1997). Mapping creativity with a capital 'C'. *ETC: A Review of General Semantics, 54*(4), 447.

Linderman, E. W., & Linderman, M. M. (1984). *Arts and crafts for the classroom.* New York: Prentice-Hall.

Lindon, J. (2001). *Understanding children's play.* Cheltenham, UK: Nelson Thomas.

Livo, N. J., & Rietz, S. A. (1986). *Storytelling: Process and practice.* Littleton, CO: Libraries Unlimited.

Lowe, K. (2002). *What's the story? Making meaning in primary classrooms.* Sydney: Primary English Teaching Association.

Lowenfeld, V. (W. L. Brittain, Ed.) (1968). *Viktor Lowenfeld speaks on art and creativity* Washington, DC: National Arts Education Association.

Lowenfeld, V., & Brittain, W. (1987). *Creative and mental growth* (8th ed.). New York: Macmillan.

Mackintosh, C. (2011). *Marshall Armstrong is new to our school.* London: Harper Collins.

Mai, L., & Gibson, R. (2009). The young child and the masterpiece: A review of the literature on aesthetic experiences in early childhood. *International Journal of the Arts in Society, 4*(3), 357–368.

Mai, L., & Gibson, R. (2011). The rights of the putti: A review of the literature on children as cultural citizens in art museums. *Museum Management and Curatorship, 26*(4), 355–371.

Mallan, K. (1993). Once there was a story about three turtles: Oral narrative styles of pre-school children. *The Australian Journal of Language and Literacy, 16*(3), 249–260.

McArdle, F. (2003). The visual arts: Ways of seeing. In S. Wright (Ed), *Children, meaning-making and the arts* (pp. 35–62). Frenchs Forest, NSW: Pearson/Prentice-Hall.

McGrath Speaker, K., Taylor, D., & Kamen, R. (2004). Storytelling: Enhancing language acquisition in young children. *Education, 125*(1), 3–15.

McKechnie, S. (1996). Choreography as research. In M. M. Stoljar (Ed.), *Creative investigations: Redefining research in the Arts and Humanities.* Canberra: The Australian Academy of the Humanities.

McMullen, J. (2010, October). *True Stories.* Opening address of the *True Stories* Aboriginal Art Exhibition, curated by Hetty Perkins, Art Gallery of New South Wales, Sydney.

McRae, R. (1991). *Cry me a river.* North Ryde, NSW: Harper Collins.

Meek, M. (1988). *How texts teach what readers learn.* Gloucestershire, UK: Thimble Press.

Meiners, J. (2005). In the beginning: Young children and arts education. *International Journal of Early Childhood, 37*(2), 37–44.

Mello, R. (2001a, July). *Building bridges: How storytelling influences teacher/student relationships.* Paper presented at Storytelling in the Americas Conference. Brock University, Ontario, Canada.

Mello, R. (2001b). The power of storytelling: How oral narrative influences children's relationships in classrooms. *International Journal of Education and the Arts, 2*(1). Retrieved from http://www.ijea.org/v2n1/

Mendoza, J., & Katz, L. G. (2008). Introduction to the special section on dramatic play. *Early Childhood Research and Practice, 10*(2) [online journal]. Retrieved from http://www.ecrp.uiuc.edu/vl0n2/introduction.html

Miller, C., & Saxton, J. (2004). *Into the story: Language in action through drama.* Portsmouth, NH: Heinemann.

Miller, E., & Almon, J. (2009). *Crisis in the kindergarten: Why children need to play in school.* College Park, MD: Alliance for Childhood.

Munns, G. (2007). A sense of wonder: Pedagogies to engage students who live in poverty. *International Journal of Inclusive Education, 11*(3), 301–315.

Munsch, R. (1989). *The paperbag princess* (M. Martchenko, Ilus.). Sydney: Ashton Scholastic.

Nicolopoulou, A. (2005). Play and narrative in the process of development: Commonalities, differences, and interrelations. *Cognitive Development, 20*(4), 495–502.

Nicolopoulou, A. (2008). The elementary forms of narrative coherence in young children's storytelling. *Narrative Inquiry, 18*(2), 299–325.

Nicolopoulou, A., McDowell, J., & Brockmeyer, C. (2006). Narrative play and emergent literacy: Storytelling and story-acting meet journal writing. In D. Singer, R. Golinkoff & K. Hirsh-Pasek (Eds.), *Play = learning: How play motivates and enhances children's cognitive and social–emotional growth* (pp. 124–144). New York: Oxford University Press.

Norfolk, S., Stenson, J., & Williams, D. (Eds.). (2006). *The storytelling classroom: Applications across the curriculum.* Westport, CT: Libraries Unlimited.

NSW Department of Education and Training. (2003). *Quality teaching in NSW Public Schools: Discussion paper.* Retrieved from http://www.schools.nsw.edu.au/media/downloads/languagesupport/qualteach_nswps/quali_teach_en.pdf

Office of the High Commissioner for Human Rights. (1989). *Convention on the Rights of the Child.* Retrieved from http://www2.ohchr.org/english/law/crc.htm

O'Hare, J. (2005). Puppetry in education: Process or product? In M. Bernier & J. O'Hare (Eds.), *Puppets in education and therapy: Unlocking doors to the mind and heart.* Bloomington, IN: Authorhouse.

OHCHR *see* Office of the High Commissioner for Human Rights

O'Neill, C. (1995). *Drama worlds: A framework for process drama.* Portsmouth, NH: Heinemann.

Orff, C., & Keetman, G. (1950). *Musik für Kinder 1.* Mainz: Schott.

O'Toole, J., & Dunn, J. (2002). *Pretending to learn: Helping children to learn through drama.* Sydney: Pearson.

Paley, V. G. (1990). *The boy who would be a helicopter: The uses of storytelling in the classroom.* Cambridge, MA: Harvard University Press.

Palmer, P. J. (1998). *The courage to teach: Exploring the inner landscape of a teacher's life.* San Francisco: Jossey-Bass.

Parten, M. (1932). Social participation among preschool children. *Journal of Abnormal and Social Psychology, 27,* 243–269.

Pascoe, R. (2007). *National review of school music education.* Canberra: Department of Education, Science and Training.

Paterson, K. (1995). *A sense of wonder.* Penguin: London.

PEEL *see* Project for Enhancing Effective Learning

Pellegrini, A., & Smith, P. (1998). The development of play during childhood: Forms and possible functions. *Child Psychology and Psychiatry Review, 3*(2), 51–57.

Perkins, D. N. (1988). Art as an occasion of intelligence. *Educational Leadership,* Dec/Jan, 36–42.

Piaget, J. (1962). *Play, dreams, and imitation in childhood.* New York: Norton.

Piscitelli. B. (2005, June). *Young children as cultural citizens*. Paper presented at Our Children the Future Conference, Adelaide, South Australia. Retrieved from http://www.octf.sa.edu.au/files/links/Piscitell_1.doc

Piscitelli, B., Weier, K., & Everett, M. (2003). Museums and young children: Partners in learning about the world. In S. Wright (Ed.), *Children, meaning-making and the arts* (pp. 158–175). Sydney: Pearson Prentice-Hall.

Poston-Anderson, B., & Redfern, L. (1996). Once upon our time: Research into the value of told story today. *ORANA, 32*(4), 241–247.

President's Committee on the Arts and Humanities. (2011). *Reinvesting in arts education: Winning America's future through creative schools*. Washington, DC: Author.

Project for Enhancing Effective Learning. (2009). *About PEEL*. Retrieved from http://www.peelweb.org/index.cfm?resource=about

Robinson, K. (1999). *All our futures: Creativity, culture and education*. Report to the National Advisory Committee on Creative & Cultural Education. London: Department for Education and Employment.

Robinson, K. (2009). *The element: How finding your passion changes everything*. Melbourne: Penguin.

Rooks, D. (1998). Can I tell you my story? How storytelling contributes to pupils' achievements in other aspects of speaking and listening and to their understanding of how language works. *Literacy, 32*(1), 24–28.

Rosen, B. (1988). *And none of it was nonsense: The power of storytelling in school*. Portsmouth, NH: Heinemann.

Rosen, M. (1989). *We're going on a bear hunt* (H. Oxenbury, Illus.). London: Walker Books.

Salmon, M. D., & Sainato, D. M. (2005). Beyond Pinocchio: Puppets as teaching tools in inclusive early childhood classrooms. *Young Exceptional Children, 8*(12), 12–19.

Sawyer, R. K. (1997). *Pretend play as improvisation: Conversation in the preschool classroom*. Mahwah, NJ: Lawrence Erlbaum.

Saxby, M. (1997). *Books in the life of the child*. Melbourne: Macmillan.

Scales, B., Almy, M., Nicolopulou, A., & Ervin-Tripp, S. (1991). Defending play in the lives of children. In B. Scales, M. Almy, A. Nicolopulou, & S. Ervin-Tripp (Eds.), *Play and the social context of development in early care and education* (pp. 15–31). New York: Teachers' College, Columbia University.

Schiller, F. (1967) [1795]. *On the aesthetic education of man*. Oxford, UK: Oxford University Press.

Schiller, W. (2005). Children's perceptions of live arts performances: A longitudinal study. *Early Child Development and Care, 175*(6), 543–552.

Schiller, W., & Meiners, J. (2011). Dance: Moving beyond steps to ideas. In S. Wright (Ed.), *Children, meaning-making and the arts* (3rd ed., p. 85–113). Sydney: Pearson.

Schirrmacher, R. (1998). *Art and creative development for young children*. Albany, NY: Delmar.

Scieszka, J. (1991). *The frog prince continued* (S. Johnson, Ilus.). London: Viking.

Scieszka, J., & Smith, L. (1996). *The true story of the three little pigs*. New York: Puffin Books.

Sendak, M. (1967). *Where the wild things are*. London: Bodley Head.

Shimojima, A. (2006). From the library media centre: Storytelling through the grades. In S. Norfolk, J. Stenson & D. William (Eds.), *The storytelling classroom: Applications across the curriculum* (pp. 1–4). Westport, CT: Libraries Unlimited.

Sim, C. (2004). The personal as pedagogical practice. *Teachers and teaching, 10*(4), 351–364.

Singer, J. (2006). Learning to play and learning through play. In D. Singer, R. Michnick Golinkoff & K. Hirsh-Pasek (Eds.), *Play = learning: How play motivates and enhances children's cognitive and social-emotional growth* (pp. 1–13). New York: Oxford University Press.

Smilansky, S. (1968). *The effects of socio-dramatic play on disadvantaged preschool children*. New York: Wiley.

Smith, N. (1983). *Experience and art: Teaching children to paint*. New York: Teachers College Press.

Solis, S. (2006). *Storytime yoga: Teaching yoga to children through story*. Boulder, CO: Mythic Yoga Studio.

Spence, B. (2004). *Reading aloud to children*. Primary English Note 146. Sydney: Primary English Teaching Association.

Spence, N. (2011, November 30). If you can't play as a child, then when can you? *Sydney Morning Herald*. Retrieved from http://www.smh.com.au/opinion/society-and-culture/if-you-cant-play-as-a-achild-then-when-can-you-20111130-106bb.html.

Starko, A. (1995). *Creativity in the classroom: Schools of curious delight*. White Plains, NY: Longman.

Steiner, R. (1995)[1924]. *The kingdom of childhood. Introductory talks on Waldorf education*. (Rudolf Steiner Press, Rev. Trans.). Hudson, New York: Anthroposophic Press.

Stinson, S. (1988). *Dance for young children: Finding the magic in movement*. Reston, VA: The American Alliance for Health, Physical Education, Recreation, and Dance.

Suggate, S. (2009). School entry age and reading achievement in the 2006 Programme for International Student Assessment (PISA). *International Journal of Reading, 48*(3), 51–61.

Tarr, P. (2004). Consider the walls. *Young Children, 59*(3), 88–92.

Thompson, C. (1990). 'I make a mark': The significance of talk in young children's artistic development. *Early Childhood Research Quarterly, 5*, 215–232.

Thomson, P., & Sefton-Green, J. (Eds.). (2011). *Researching creative learning: Methods and issues*. London: Routledge.

Torrance, E. P. (1970). *Encouraging creativity in the classroom*. Dubuque, IA: William C. Brown.

Troughton, J. (2004). *What made Tiddalik laugh*. Melbourne: Thomas Nelson. Retrieved from http://www.workingwithatsi.info/content/Tiddalik.htm

Vecchi, V. (2010). *Art and creativity in Reggio Emilia: Exploring the role and potential of ateliers in early childhood education*. Oxford, UK: Routledge.

Vinson, T. (2004). *Community adversity and resilience: The distribution of social disadvantage in Victoria and New South Wales and the mediating role of social cohesion*. Melbourne: Ignatius Centre for Social Policy & Research.

Vinson, T. (2006). *The education and care of our children: Good beginnings.* Sydney: NSW Teachers Federation.

Vinson, T. (2007). *Dropping off the edge.* Sydney: Jesuit Social Services/Catholic Social Services Australia.

Vinson, T. (2009). *Markedly socially disadvantaged localities in Australia: Their nature and possible remediation.* Camberra: Social Inclusion Unit, Australian Department of Education, Employment and Workplace Relation. Retrieved from http://www.apo.org.au/research/markedly-socially-disadvantaged-localities-australia

Vygotsky, L. (1966) [1933]. *Play and its role in the mental development of the child.* Retrieved from http://www.marxists.org/archive/vygotsky/works/1933/play.htm

Vygotsky, L. (1978). *Mind in society.* Cambridge, MA: Harvard University Press.

Waddell, M. (1991). *Farmer duck* (H. Oxenbury, Illus.). London: Walker Books.

Wagner, J., & Roenfeldt, R. (1995). *The werewolf knight.* Sydney: Random House.

Weitzman, J. P. (2002). *You can't take a balloon into the Museum of Fine Arts* (R. P. Glasser, Illus.). New York: Dial Books.

Wells, G. (1986). *The meaning makers: Children learning language and using language to learn.* Portsmouth, NH: Heinemann.

Wheatley, N. (2010). *Playground.* Sydney: Walker Books.

Whitehead, M. R. (2004). *Language and literacy in the early years.* London: Sage Publications.

Wilson, M., & Wilson, B. (1982). *Teaching children to draw.* Englewood Cliffs, NJ: Prentice-Hall.

Windmill Theatre. (2012). *Our school's education program* [web page]. Retrieved from http://www.windmill.org.au/educate/our-schools-education-program

Winnicott, D. W. (1980). *Playing and reality.* Middlesex, UK: Penguin.

Wright, S. (2011). Ways of knowing in the arts. In S. Wright (Ed.), *Children, meaning-making and the arts* (2nd ed., pp. 1–29). Sydney: Pearson.

Wright, S. (2012) *Whats on: I, bunyip.* Retrieved July 9, 2012, from http://www.theartscentregc.com.au/whats-on/whats-on-items/i,-bunyip

Yolen, J. (2000). *Touch magic: Fantasy, faerie and folklore in the literature of childhood.* New York: August House.

Zigler, E. & Bishop-Josef, S. (2009). Play under siege: An historical overview. *Zero to Three, 30*(1), 4–11.

Zipes, J. (1995). *Creative storytelling: Building community, changing lives.* New York: Routledge.

INDEX